A SHORT HISTORY OF THE MIDDLE AGES

A SHORT HISTORY OF THE MIDDLE AGES

VOLUME II: FROM *c.*900 TO *c.*1500

BARBARA H. ROSENWEIN
FOURTH EDITION

 UNIVERSITY OF TORONTO PRESS

Library and Archives Canada Cataloguing in Publication

Rosenwein, Barbara H., author
 A short history of the Middle Ages / Barbara H. Rosenwein.—Fourth edition.

Includes bibliographical references and index.
Contents: v. 1. From c.300 to c.1150—v. 2. From c.900 to c.1500.
Issued in print and electronic formats.
ISBN 978-1-4426-0614-2 (pbk. : v. 1).—ISBN 978-1-4426-0617-3 (pbk. : v. 2).—
ISBN 978-1-4426-0615-9 (pdf : v. 1).—ISBN 978-1-4426-0616-6 (epub : v. 1).—
ISBN 978-1-4426-0618-0 (pdf : v. 2).—ISBN 978-1-4426-0619-7 (epub : v. 2)

 1. Middle Ages. 2. Europe—History—476-1492. I. Title.

D117.R67 2014a 940.1 C2013-906715-9
 C2013-906716-7

We welcome comments and suggestions regarding any aspect of our publications—please feel free to contact us at news@utphighereducation.com or visit our Internet site at www.utppublishing.com.

North America
5201 Dufferin Street
North York, Ontario, Canada, M3H 5T8

2250 Military Road
Tonawanda, New York, USA, 14150

ORDERS PHONE: 1–800–565–9523
ORDERS FAX: 1–800–221–9985
ORDERS E-MAIL: utpbooks@utpress.utoronto.ca

UK, Ireland, and continental Europe
NBN International
Estover Road, Plymouth, PL6 7PY, UK
ORDERS PHONE: 44 (0) 1752 202301
ORDERS FAX: 44 (0) 1752 202333
ORDERS E-MAIL: enquiries@nbninternational.com

Every effort has been made to contact copyright holders; in the event of an error or omission, please notify the publisher.

The University of Toronto Press acknowledges the financial support for its publishing activities of the Government of Canada through the Canada Book Fund.

Printed in Canada

MIX
Paper from
responsible sources
FSC® C103567

For Sophie

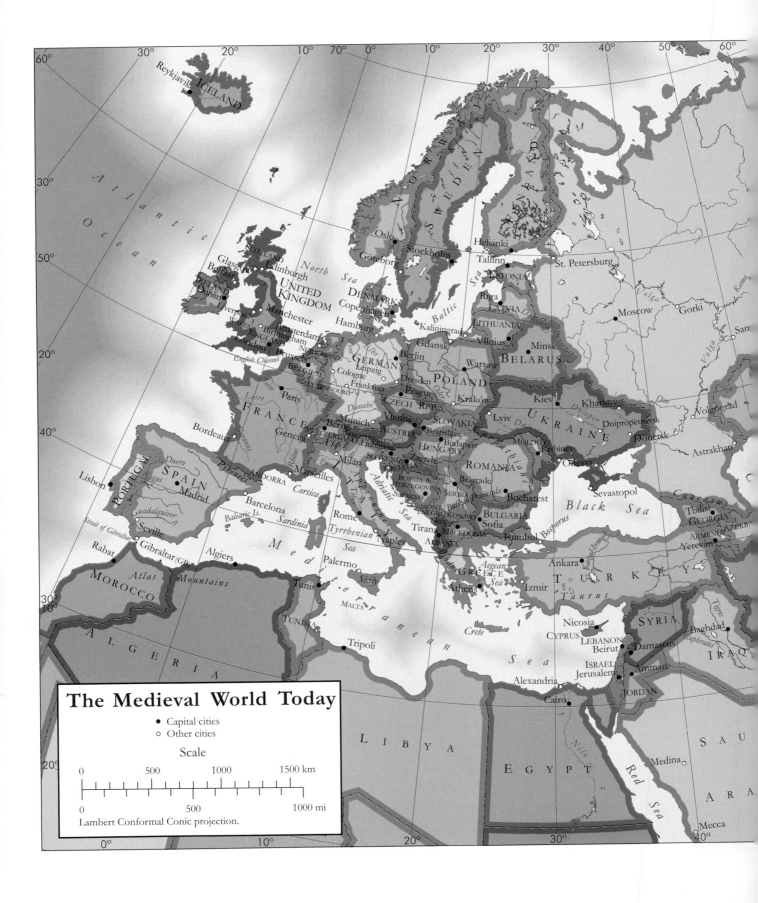

The Medieval World Today

- ● Capital cities
- ○ Other cities

Scale

0 500 1000 1500 km

0 500 1000 mi

Lambert Conformal Conic projection.

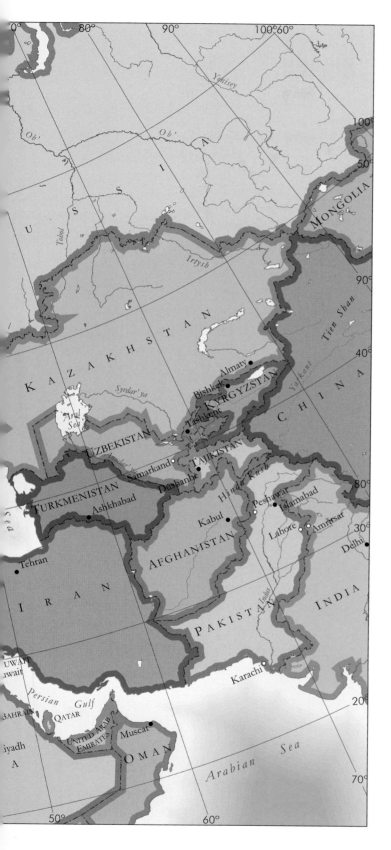

THE UNION of the Roman empire was dissolved; its genius was humbled in the dust; and armies of unknown barbarians, issuing from the frozen regions of the North, had established their victorious reign over the fairest provinces of Europe and Africa.

Edward Gibbon,
The Decline and Fall of the Roman Empire

IT MAY very well happen that what seems for one group a period of decline may seem to another the birth of a new advance.

Edward Hallett Carr, *What is History?*

CONTENTS

MAPS

PLATES

GENEALOGIES

FIGURES

ABBREVIATIONS, DATE CONVENTIONS, WEBSITES

ABBREVIATIONS

c. circa. Used in dates to mean that they are approximate.
cent. century
d. date of death
emp. emperor
fl. flourished. This is given when even approximate birth and death dates are unknown.
r. dates of reign

DATE CONVENTIONS

All dates are CE/AD unless otherwise noted (the two systems are interchangeable). The dates of popes are not preceded by r. because popes took their papal names upon accession to office, and the dates after those names apply only to their papacies.

The symbol / between dates indicates uncertainty: e.g. Boethius (475/480–524) means that he was born at some time between 475 and 480.

WEBSITES

http://www.utphistorymatters.com = The website for this book, which has practice short-answer and discussion questions (with sample answers provided), as well as maps, genealogies, and links to other medieval web resources.

http://labyrinth.georgetown.edu = The Labyrinth: Resources for Medieval Studies sponsored by Georgetown University.

http://www.roman-emperors.org = *De Imperatoribus Romanis*: An Online Encyclopedia of Roman Rulers and Their Families (to 1453).

WHY THE MIDDLE AGES MATTER TODAY

"The past is never dead. It's not even past," wrote William Faulkner in *Requiem for a Nun*. Faulkner was speaking of the past experiences of one human being. Can his statement apply to the historical past? Above all, can it apply to a period so far behind us that it has another name: the Middle Ages? Do the Middle Ages still shape our world?

To be sure! We can say that universities as we know them "began" in the Middle Ages; that medieval representative institutions were forerunners of the US houses of Congress and the Canadian Parliament; and that (giving the question of origins a less positive spin) the idea of making Jews wear a special marker, so important a feature of Nazi Germany in the 1930s, goes back to 1215. Today Neapolitans can walk by the very priory of San Domenico where Thomas Aquinas entered the order of Preachers, the Dominicans, while Americans in Washington, DC, can ogle Washington National Cathedral, built in Gothic style.

So medieval history is relevant today. It helps explain our surroundings and the origins of many of our institutions.

But immediate relevance is not the only reason why the Middle Ages matter. To put it bluntly: they matter because they are past, yet still familiar. The religions that flourished then—Islam, Christianity, Judaism, and the many dissidents within these folds—remain with us, even though they have changed dramatically. This is true as well of many of our institutions—the papacy, royalty, and towns, for example. The problems confronting people in the Middle Ages, not just basic problems such as giving birth, surviving, getting ill, and dying, but sophisticated problems—attempts at thought control, manipulation of markets, outlets and barriers to creativity—are recognizably analogous to our own.

Yet much is *very* different today. This isn't true just at the level of tools—the Middle Ages had nothing that was powered by electricity, no instantaneous communication methods—but also at the level of assumptions about the world. For example, the Middle Ages lacked our ideas and feelings associated with "nationalism." The nation-state, of overriding importance in our time, was unknown in the Middle Ages, even though medieval history became a discipline precisely to prove the reality of nations. (That last fact explains the origins of some of the great medieval primary-source collections undertaken in the nineteenth century, such as the *Monumenta Germaniae Historica*, the Historical Monuments of Germany, whose motto, *Sanctus amor patriae dat animum*, linked "holy love for the Fatherland" with soul, spirit, and inspiration.)

In the end, then, the Middle Ages matter today because they are not so far away as to be entirely foreign, and yet they are far enough away. As the Middle Ages unfolded and became something else (however we may want to define the period that comes next), we can see slow change over time, which we cannot do with our own period. We can then assess what both its stability and its changes may mean for our understanding of human nature, human society, ourselves, and our future.

ACKNOWLEDGMENTS

I would like to thank all the readers, many anonymous, who made suggestions for improving earlier editions of *A Short History of the Middle Ages*. While I hope I will be forgiven for not naming everyone—a full list of names would begin to sound like a roll call of medievalists, both American and European—I want to single out those who were of special help: Eduardo Aubert, Monique Bourin, Elizabeth A.R. Brown, Leslie Brubaker, D.B. van Espelo, Dominique Iogna-Prat, Herbert Kessler, Maureen C. Miller, Eduard Mühle, David Petts, Faith Wallis, Anders Winroth, and Ian Wood. Piotr Górecki supplied me with detailed notes and bibliography and generously critiqued my attempts to write about the history of East Central Europe. Elina Gertsman was a never-ending font of knowledge and inspiration for all matters artistic. Kiril Petkov was a constant and generous resource for matters Bulgarian. Although Riccardo Cristiani was hired simply to check facts, his work for me became a true collaboration. He wrote the questions and answers for the website of this book, compiled the index, and not only corrected many obscurities, infelicities, and errors but also suggested welcome changes and additions. (The mistakes that remain are, to be sure, mine alone.) The people with whom I worked at the University of Toronto Press were unfailingly helpful and efficacious: Judith Earnshaw and Natalie Fingerhut, with whom I was in constant touch, as well as Martin Boyne, Liz Broes, Anna Del Col, Michael Harrison, Matthew Jubb, Beate Schwirtlich, Zack Taylor, and Daiva Villa. I am grateful to the librarians of Loyola University Chicago's Cudahy library—especially Frederick Barnhart, Jennifer Jacobs, Linda Lotton, the late Bonnie McNamara, Jeannette Pierce, David Schmidt, Ursula Scholz, and Jennifer Stegen—who cheerfully fed my voracious hunger for books. Finally, I thank my family, and I dedicate this book to its youngest member, my granddaughter Sophie, born in 2011. May she find much in the Middle Ages to wonder at and enjoy.

FOUR

POLITICAL COMMUNITIES REORDERED
(c.900–c.1050)

THE LARGE-SCALE centralized governments of the ninth century dissolved in the tenth. The fission was least noticeable at Byzantium, where, although important landowning families emerged as brokers of patronage and power, the primacy of the emperor was never effectively challenged. In the Islamic world, however, new dynastic groups established themselves as regional rulers. In Western Europe, Carolingian kings ceased to control land and men, while new political entities—some extremely local and weak, others quite strong and unified—emerged in their wake.

BYZANTIUM: THE STRENGTHS AND LIMITS OF CENTRALIZATION

By 1025 the Byzantine Empire once again touched the Danube and Euphrates Rivers. Its emperors maintained the traditional cultural importance of Constantinople by carefully orchestrating the radiating power of the imperial court. Yet at the same time, powerful men in the countryside gobbled up land and dominated the peasantry, challenging the dominance of the center.

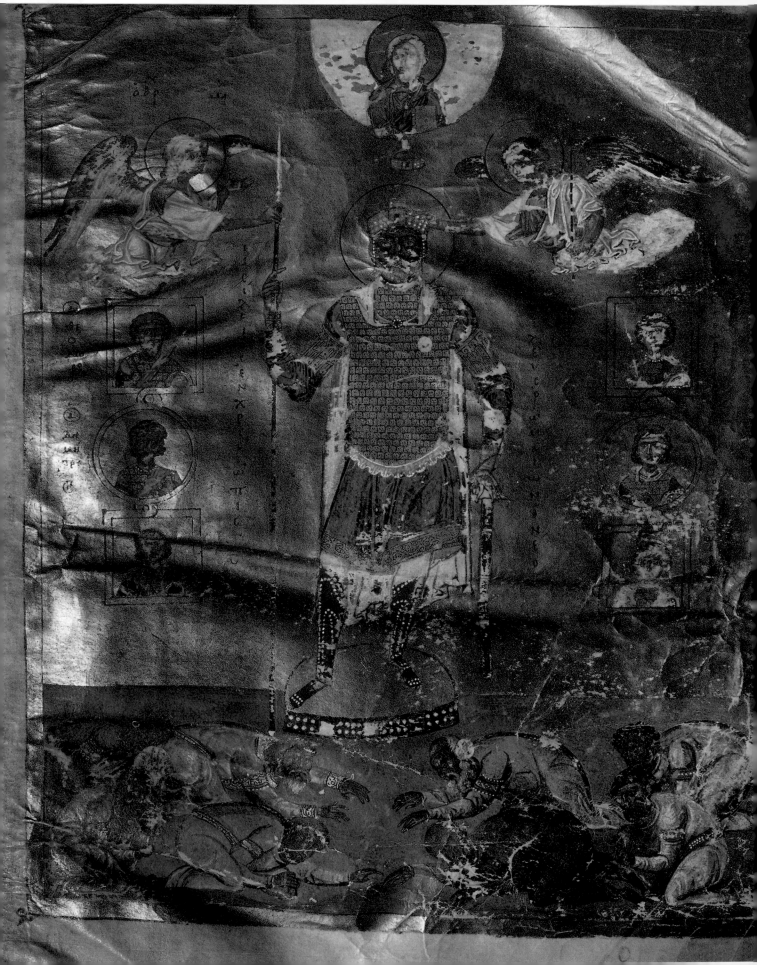

A Wide Embrace and Its Tensions

The artist who painted this image of Basil at the start of a Psalter had reason to substitute him for the usual portrait of King David, the presumed author of the psalms. Like the biblical slayer of Goliath, Basil also was a giant-slayer—in this case via wars of expansion. To be sure, he was following in the footsteps of earlier tenth-century soldier-emperors. Crete, lost to the Muslims in the ninth century, was retaken by Romanus II in 961; Nicephorus II reconquered Cyprus in 965 and Antioch in 969. But in 1018 Basil conquered Bulgaria, which had created a rival empire right on Byzantium's northern flank. Basil put the whole of the Balkans under Byzantine rule and divided its territory into themes. No wonder he was nicknamed the "Bulgar Slayer."

At the same time, moreover, Basil was busy setting up protectorates against the Muslims on his eastern front; at the end of his life he was preparing an expedition to Sicily. By 1025 the Byzantine army was rarely used to protect the empire's interior; it was mobilized to move outward, both east- and westward.

No longer was the Byzantine Empire the tight fist centered on Anatolia that it had been in the dark days of the eighth century. On the contrary, it was an open hand: sprawling, multi-ethnic, and multilingual. To the east it embraced Armenians, Syrians, and Arabs; to the north it included Slavs and Bulgarians (by now themselves Slavic speaking) as well as Pechenegs, a Turkic group that had served as allies of Bulgaria; to the west, in the Byzantine toe of Italy, it included Lombards, Italians, and Greeks. There must have been Muslims right in the middle of Constantinople: a mosque there, built in the eighth century, was restored and reopened in the eleventh century. Soldiers from the region of Kiev formed the backbone of Basil's "Varangian Guard," his elite troops. By the mid-eleventh century, Byzantine mercenaries included "Franks" (mainly from Normandy), Arabs, and Bulgarians as well. In spite of ingrained prejudices, Byzantine princesses had occasionally been married to foreigners before the tenth century, but in Basil's reign this happened to a sister of the emperor himself.

All this openness went only so far, however. Toward the middle of the eleventh century, the Jews of Constantinople were expelled and resettled in a walled quarter in Pera, on the other side of the Golden Horn (see Map 4.1). Even if they did not expel Jews so dramatically, many Byzantine cities forbade Jews from mixing with Christians. Around the same time, the rights of Jews as "Roman citizens" were denied; henceforth, in law at least, they had only servile status. The Jewish religion was condemned as a heresy.

Ethnic diversity was in part responsible for new regional political movements that threatened centralized imperial control. More generally, however, regional revolts were the result of the rise of a new class of wealthy provincial landowners, the *dynatoi* (sing. *dynatos*), "powerful men." Benefiting from a general quickening in the economy and the rise of new urban centers, they took advantage of the unaccustomed wealth, buying land from still impoverished peasants as yet untouched by the economic upswing. In his *Novel* (New Law) of 934, Emperor Romanus I Lecapenus (r.920–944) bewailed the "intrusion" of the rich

Plate 4.1: Emperor Basil II (r.976–1025). Painted on shiny gold leaf, this depiction of Emperor Basil II shows him triumphant over his enemies. Beneath his armor he is wearing a long-sleeved purple tunic trimmed with gold. Two archangels hover above him. Gabriel, on the left, gives him a lance, while Michael, on the right, transmits to him the crown offered by Christ. The emperor grasps a sword in one hand, while in his other hand he holds a staff that touches the neck of one of the semi-prone figures beneath his feet. On either side of the emperor are busts of saints.

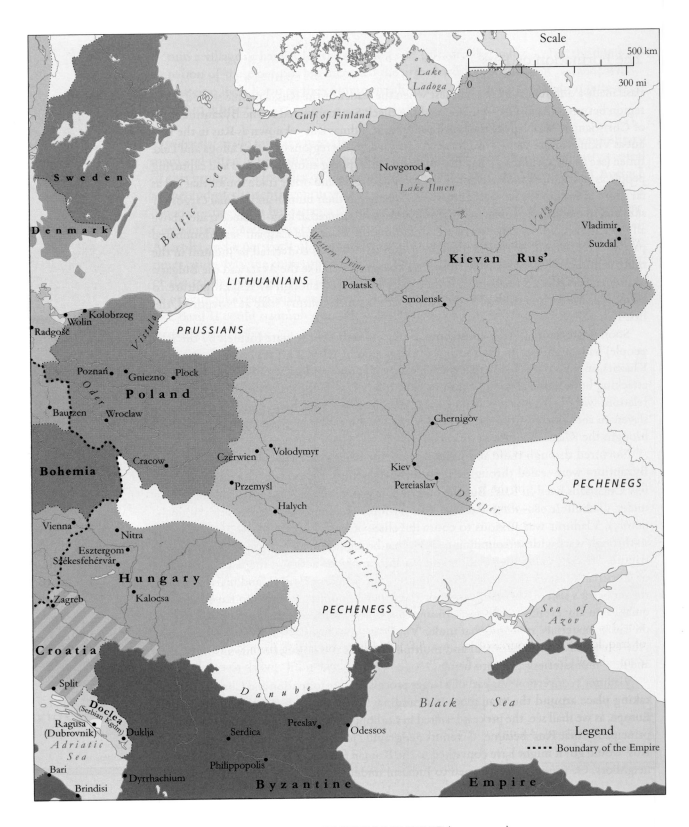

Scale

0 500 km

0 300 mi

Gulf of Finland

Lake Ladoga

Sweden

Denmark

Baltic Sea

Novgorod

Lake Ilmen

Volga

Vladimir

Suzdal

Kievan Rus'

LITHUANIANS

Western Dvina

Polatsk

PRUSSIANS

Smolensk

Kolobrzeg

Wolin

Radgošč

Vistula

Oder

Poznań

Gniezno

Plock

Poland

Bautzen

Wroclaw

Chernigov

Cracow

Czerwien

Volodymyr

Bohemia

Przemyśl

Kiev

Pereiaslav

Dnieper

PECHENEGS

Halych

Vienna

Nitra

Esztergom

Székesfehérvár

Dniester

Hungary

Zagreb

Kalocsa

PECHENEGS

Sea of Azov

Croatia

Split

Danube

Black Sea

Doclea
(Serbian Kgdm)

Ragusa
(Dubrovnik)

Duklja

Serdica

Preslav

Odessos

Adriatic Sea

Bari

Philippopolis

Legend

Brindisi

Dyrrhachium

Byzantine

Empire

Boundary of the Empire

indeed, it might have adopted Islam, given that the Volga Bulgars had converted to Islam in the early tenth century. It is likely that Vladimir chose the Byzantine form of Christianity because of the prestige of the empire under Basil.

That momentary decision left lasting consequences. Rus', ancestor of Russia, became the heir of the Byzantium. Choosing Christianity linked Russia to the West, but choosing the Byzantine form guaranteed that Russia would always stand apart from Europe.

DIVISION AND DEVELOPMENT IN THE ISLAMIC WORLD

While at Byzantium the forces of decentralization were feeble, they carried the day in the Islamic world. Where once the caliph at Baghdad or Samarra could boast collecting taxes from Kabul (today in Afghanistan) to Benghazi (today in Libya), in the eleventh century a bewildering profusion of regional groups and dynasties divided the Islamic world. Yet this was in general a period of prosperity and intellectual blossoming.

Map 4.3 (facing page): Kievan Rus', *c.*1050

The Emergence of Regional Powers

The Muslim conquest had not eliminated, but rather papered over, local powers and regional affiliations. While the Umayyad and Abbasid caliphates remained strong, they imposed their rule through their governors and army. But when the caliphate became weak, as it did in the tenth and eleventh centuries, old and new regional interests came to the fore.

A glance at a map of the Islamic world *c.*1000 (Map 4.4) shows, from east to west, the main new groups that emerged: the Samanids, Buyids, Hamdanids, Fatimids, and Zirids. But the map hides the many territories dominated by smaller independent rulers. North of the Fatimid Caliphate, al-Andalus had a parallel history. Its Umayyad ruler took the title of caliph in 929, but in the eleventh century he too was unable to stave off political fragmentation.

The key cause of the weakness of the Abbasid caliphate was lack of revenue. When landowners, governors, or recalcitrant military leaders in the various regions of the Islamic world refused to pay taxes into the treasury, the caliphs had to rely on the rich farmland of Iraq, long a stable source of income. But a deadly revolt lasting from 869 to 883 by the Zanj—black slaves from sub-Saharan Africa who had been put to work to turn marshes into farmland—devastated the Iraqi economy. Although the revolt was put down and the head of its leader was "displayed on a spear mounted in front of [the winning general] on a barge," there was no chance for the caliphate to recover.[4] In the tenth century the Qaramita (sometimes called the "Carmathians"), a sect of Shi'ites based in Arabia, found Iraq easy prey. The result was decisive: the caliphs could not pay their troops. New men— military leaders with their own armies and titles like "commander of commanders"—took

the reins of power. They preserved the Abbasid line, but they reduced the caliph's political authority to nothing.

The new rulers represented groups that had long awaited power. The Buyids, for example, belonged to ancient warrior tribes from the mountains of Iran. Even in the tenth century, most were relatively new converts to Islam. Bolstered by long-festering local discontent, one of them became "commander of commanders" in 945. Thereafter, the Buyids, with help from their own Turkish mercenaries, dominated the region south of the Caspian Sea, including Baghdad (once again the home of the caliphs) itself. Yet already by the end of the tenth century, other local men were challenging Buyid rule in a political process—the progressive regionalization and fragmentation of power—echoed elsewhere in the Islamic world and in parts of Western Europe as well.

The most important of the new regional rulers were the Fatimids. They, like the Qaramita (and, increasingly in the course of time, the Buyids), were Shi'ites, taking their name from Muhammad's daughter Fatimah, wife of Ali. The Fatimid leader claimed not only to be the true *imam*, descendant of Ali, but also the *mahdi*, the "divinely guided" messiah, come to bring justice on earth. Because of this, the Fatimids were proclaimed "caliphs" by their followers—the true "successors" of the Prophet. (See the list of Fatimid caliphs on p. 342.) Allying with the Berbers in North Africa, by 909 the Fatimids had

Map 4.4: Fragmentation of the Islamic World, *c.*1000

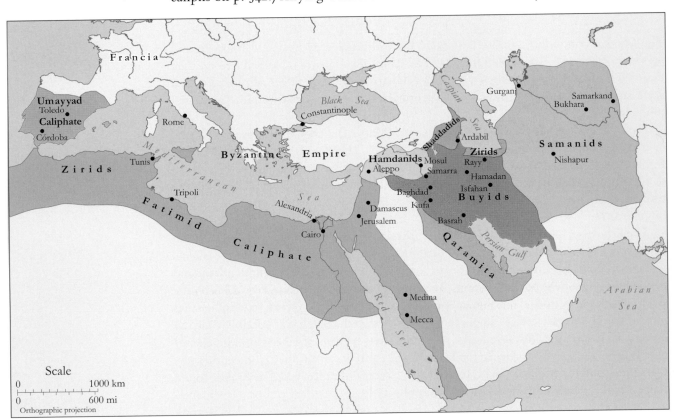

established themselves as rulers in what is today Tunisia and Libya. Within a half-century they had moved eastward (largely abandoning the Maghreb to the Zirids), to rule Egypt, southern Syria, and the western edge of the Arabian Peninsula.

The Fatimids looked east rather than west because the east was rich and because Sunnis, hostile to Shi'ite rule, dominated the western regions. The most important of these Sunni rulers were the Umayyads at Córdoba. Abd al-Rahman III (r.912–961) took the title caliph in 929 as a counterweight to the Fatimids, although he claimed to rule only all of al-Andalus, not the whole Islamic world. An active military man backed by an army made up mainly of Slavic slaves, al-Rahman defeated his rivals and imposed his rule not only on southern Iberia (as his predecessors had done) but also in northern regions (near the Christian kingdoms) and in the Maghreb. Under al-Rahman and his immediate successors, al-Andalus became a powerful centralized state. But regional Islamic rulers there worked to undermine the authority of the Umayyads, so that between 1009 and 1031 bitter civil war undid the dynasty's power. After 1031, al-Andalus was split into small emirates called *taifas*, ruled by local strongmen.

Thus in the Islamic world, far more decisively than at Byzantium, newly powerful regional rulers came to the fore. Nor did the fragmentation of power end at the regional level. To pay their armies, rulers often resorted to granting their commanders *iqta*—lands and villages—from which the *iqta*-holder was expected to gather revenues and pay their troops. As we shall see, this was a bit like the Western European institution of the fief. It meant that even minor commanders could act as local governors, tax-collectors, and military leaders. But there was a major difference between this institution and the system of fiefs and vassals in the West: while vassals were generally tied to one region and one lord, the troops under Islamic local commanders were often foreigners and former slaves, unconnected to any particular place and easily wooed by rival commanders.

Cultural Unity, Religious Polarization

The emergence of local strongmen meant not the end of Arab court culture but a multiplicity of courts, each attempting to out-do one another in brilliant artistic, scientific, theological, and literary productions. Cairo, for example, founded by the Fatimids, was already a huge urban complex by 1000. Imitating the Abbasids, the Fatimid caliphs built mosques and palaces, fostered court ceremonials, and turned Cairo into a center of intellectual life. One of the Fatimid caliphs, al-Hakim (r.996–1021), founded the *dar al-ilm*, a sort of theological college plus public library.

Even more impressive was the Umayyad court at Córdoba, the wealthiest and showiest city of the West. It boasted 70 public libraries in addition to the caliph's private library of perhaps 400,000 books. The Córdoban Great Mosque was a center for scholars from the rest of the Islamic world (the caliphs paid their salaries), while nearly 30 free schools were set up throughout the city.

Córdoba was noteworthy, not only because of the brilliance of its intellectual life, but also because of the role women played in it. Elsewhere in the Islamic world there were certainly a few unusual women associated with cultural and scholarly life. But at Córdoba this was a general phenomenon: women were not only doctors, teachers, and librarians but also worked as copyists for the many books so widely in demand.

Male scholars were, however, everywhere the norm. They moved easily from court to court. Ibn Sina (980–1037), known to the West as Avicenna, began his career serving the ruler at Bukhara in Central Asia, and then moved westward to Gurganj, Rayy, and Hamadan before ending up for thirteen years at the court of Isfahan in Iran. Sometimes in favor and sometimes decidedly not so (he was even briefly imprisoned), he nevertheless managed to study and practice medicine and write numerous books on the natural sciences and philosophy. His pioneering systematization of Aristotle laid the foundations of future philosophical thought in the field of logic: "There is a method by which one can discover the unknown from what is known. It is the science of logic…. [It is also] concerned with the different kinds of valid, invalid, and near valid inferences."[5]

Despite its political disunity, then, the Islamic world of the tenth and eleventh centuries remained in many ways an integrated culture. This was partly due to the model of intellectual life fostered by the Abbasids, which even in decline was copied by the new rulers, as we have just seen. It was also due to the common Arabic language, the glue that bound the astronomer at Córdoba to the philosopher at Cairo.

Writing in Arabic, Islamic authors could count on a large reading public. Manuscripts were churned out quickly via a well-honed division of labor: scribes, illustrators, page cutters, and book-binders specialized in each task. Children were sent to school to learn the Qur'an; listening, reciting, reading, and writing were taught in elementary schools along with good manners and religious obligations. Although a conservative like al-Qabisi (d. 1012) warned that "[a girl] being taught letter-writing or poetry is a cause for fear," he also insisted that parents send their children to school to learn "vocalization, spelling, good handwriting, [and] good reading." He even admitted that learning about "famous men and chivalrous knights" might be acceptable.[6]

Educated in the same texts across the whole Islamic world, Muslims could easily communicate, and this facilitated open networks of trade. With no national barriers to commerce and few regulations, merchants regularly dealt in far-flung, various, and sometimes exotic goods. From England came tin, while salt and gold were imported from Timbuktu in west-central Africa; from Russia came amber, gold, and copper; slaves were wrested from sub-Saharan Africa, the Eurasian steppes, and Slavic regions.

Although Muslims dominated these trade networks, other groups were involved in commerce as well. We happen to know a good deal about one Jewish community living at Fustat, about two miles south of Cairo. It observed the then-common custom of depositing for eventual ritual burial all worn-out papers containing the name of God. For good measure, the Jews in this community included everything written in Hebrew letters: legal documents, fragments of sacred works, marriage contracts, doctors' prescriptions, and so on. By chance, the materials that they left in their *geniza* (depository) at Fustat were

preserved rather than buried. They reveal a cosmopolitan, middle-class society. Many were traders, for Fustat was the center of a vast and predominately Jewish trade network that stretched from al-Andalus to India.

Consider the Tustari brothers, Jewish merchants from southern Iran. By the early eleventh century, the brothers had established a flourishing business in Egypt. Informal family networks offered them many of the same advantages as branch offices: friends and family in Iran shipped the Tustaris fine textiles to sell in Egypt, while they exported Egyptian fabrics back to Iran.

Only Islam itself, ironically, pulled Islamic culture apart. In the tenth century the split between the Sunnis and Shi'ites widened to a chasm. At Baghdad, al-Mufid (d.1022) and others turned Shi'ism into a partisan ideology that insisted on publicly cursing the first two caliphs, turning the tombs of Ali and his family into objects of veneration, and creating an Alid caliph by force. Small wonder that the Abbasid caliphs soon became ardent spokesmen for Sunni Islam, which developed in turn its own public symbols. Many of the new dynasties—the Fatimids and the Qaramita especially—took advantage of the newly polarized faith to bolster their power.

THE WEST: FRAGMENTATION AND RESILIENCE

Fragmentation was the watchword in Western Europe in many parts of the shattered Carolingian Empire. Historians speak of "France," "Germany," and "Italy" in this period as a shorthand for designating broad geographical areas (as will be the case in this book). But there were no national states, only regions with more or less clear borders and rulers with more or less authority. In some places—in parts of "France," for example—regions as small as a few square miles were under the control of different lords who acted, in effect, as independent rulers. Yet this same period saw unified European kingdoms emerge, or begin to emerge. To the north coalesced England, Scotland, and two relatively unified Scandinavian states—Denmark and Norway. In the center-east appeared Bohemia, Poland, and Hungary. In the center of Europe, a powerful royal dynasty from Saxony, the Ottonians, came to rule an empire stretching from the North Sea to Rome.

The Last Invaders of the West

Three groups invaded Western Europe during the ninth and tenth centuries: the Vikings, the Muslims, and the Magyars (called Hungarians by the rest of Europe). (See Map 4.5.) In the short run, they wreaked havoc on land and people. In the long run, they were absorbed into the European population and became constituents of a newly prosperous and aggressive European civilization.

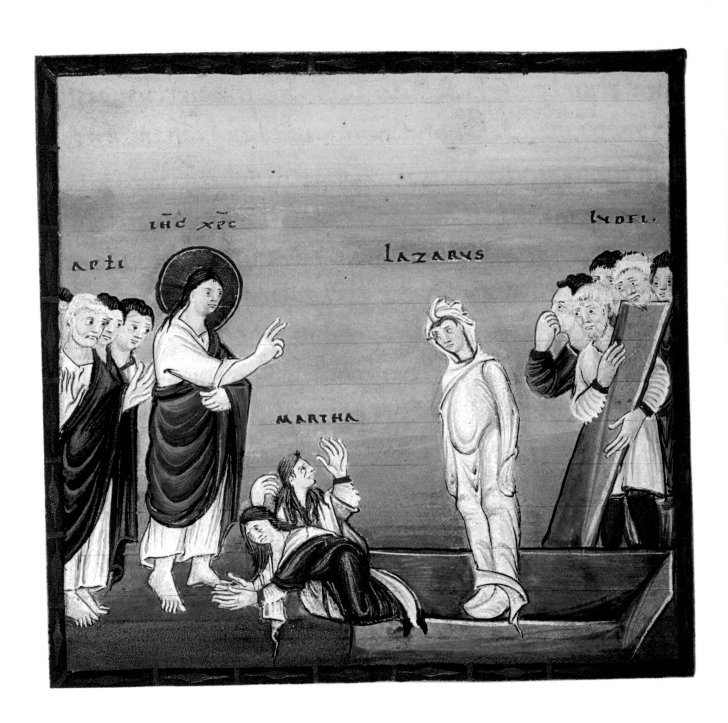

Plate 4.2 (facing page):
The Raising of Lazarus,
Egbert Codex (985–990).
This miniature is one of 51
illustrations in a Pericopes,
a book of readings arranged
for the liturgical year. The
story of the Raising of
Lazarus, which is recounted
in John 11:1–45, is read during
the week before Easter.
Of the many elements of
this story, the artist chose
a few important moments,
arranging them into a unified
scene.

Plate 4.3: Christ Asleep,
Hitda Gospels (c.1000–c.1020).
The moral of the story (which
is told in Matt. 8:23–26) is
right in the picture: as the
apostles look anxiously
toward the mast to save them
from the stormy sea, one (in
the exact center) turns to
rouse the sleeping Christ, the
real Savior.

such as Cicero and Horace as well as Scripture, while their episcopal teachers wrote histories, saints' lives, and works on canon law. One such was the *Decretum* (1008/1012) by Burchard, bishop of Worms. This widely influential collection—much like the compilations of *hadith* produced about a century before in the Islamic world—winnowed out the least authoritative canons and systematized the contradictory ones. The men at the cathedral schools were largely in training to become courtiers, administrators, and bishops themselves.

Bishops such as Egbert, archbishop of Trier (r.977–993), appreciated art as well as scholarship. Plate 4.2, an illustration of the Raising of Lazarus, from the Egbert Codex (named for its patron), is a good example of what is called the "Ottonian style." Drawing above all on the art of the late antique "renaissance," the Egbert Codex artists nevertheless achieved an effect all their own. Utterly unafraid of open space, which was rendered in otherworldly pastel colors, they focused on the figures, who gestured like actors on a stage. In Plate 4.2 the apostles are on the left-hand side, their arms raised and hands wide open with wonder at Christ. He has just raised the dead Lazarus from the tomb, and one of the Jews, on the right, holds his nose. Two women—Mary and Martha, the sisters of Lazarus—fall at Christ's feet, completing the dramatic tableau.

At around the same time, in convents that provided them with comfortable private apartments, noblewomen were writing books and supporting other artists and scholars. Plate 4.3 is from a manuscript made at Cologne between *c.*1000 and *c.*1020 for Abbess Hitda of Meschede. It draws on Byzantine and Carolingian models as well as the palette of the Egbert Codex to produce a calm Christ, asleep during a wild storm on the Sea of Galilee that ruffles the sails of the ship and seems to toss it into sheer air. The marriage of Otto II to a Byzantine princess, Theophanu, helps account for the Byzantine influence.

Among the most active patrons of the arts were the Ottonian kings themselves. In a Gospel book made for Otto III—a work fit for royal consumption—the full achievement of Ottonian culture is made clear. Plate 4.4 shows one of 29 full-page miniatures in this manuscript, whose binding alone—set with countless gems around a Byzantine carved ivory—was worth a fortune. The figure of the evangelist Luke emerges from a pure gold-leaf background, while the purple of his dress and the columns that frame him recall imperial majesty. At the same time, Luke is clearly of another world, and his Gospels have here become a theological vision.

France

By contrast with the English and German kings, those in France had a hard time coping with invasions. Unlike Alfred's dynasty, which started small and built slowly, the French kings had half an empire to defend. Unlike the Ottonians, who asserted their military prowess in decisive battles such as the one at Lechfeld, the French kings generally had to let local men both take the brunt of the attacks and reap the prestige and authority that came with military leadership. Nor did the French kings have the advantage of Germany's tributaries, silver mines, or Italian connections. Much like the Abbasid caliphs at Baghdad,

the kings of France saw their power wane. During most of the tenth century, Carolingian kings alternated on the throne with kings from a family that would later be called the "Capetians." At the end of that century the most powerful men of the realm, seeking to stave off civil war, elected Hugh Capet (r.987–996) as their king. The Carolingians were displaced, and the Capetians continued on the throne until the fourteenth century. (See Genealogy 5.4: The Capetian Kings of France, on p. 177.)

The Capetians' scattered but substantial estates lay in the north of France, in the region around Paris. Here the kings had their vassals and their castles. This "Ile-de-France" (which was all there was to "France" in the period; see Map 4.6) was indeed an "island,"—an île—surrounded by independent castellans. In the sense that he, too, had little more military power than other castellans, Hugh Capet and his eleventh-century successors were similar to local strongmen. But the Capetian kings had the prestige of their office. Anointed with holy oil, they represented the idea of unity and God-given rule inherited from Charlemagne. Most of the counts and dukes—at least those in the north of France—swore homage and fealty to the king, a gesture, however weak, of personal support. Unlike the German kings, the French could rely on vassalage to bind the great men of the realm to them.

New States in East Central Europe

Around the same time as Moravia and Bulgaria lost their independence to the Magyars and the Byzantines (respectively), three new polities—Bohemia, Poland, and Hungary—emerged in East Central Europe. In many ways they formed an interconnected bloc, as their ruling houses intermarried with one another and with the great families of the Empire—the looming power to the west. Bohemia and Poland both were largely Slavic-speaking; linguistically Hungary was odd man out, but in almost every other way it was typical of the fledgling states in the region.

BOHEMIA AND POLAND

While the five German duchies were subsumed by the Ottonian state (see p. 139), Bohemia in effect became a separate duchy of the Ottonian Empire. (See Map 4.6.) Already Christianized, largely under the aegis of German bishops, Bohemia was unified in the course of the tenth century. (One of its early rulers was Wenceslas—the carol's "Good King Wenceslas"—who was to become a national saint after his assassination.) Its princes were supposed to be vassals of the emperor in Germany. Thus when Bretislav I (d.1055) tried in 1038 to expand into what was by then Poland, laying waste the land all the way to Gniezno and kidnapping the body of the revered Saint Adalbert, Emperor Henry III (d.1056) declared war, forcing Bretislav to give up the captured territory and hostages. Although left to its own affairs internally, Bohemia was thereafter semi-dependent on the Empire.

SEEING THE MIDDLE AGES

Plate 4.4 (facing page):

Saint Luke, Gospel Book of Otto III (998–1001)

This is a complicated picture. How can we tease out its meaning? We know that the main subject is the evangelist Saint Luke, first because this illustration precedes the text of the Gospel of Saint Luke in the manuscript, and second because of the presence of the ox (who is labeled "Luc"). Compare Plate 2.5 on p. 67 of *A Short History of the Middle Ages*, Vol. I, which shows the same symbol and also includes the label "Agios Lucas"—Saint Luke. In that plate, Luke is writing his gospel. Here Luke is doing something different. But what?

An important hint is at the bottom of the page: the Latin inscription there says, "From the fountain of the Fathers, the ox draws water for the lambs." So Luke (the ox) draws water, or nourishment, from the Fathers for the "lambs," who are in fact shown drinking from the stream. Who are the lambs? In the same manuscript, the page depicting the evangelist Saint Matthew, which precedes his own Gospel, shows men, rather than lambs, drinking from the streams: clearly the lambs signify the Christian people.

Above Luke's head are the "Fathers." They are five of the Old Testament prophets, each provided with a label; the one to Luke's right, for example, is "Abacuc"—Habakkuk. Behind each prophet is an angel (David, at the very top, is accompanied by two), and each is surrounded by a cloud of glory, giving off rays of light that appear like forks jutting into the sky. The artist was no doubt thinking of Paul's Epistle to the Hebrews (12:1) where, after naming the great Old Testament prophets and their trials and tribulations, Paul calls them a "cloud of witnesses over our head" who help us to overcome our sins. But the artist must also have had in mind Christ's Second Coming, when, according to Apoc. 4:2–3, Christ will be seated on a "throne set in heaven" with "a rainbow round about the throne." In our plate, Luke sits in the place of Christ.

Thus this picture shows the unity of the Gospel of Luke with both the Old Testament and the final book of the Bible, the Apocalypse. Luke is the continuator and the guardian of the prophets, whose books are piled on his lap.

There is more. The figure of Luke forms the bottom half of a cross, with the ox in the center. The lamb and the ox were both sacrificial animals, signifying Christ himself, whose death on the cross redeemed mankind. Thus Luke not only "draws water for the lambs" from the Fathers, but he prefigures the Second Coming of Christ himself, the moment of salvation. The mandorla—the oval "halo" that surrounds him—was frequently used to portray Christ in glory.

Why would Emperor Otto III want to own a Gospel book of such theological sophistication? It is very likely because he saw himself as part of the divine order. He called himself the "servant of Jesus Christ," and he appears in one manuscript within a mandorla, just like Luke. (See the illustration below.) In this depiction, the symbols of the evangelists hold up the scarf of heaven that bisects the emperor: his feet touch the ground (note the cringing figure of Earth holding him up), while his head touches the cross of Christ, whose hand places a crown on his head. Otto III saw himself—much like Christ (and Luke)—as mediating between the people and God.

Otto III Enthroned, Aachen Gospels, (*c*.996)

Further Reading

Mayr-Hartung, Henry. *Ottonian Book Illumination: An Historical Study.* 2nd rev. ed. London: Harvey Miller, 1999.

Nees, Lawrence. *Early Medieval Art.* Oxford: Oxford University Press, 2002.

What was this "Poland" of such interest to Bretislav and Henry? Like the Dane Harald Bluetooth, and around the same time, the ruler of the region that would become Poland, Mieszko I (r.*c*.960–992), became Christian. In 990/991 he put his realm under the protection of the pope, tying it closely to the power of Saint Peter. Mieszko built a network of defensive structures manned by knights, subjected the surrounding countryside to his rule, and expanded his realm in all directions. Mieszko's son Boleslaw the Brave (or, in Polish, Chrobry) (r.992–1025), "with fox-like cunning" (as a hostile German observer put it), continued his father's expansion, for a short time even becoming duke of Bohemia.[15] Above all, Boleslaw made the Christian religion a centerpiece of his rule when Gniezno was declared an archbishopric. It was probably around that time that Boleslaw declared his alliance with Christ on a coin: on one side he portrayed himself as a sort of Roman emperor, while on the other he displayed a cross.[16] Soon the Polish rulers could count on a string of bishoprics—and the bishops who presided in them. A dynastic crisis in the 1030s gave Bretislav his opening, but, as we have seen, that was quickly ended by the German emperor. Poland persisted, although somewhat reduced in size.

HUNGARY

Polytheists at the time of their entry into the West, most Magyars were peasants, initially specializing in herding but soon busy cultivating vineyards, orchards, and grains. Above them was a warrior class, and above the warriors were the elites, whose richly furnished graves reveal the importance of weapons, jewelry, and horses to this society. Originally organized into tribes led by dukes, by the mid-tenth century the Hungarians recognized one ruling house—that of prince Géza (r.972–997).

Like the ambitious kings of Scandinavia, Géza was determined to give his power new ballast via baptism. His son, Stephen I (r.997–1038), consolidated the change to Christianity: he built churches and monasteries, and required everyone to attend church on Sundays. Establishing his authority as sole ruler, Stephen had himself crowned king in the year 1000 (or possibly 1001). Around the same time, "governing our monarchy by the will of God and emulating both ancient and modern caesars [emperors]," he issued a code of law that put his kingdom in step with other European powers.[17]

<p style="text-align:center">★ ★ ★ ★ ★</p>

Political fragmentation did not mean chaos. It simply betokened a new order. At Byzantium, in any event, even the most centrifugal forces were focused on the center; the real trouble for Basil II, for example, came from *dynatoi* who wanted to be emperors, not from people who wanted to be independent regional rulers. In the Islamic world fragmentation largely meant replication, as courts patterned on or competitive with the Abbasid model were set up by Fatimid caliphs and other rulers. In Europe, the rise of local rulers was accompanied by the widespread adoption of forms of personal dependency—vassalage, serfdom—that could be (and were) manipulated even by kings, such as the Capetians, who seemed to

have lost the most from the dispersal of power. Another institution that they could count on was the church. No wonder that in Rus', Scandinavia, and East Central Europe, state formation and Christianization went hand in hand.

The *real* fragmentation was among the former heirs of the Roman Empire. They did not speak the same language, they were increasingly estranged by their religions, and they knew almost nothing about one another. In the next century the West, newly prosperous and self-confident, would go on the offensive. Henceforth, without forgetting about the Byzantine and Islamic worlds, we shall focus on this aggressive and dynamic new society.

CHAPTER FOUR KEY EVENTS

c.790–*c*.950	Invasions into Europe by Vikings, Muslims, and Hungarians
869–883	Zanj revolt in Iraq
871–899	Reign of King Alfred the Great of England
c.909	Fatimids (in North Africa) establish themselves as caliphs
929	Abd al-Rahman III (at Córdoba in al-Andalus) takes title of caliph
955	Victory of Otto I over Hungarians at Lechfeld
962	Otto I crowned emperor
980–1037	Ibn Sina (Avicenna)
988	Conversion of Vladimir, ruler of Rus', to Byzantine Christianity
989	"Peace of God" movement begins
990/991	Mieszko I puts Poland under papal protection
1000 (or 1001)	Stephen I crowned king of Hungary
1025	Death of Basil II the Bulgar Slayer
c.1031	Al-Andalus splits into *taifas*

NOTES

1 Quoted in Henry Maguire, "Images of the Court," in *The Glory of Byzantium: Art and Culture of the Middle Byzantine Era,* A.D. *843–1261,* ed. Helen C. Evans and William D. Wixom (New York: Metropolitan Museum of Art, 1997), p.183.

2 Romanus I Lecapenus, *Novel,* in *Reading the Middle Ages: Sources from Europe, Byzantium, and the Islamic World,* ed. Barbara H. Rosenwein, 2nd ed. (Toronto: University of Toronto Press, 2014), p. 174.

3 *The Russian Primary Chronicle,* in *Reading the Middle Ages,* p. 215.

4 Al-Tabari, *The Defeat of the Zanj Revolt,* in *Reading the Middle Ages,* p. 172.

5 Ibn Sina (Avicenna), *Treatise on Logic,* in *Reading the Middle Ages,* p. 204.

6 Al-Qabisi, *A Treatise Detailing the Circumstances of Students and the Rules Governing Teachers and Students*, in *Reading the Middle Ages*, p. 199.

7 *Agreements between Count William of the Aquitanians and Hugh IV of Lusignan*, in *Reading the Middle Ages*, p. 183.

8 *Charter of Guillem Guifred*, in *Reading the Middle Ages*, p. 189.

9 Andrew of Fleury, *The Miracles of St. Benedict*, in *Reading the Middle Ages*, p. 187.

10 King Alfred, *Prefaces to Gregory the Great's Pastoral Care*, in *Reading the Middle Ages*, p. 221.

11 *The Battle of Brunanburh*, in *The Battle of Maldon and Other Old English Poems*, trans. Kevin Crossley-Holland, ed. Bruce Mitchell (London: McMillan, 1966), p. 42.

12 For an image of this runestone see *The Jelling Monument*, in *Reading the Middle Ages*, Plate 13, p. 249. For the quote, ibid., p. 226.

13 Ruotger, *Life of Bruno, Archbishop of Cologne*, in *Reading the Middle Ages*, p. 218.

14 Ibid., p. 217.

15 See Thietmar of Merseburg, *Chronicle*, in *Reading the Middle Ages*, p. 212.

16 For an image of this coin, see *Reading the Middle Ages*, Plate 12, p. 248.

17 King Stephen, *Laws*, in *Reading the Middle Ages*, p. 206.

FURTHER READING

Bachrach, David S. *Warfare in Tenth-Century Germany*. Woodbridge: Boydell, 2012.

Bagge, Sverre, Michael H. Gelting, and Thomas Lindkvist, eds. *Feudalism: New Landscapes of Debate*. Turnhout: Brepols, 2011.

Berend, Nora, ed. *Christianization and the Rise of Christian Monarchy: Scandinavia, Central Europe, and Rus' c. 900–1200*. Cambridge: Cambridge University Press, 2007.

Bonfil, Robert, Oded Irshai, Guy G. Stoumsa, et al., eds. *Jews in Byzantium: Dialetics of Minority and Majority Cultures*. Leiden: Brill, 2012.

Brink, Stefan, with Neil Price, eds. *The Viking World*. London: Routledge, 2008.

Chiarelli, Leonard C. *A History of Muslim Sicily*. Malta: Santa Venera, 2010.

Engel, Pál. *The Realm of St. Stephen: A History of Medieval Hungary, 895–1526*. Trans. Tamás Pálosfalvi. London: I.B. Tauris, 2001.

Evans, Helen C., and William D. Wixom. *The Glory of Byzantium: Art and Culture of the Middle Byzantine Era, a.d. 843–1261*. New York: Metropolitan Museum of Art, 1997.

Foot, Sarah. *Æthelstan: The First King of England*. New Haven, CT: Yale University Press, 2011.

Franklin, Simon, and Jonathan Shepard. *The Emergence of Rus, 750–1200*. London: Longman, 1996.

Jones, Anna Trumbore. *Noble Lord, Good Shepherd: Episcopal Power and Piety in Aquitaine, 877–1050*. Leiden: Brill, 2009.

Moore, R.I. *The First European Revolution, c. 970–1215*. Oxford: Wiley-Blackwell, 2000.

Neville, Leonora. *Authority in Byzantine Provincial Society, 950–1100*. Cambridge: Cambridge University Press, 2004.

Raffensperger, Christian. *Reimagining Europe: Kievan Rus' in the Medieval World*. Cambridge, MA: Harvard University Press, 2012).

Reuter, Timothy. *Germany in the Early Middle Ages, c.800–1056*. London: Longman, 1991.

Winroth, Anders. *The Conversion of Scandinavia: Vikings, Merchants, and Missionaries in the Remaking of Northern Europe*. New Haven, CT: Yale University Press, 2012.

To test your knowledge of this chapter, please go to

www.utphistorymatters.com

for Study Questions.

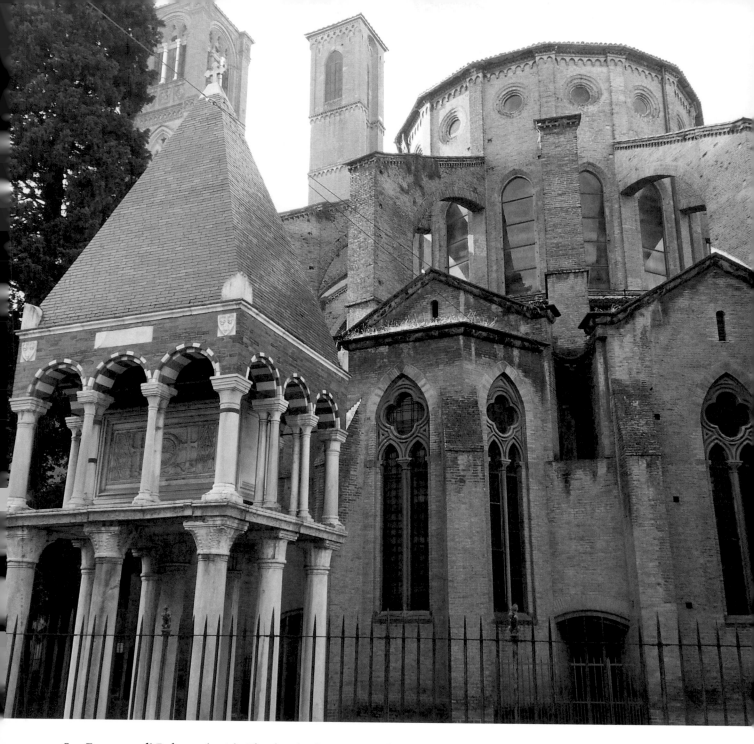

San Francesco di Bologna (1263): The church of San Francesco in Bologna, completed in 1263, was one of the first Italian churches to adopt the Gothic style, which originated in France. This photograph shows the apse (the east end) of the church. From its central polygonal structure radiate both chapels and flying buttresses. The buttresses take weight off the walls and allow them to be pierced by large lancet windows. But compared to the apse of a French Gothic church such as Notre Dame (see Plate 6.2 on p. 223), San Francesco's windows are small and its buttresses solid and sober. Some Italian churches had

a free-standing campanile (bell tower), the most famous being the round leaning tower at Pisa (see Plate 5.5 on p. 184). San Francesco had *two* bell towers, both square. Further east, beyond the apse, was a cemetery. The tomb in the photograph was built for Odofredo Denari (d. 1265), a lawyer and professor who was especially celebrated for his "glosses" (marginal comments) on laws inherited from ancient Rome. He was a later example of the Bolognese school of law that was already famous in the time of the Four Doctors (see pp. 179 and 210). (Image courtesy of Riccardo Cristiani.)

FIVE

THE EXPANSION OF EUROPE
(c. 1050–c. 1150)

EUROPEANS FLEXED THEIR MUSCLES in the second half of the eleventh century. They built cities, reorganized the church, created new varieties of religious life, expanded their intellectual horizons, pushed aggressively at their frontiers, and even waged war over 1,400 miles away, in what they called the Holy Land. Expanding population and a vigorous new commercial economy lay behind all this. So, too, did the weakness, disunity, and beckoning wealth of their neighbors, the Byzantines and Muslims.

THE SELJUKS

In the eleventh century the Seljuk Turks, a new group from outside the Islamic world, entered and took over its eastern half. Eventually penetrating deep into Anatolia, they took a great bite out of Byzantium. Soon, however, the Seljuks themselves split apart, and the Islamic world fragmented anew under the rule of dozens of emirs.

From the Sultans to the Emirs

Pastoralists on horseback, a Turkic people called the "Seljuks" (after the name of their most enterprising leader) crossed from the region east of the Caspian Sea into Iran in about the year 1000. Within a little over fifty years, the Seljuks had allied themselves with the caliphs as upholders of Sunni orthodoxy, defeated the Buyids, taken over the cities of Iran and Iraq, and started collecting taxes. Between 1055 and 1092, a succession of formidable

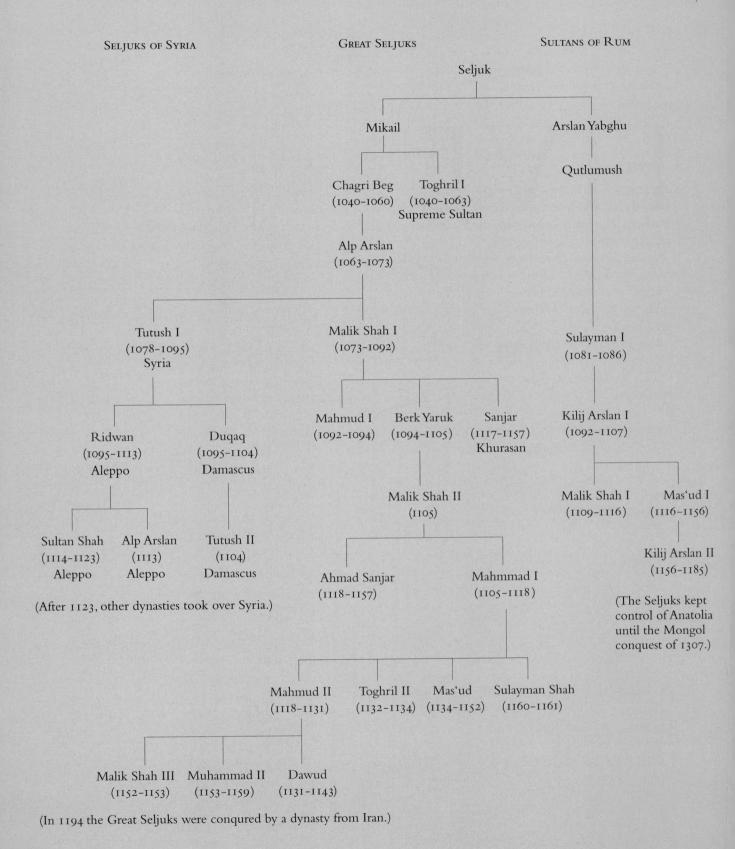

SELJUKS OF SYRIA GREAT SELJUKS SULTANS OF RUM

Seljuk

Mikail Arslan Yabghu

Chagri Beg Toghril I Qutlumush
(1040-1060) (1040-1063)
Supreme Sultan

Alp Arslan
(1063-1073)

Tutush I Malik Shah I Sulayman I
(1078-1095) (1073-1092) (1081-1086)
Syria

Ridwan Duqaq Mahmud I Berk Yaruk Sanjar Kilij Arslan I
(1095-1113) (1095-1104) (1092-1094) (1094-1105) (1117-1157) (1092-1107)
Aleppo Damascus Khurasan

Sultan Shah Alp Arslan Tutush II Malik Shah II Malik Shah I Mas'ud I
(1114-1123) (1113) (1104) (1105) (1109-1116) (1116-1156)
Aleppo Aleppo Damascus

Kilij Arslan II
(1156-1185)

Ahmad Sanjar Mahmmad I
(1118-1157) (1105-1118)

(After 1123, other dynasties took over Syria.)

(The Seljuks kept
control of Anatolia
until the Mongol
conquest of 1307.)

Mahmud II Toghril II Mas'ud Sulayman Shah
(1118-1131) (1132-1134) (1134-1152) (1160-1161)

Malik Shah III Muhammad II Dawud
(1152-1153) (1153-1159) (1131-1143)

(In 1194 the Great Seljuks were conqured by a dynasty from Iran.)

Seljuk leaders—Toghril I, Alp Arslan, and Malik Shah I (see Genealogy 5.1: The Early Seljuks)—proclaimed themselves rulers, "sultans," of a new state. Bands of herdsmen followed in their wake, moving their sheep into the very farmland of Iran (disrupting agriculture there), then continuing westward, into Armenia, which had been recently annexed by Byzantium. Meanwhile, under Alp Arslan (r.1063–1073), the Seljuk army (composed precisely of such herdsmen but also, increasingly, of other Turkic tribesmen recruited as slaves or freemen) harried Syria. This was Muslim territory, but it was equally the back door to Byzantium. Thus the Byzantines got involved, and throughout the 1050s and 1060s they fought numerous indecisive battles with the Seljuks. Then in 1071 a huge Byzantine force met an equally large Seljuk army at Manzikert (today Malazgirt, in Turkey). The battle ended with the Byzantines defeated and Anatolia open to a flood of militant nomads. (See Map 5.1.)

The Seljuks of Anatolia set up their own sultanate and were effectively independent of the Great Seljuks who ruled (and disputed among themselves) in Iran and Iraq. For the Anatolian Seljuks, this once-central Byzantine province was Rum, "Rome." Meanwhile, other Turks in the Seljuk entourage took off on their own, hiring themselves out as military leaders. Atsiz ibn Uwaq is a good example. For a while he worked for Alp Arslan, but around 1070 he was called on by the Fatimid governor of Syria to help fight off rebellious

Genealogy 5.1 (facing page): The Early Seljuks

Map 5.1: The Byzantine Empire and the Seljuk World, *c.*1090

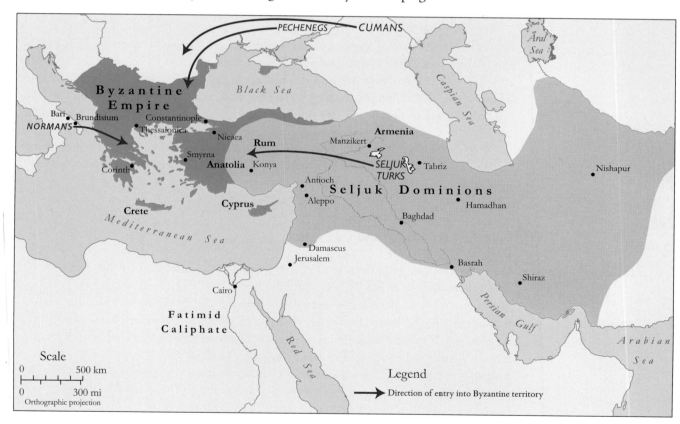

Arab tribes there. Dissatisfied with his pay and plunder, Atsiz decided to work for himself, briefly carving out his own regional principality centered on Damascus. He was, however, ousted by a son of Alp Arslan, Tutush I, in 1078.

Atsiz was born a generation too soon; later, men like him were more successful. After the death of Malik Shah I in 1092, the Seljuks could no longer maintain centralized rule over the Islamic world, even though they still were valued, if only to confer titles like "emir" on local rulers who craved legitimacy. Nor could the Fatimids prevent their own territories from splintering into tiny emirates, each centered on one or a few cities. Some emirs were from the Seljuk family; others were military men who originally served under them. We shall see that the tiny states set up by the crusaders who conquered the Levant in 1099 were, in size, not so very different from their neighboring Islamic emirates.

In the western part of North Africa, the Maghreb, Berber tribesmen forged a state similar to that of the Seljuks. Fired (as the Seljuks had been) with religious fervor on behalf of Sunni orthodoxy, the Berber Almoravids took over northwest Africa in the 1070s and 1080s. In 1086, invited by the ruler of Seville to help fight Christian armies from the north, they sent troops into al-Andalus. This military "aid" soon turned into conquest. By 1094 all of al-Andalus not yet conquered by the Christians was under Almoravid control. Almoravid hegemony over the western Islamic world ended only in 1147, with the triumph of the Almohads, a rival Berber group.

Together, the Seljuks and Almoravids rolled back the Shi'ite wave. They kept it back through a new system of higher education, the *madrasas*. As we have seen (see Chapter 4), the Islamic world had always supported elementary schools. The *madrasas*, normally attached to mosques, went beyond this by serving as centers of advanced scholarship. There young men attended lessons in religion, law, and literature. Sometimes visiting scholars arrived to debate at lively public displays of intellectual brilliance. More regularly, teachers and students carried on a quiet regimen of classes on the Qur'an and other texts. In the face of Sunni retrenchment, some Shi'ite scholars modified their teachings to be more palatable to the mainstream. The conflicts between the two sects receded as Muslims drew together to counter the crusaders.

Byzantium: Bloodied but Unbowed

There would have been no crusaders if Byzantium had remained strong. But the once triumphant empire of Basil II was unable to sustain its successes in the face of Turks and Normans. We have already discussed the triumph of the Turks in Anatolia; meanwhile, in the Balkans, the Turkic Pechenegs raided with ease. The Normans, some of whom (as we saw on p. 130) had established themselves in southern Italy, began attacks on Byzantine territory there and conquered its last stronghold, Bari, in 1071. Ten years later, Norman knights were attacking Byzantine territory in the Balkans. In 1130 the Norman Roger II (r.1130–1154) became king of a territory that ran from southern Italy to Palermo—the Kingdom of Sicily. It was a persistent thorn in Byzantium's side.

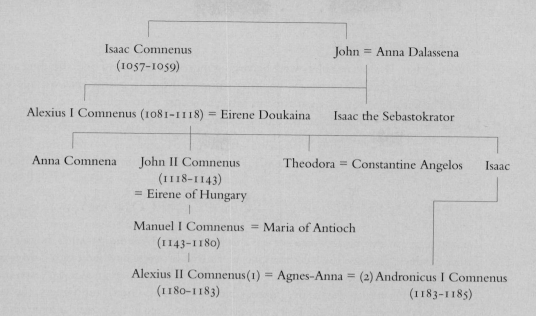

Genealogy 5.2: The Comnenian Dynasty

Clearly the Byzantine army was no longer very effective. Few themes were still manned with citizen-soldiers, and the emperor's army was also largely made up of mercenaries—Turks and Russians, as had long been the case, and increasingly Normans and Franks as well. But the Byzantines were not entirely dependent on armed force; in many instances they turned to diplomacy to confront the new invaders. When Emperor Constantine IX (r. 1042–1055) was unable to prevent the Pechenegs from entering the Balkans, he shifted policy, welcoming them, administering baptism, conferring titles, and settling them in depopulated regions. Much the same process took place in Anatolia, where the emperors at times welcomed the Turks to help them fight rival *dynatoi*. Here the invaders were sometimes also welcomed by Christians who did not adhere to Byzantine orthodoxy; the Monophysites of Armenia were glad to have new Turkic overlords. The Byzantine grip on its territories loosened and its frontiers became nebulous, but Byzantium still stood.

There were changes at the imperial court as well. The model of the "public" emperor ruling alone with the aid of a civil service gave way to a less costly, more "familial" model of government. To be sure, for a time competing *dynatoi* families swapped the imperial throne. But Alexius I Comnenus (r. 1081–1118), a Dalassenus on his mother's side, managed to bring most of the major families together through a series of marriage alliances. (The Comneni remained on the throne for about a century; see Genealogy 5.2: The Comnenian Dynasty.) Until her death in c. 1102, Anna Dalassena, Alexius's mother, held the reins of government while Alexius occupied himself with military matters. At his revamped court, which he moved to the Blachernai palace area, at the northwestern tip of the city (see Map 4.1 on p. 116), his relatives held the highest positions. Many of them received *pronoiai* (sing. *pronoia*), temporary grants of imperial lands that they administered and profited from.

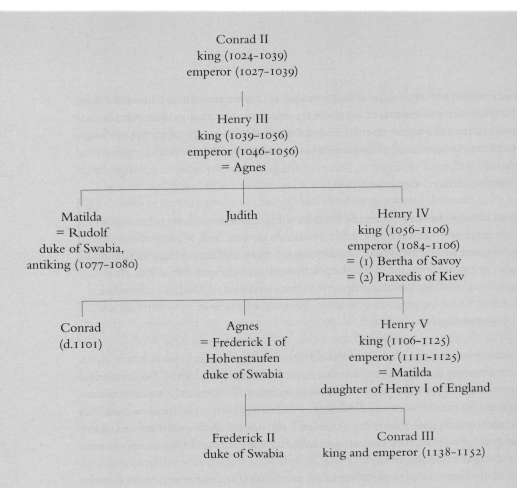

Conrad II
king (1024–1039)
emperor (1027–1039)

Henry III
king (1039–1056)
emperor (1046–1056)
= Agnes

Matilda
= Rudolf
duke of Swabia,
antiking (1077–1080)

Judith

Henry IV
king (1056–1106)
emperor (1084–1106)
= (1) Bertha of Savoy
= (2) Praxedis of Kiev

Conrad
(d.1101)

Agnes
= Frederick I of
Hohenstaufen
duke of Swabia

Henry V
king (1106–1125)
emperor (1111–1125)
= Matilda
daughter of Henry I of England

Frederick II
duke of Swabia

Conrad III
king and emperor (1138–1152)

Genealogy 5.3: The Salian Kings and Emperors

which deposed three papal rivals and elected another. When that pope and his successor died, Henry appointed Bruno of Toul, a member of the royal family, seasoned courtier, and reforming bishop. Taking the name Leo IX (1049–1054), the new pope surprised his patron: he set out to reform the church under papal, not imperial, control.

Leo revolutionized the papacy. He had himself elected by the "clergy and people" to satisfy the demands of canon law. Unlike earlier popes, Leo often left Rome to preside over church councils and make the pope's influence felt outside Italy, especially in France and Germany. To the papal curia Leo brought the most zealous church reformers of his day: Peter Damian, Hildebrand of Soana (later Pope Gregory VII), and Humbert of Silva Candida. They put new stress on the passage in Matthew's gospel (Matt. 16:19) in which Christ tells Peter that he is the "rock" of the church, with the keys to heaven and the power to bind (impose penance) and loose (absolve from sins). As the successor to the special privileges of Saint Peter, the Roman church, headed by the pope, was "head and mother of all churches." What historians call the doctrine of "papal supremacy" was thus announced.

Its impact was soon felt at Byzantium. On a mission at Constantinople in 1054 to forge an alliance with the emperor against the Normans and, at the same time, to "remind" the patriarch of his place in the church hierarchy, Humbert ended by excommunicating the

patriarch and his followers. In retaliation, the patriarch excommunicated Humbert and his fellow legates. Clashes between the Roman and Byzantine churches had occurred before and had been patched up, but this one, though not recognized as such at the time, marked a permanent schism. After 1054, the Roman Catholic and Greek Orthodox churches largely went their separate ways.

More generally, the papacy began to wield new forms of power. It waged unsuccessful war against the Normans in southern Italy and then made the best of the situation by granting them parts of the region—and Sicily as well—as a fief, turning former enemies into vassals. It supported the Christian push into the *taifas* of al-Andalus, transforming the *"reconquista"*—the conquest of Islamic Spain—into a holy war: Pope Alexander II (1061–1073) forgave the sins of the Christians on their way to the battle of Barbastro.

The Investiture Conflict and Its Effects

The papal reform movement is associated particularly with Pope Gregory VII (1073–1085), hence the term "Gregorian reform." A passionate advocate of papal primacy (the theory that the pope is the head of the church), Gregory was not afraid to clash directly with the king of Germany, Henry IV (r.1056–1106), over church leadership. In Gregory's view—an astonishing one at the time, given the religious and spiritual roles associated with rulers—kings and emperors were simple laymen who had no right to meddle in church affairs. Henry, on the other hand, brought up in the traditions of his father, Henry III, considered it part of his duty to appoint bishops and even popes to ensure the well-being of church and empire together.

The pope and the king first collided over the appointment of the archbishop of Milan. Gregory disputed Henry's right to "invest" the archbishop (i.e., put him into his office). In the investiture ritual, the emperor or his representative symbolically gave the church and the land that went with it to the bishop or archbishop chosen for the job. In the case of Milan, two rival candidates for archiepiscopal office (one supported by the pope, the other by the emperor) had been at loggerheads for several years when, in 1075, Henry invested his own candidate. Gregory immediately called on Henry to "give more respectful attention to the master of the Church," namely Peter and his living representative—Gregory himself.[5] In reply, Henry and the German bishops called on Gregory, that "false monk," to resign. This was the beginning of what historians delicately call the "Investiture Conflict" or "Investiture Controversy." In fact it was war. In February 1076, Gregory called a synod that both excommunicated Henry and suspended him from office:

> I deprive King Henry [IV], son of the emperor Henry [III], who has rebelled against [God's] Church with unheard-of audacity, of the government over the whole kingdom of Germany and Italy, and I release all Christian men from the allegiance which they have sworn or may swear to him, and I forbid anyone to serve him as king.[6]

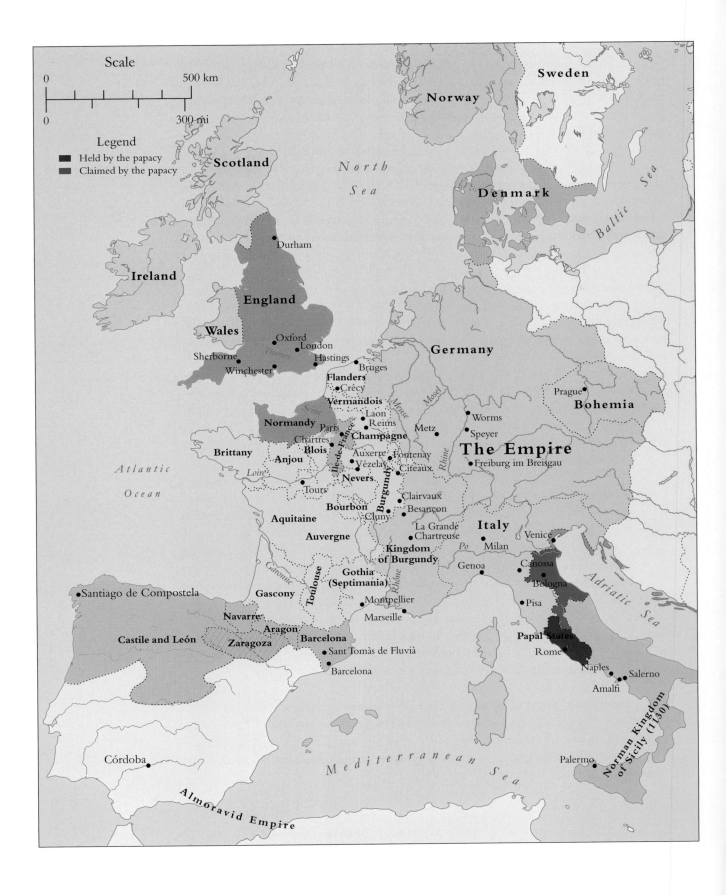

Scale

0 500 km

0 300 mi

Legend

▮ Held by the papacy
▮ Claimed by the papacy

Scotland

Ireland

North Sea

NORWAY

Sweden

Denmark

Baltic Sea

Durham

England

Wales

Oxford

Sherborne

London

Winchester

Hastings

Bruges

Flanders

Crécy

Germany

Prague

Bohemia

Vermandois

Laon

Reims

Metz

Worms

Normandy

Paris

Champagne

Speyer

Chartres

Meuse

Mosel

Blois

Île-de-France

Auxerre

Fontenay

The Empire

Brittany

Anjou

Vézelay

Citeaux

Freiburg im Breisgau

Loire

Nevers

Rhine

Tours

Burgundy

Clairvaux

Atlantic Ocean

Bourbon

Besançon

Cluny

La Grande
Chartreuse

Italy

Venice

Aquitaine

Auvergne

Po

Milan

Canossa

Adriatic Sea

Kingdom
of Burgundy

Genoa

Bologna

Santiago de Compostela

Gascony

Gothia
(Septimania)

Rhône

Pisa

Toulouse

Montpellier

Navarre

Marseille

Papal States

Aragon

Barcelona

Rome

Castile and León

Zaragoza

Sant Tomàs de Fluvià

Naples

Salerno

Barcelona

Amalfi

Córdoba

Mediterranean Sea

Almoravid Empire

Palermo

Norman Kingdom of Sicily (1130)

The last part of this decree gave it real punch: anyone in Henry's kingdom could rebel against him. The German "princes"—the aristocrats—seized the moment and threatened to elect another king. They were motivated partly by religious sentiments—many had established links with the papacy through their support of reformed monasteries—and partly by political opportunism, as they had chafed under strong German kings who had tried to keep their power in check. Some bishops, too, joined with Gregory's supporters, a major blow to Henry, who needed the troops that they supplied.

Attacked from all sides, Henry traveled in the winter of 1077 to intercept Gregory, barricaded in a fortress at Canossa, high in the Apennine Mountains (see Map 5.3). It was a refuge provided by the staunchest of papal supporters, Countess Matilda of Tuscany. In an astute and dramatic gesture, the king stood outside the castle (in cold and snow) for three days, barefoot, as a penitent. Gregory was forced, as a pastor, to lift his excommunication and to receive Henry back into the church, precisely as Henry intended. For his part, the pope had the satisfaction of seeing the king humiliate himself before the papal majesty. Although it made a great impression on contemporaries, the whole episode solved nothing. The princes elected an antiking, and bloody civil war continued intermittently until 1122.

The Investiture Conflict ended with a compromise. The Concordat of Worms (1122) relied on a conceptual distinction between two parts of investiture—the spiritual (in which the bishop-to-be received the symbols of his office) and the secular (in which he received the symbols of the material goods that would allow him to function). Under the terms of the Concordat, the ring and staff, symbols of church office, would be given by a churchman in the first part of the ceremony. Then the emperor or his representative would touch the bishop with a scepter, signifying the land and other possessions that went with his office. Elections of bishops in Germany would take place "in the presence" of the emperor—that is, under his influence. In Italy, the pope would have a comparable role.

Map 5.3 (facing page): Western Europe, *c.*1100

In the end, then, secular rulers continued to matter in the appointment of churchmen. But just as the new investiture ceremony broke the ritual into spiritual and secular halves, so too did it imply a new notion of kingship separate from the priesthood. The Investiture Conflict did not produce the modern distinction between church and state—that would develop only very slowly—but it set the wheels in motion. At the time, its most important consequence was to shatter the delicate balance among political and ecclesiastical powers in Germany and Italy. In Germany, the princes consolidated their lands and powers at the expense of the king. In Italy, the communes came closer to their goals: it was no accident that Milan gained its independence in 1097. And everywhere the papacy gained new authority: it had become a "papal monarchy."

Papal influence was felt at every level. At the general level of canon law, papal primacy was enhanced by the publication *c.*1140 of the *Decretum*, written by a teacher of canon law named Gratian. Collecting nearly two thousand passages from the decrees of popes and councils as well as the writings of the Church Fathers, Gratian set out to demonstrate their essential agreement. In fact, the book's original title was *Harmony of Discordant Canons*. If he found any "discord" in his sources, Gratian usually imposed the harmony himself by arguing that the conflicting passages dealt with different situations. A bit later another legal

scholar revised and expanded the *Decretum*, adding Roman law to the mix. At a more local level, papal denunciations of married clergy made inroads on family life. At Verona, for example, "sons of priests" disappeared from the historical record in the twelfth century. At the mundane level of administration, the papal claim to head the church helped turn the curia at Rome into a kind of government, complete with its own bureaucracy, collection agencies, and law courts. It was the teeming port of call for litigious churchmen disputing appointments and for petitioners of every sort.

The First Crusade

On the military level, the papacy's proclamations of holy wars led to bloody slaughter, tragic loss, and tidy profit. We have already seen how Alexander II encouraged the *reconquista* in Spain; it was in the wake of his call that the *taifa* rulers implored the Almoravids for help. An oddly similar chain of events took place at the other end of the Islamic world. Ostensibly responding to a request from the Byzantine Emperor Alexius for mercenaries to help retake Anatolia from the Seljuks, Pope Urban II (1088–1099) turned the enterprise into something new: a pious pilgrimage to the Holy Land to be undertaken by an armed militia—one commissioned like those of the Peace of God, but thousands of times larger—under the leadership of the papacy.

The event that historians call the First Crusade (1096–1099) mobilized a force of some 100,000 people, including warriors, old men, bishops, priests, women, children, and hangers-on. The armies were organized not as one military force but rather as separate militias, each authorized by the pope and commanded by a different individual.

Several motley bands were not authorized by the pope. Though called collectively the "Peasants' (or People's) Crusade," these irregular armies included nobles. They were inspired by popular preachers, especially the eloquent Peter the Hermit, who was described by chroniclers as small, ugly, barefoot, and—partly because of those very characteristics—utterly captivating. Starting out before the other armies, the Peasants' Crusade took a route to the Holy Land through the Rhineland in Germany.

This indirect route was no mistake. The crusaders were looking for "wicked races" closer to home: the Jews. Under Henry IV many Jews had gained a stable place within the cities of Germany, particularly along the Rhine River. The Jews received protection from the local bishops (who were imperial appointees) in return for paying a tax. Living in their own neighborhoods, the Jews valued their tightly-knit communities focused on the synagogue, which was a school and community center as well as a place of worship. Nevertheless, Jews also participated in the life of the larger Christian community. For example, Archbishop Anno of Cologne made use of the services of the Jewish money-lenders in his city, and other Jews in Cologne were allowed to trade their wares at the fairs there.

Although officials pronounced against the Jews from time to time, and although Jews were occasionally (temporarily) expelled from some Rhineland cities, they were not

persecuted systematically until the First Crusade. Then the Peasants' Crusade, joined by some local nobles and militias from the region, threatened the Jews with forced conversion or death. Some relented when the Jews paid them money; others, however, attacked. Beleaguered Jews occasionally found refuge with bishops or in the houses of Christian friends, but in many cities—Metz, Speyer, Worms, Mainz, and Cologne—they were massacred:

> Oh God, insolent men have risen against me
> They have sorely afflicted us from our youth
> They have devoured and destroyed us in their wrath against us
> Saying, let us take their inheritance for ourselves.[7]

So wrote Rabbi Eliezer ben Nathan, mourning and celebrating the Jewish martyrs who perished at the hands of the crusaders.

Leaving the Rhineland, some of the irregular militias disbanded, while others sought to gain the Holy Land via Hungary, at least one stopping off at Prague to massacre more Jews there. Only a handful of these armies continued on to Anatolia, where most of them were quickly slaughtered.

From the point of view of Emperor Alexius at Constantinople, even the "official" crusaders were potentially dangerous. One of the crusade's leaders, the Norman warrior Bohemond, had, a few years before, tried to conquer Byzantium itself. Hastily forcing oaths from Bohemond and the other lords that any previously Byzantine lands conquered would be restored to Byzantium, Alexius shipped the armies across the Bosporus.

The main objective of the First Crusade—to conquer the Holy Land—was accomplished largely because of the disunity of the Islamic world and its failure to consider the crusade a serious military threat. Spared by the Turks when they first arrived in Anatolia, the crusaders first made their way to the Seljuk capital, Nicaea. Their armies were initially uncoordinated and their food supplies uncertain, but soon they organized themselves, setting up a "council of princes" that included all the great crusade leaders, while the Byzantines supplied food at a nearby port. Surrounding Nicaea and besieging it with catapults and other war machines, the crusaders took the city on June 18, 1097, dutifully handing it over to Alexius in accordance with their oath.

Gradually, however, the crusaders forgot their oath to the Byzantines. While most went toward Antioch, which stood in the way of their conquest of Jerusalem, one leader went off to Edessa, where he took over the city and its outlying area, creating the first of the Crusader States: the County of Edessa. Meanwhile the other crusaders remained stymied before the thick and heavily fortified walls of Antioch for many months. Then, in a surprise turn-around, they entered the town but found themselves besieged by Muslim armies from the outside. Their mood grim, they rallied when a peasant named Peter Bartholomew reported that he had seen in many visions the Holy Lance that had pierced Christ's body—it was, he said, buried right in the main church in Antioch. (Antioch had a flourishing Christian population even under Muslim rule.) After a night of feverish

digging, the crusaders believed that they had discovered the Holy Lance, and, fortified by this miracle, they defeated the besiegers.

From Antioch, it was only a short march to Jerusalem, though disputes among the leaders delayed that next step for over a year. One leader claimed Antioch. Another eventually took charge—provisionally—of the expedition to Jerusalem. His way was eased by quarrels among Muslim rulers, and an alliance with one of them allowed free passage through what would have been enemy territory. In early June 1099, a large crusading force amassed before the walls of Jerusalem and set to work to build siege engines. In mid-July they attacked, breaching the walls and entering the city. "The Franks slaughtered more than 70,000 people.... [they] stripped the Dome of the Rock of more than forty silver candelabra," dryly noted a later Islamic historian looking back on the event.[8]

RULERS WITH CLOUT

While the papacy was turning into a monarchy, other rulers were beginning to turn their territories into states. They discovered ideologies to justify their hegemony, hired officials to work for them, found vassals and churchmen to support them. Some of these rulers were women.

The Crusader States

In the Holy Land, the leaders of the crusade set up four tiny states, European colonies in the Levant. Two (Tripoli and Edessa) were counties, Antioch was a principality, Jerusalem a kingdom. (See Map 5.4.) The region was habituated (as we have seen) to multi-ethnic and multi-religious territories ruled by a military elite; apart from the religion of that elite, the Crusader States were no exception. Yet, however much they engaged with their neighbors, the Europeans in the Levant saw themselves as a world apart, holding on to their western identity through their political institutions and the old vocabulary of homage, fealty, and Christianity.

The states won during the First Crusade lasted—tenuously—until 1291, though many new crusades had to be called in the interval to shore them up. Created by conquest, these states were treated as lordships. The new rulers carved out estates to give as fiefs to their vassals, who, in turn, gave portions of their holdings in fief to their own men. The peasants continued to work the land as before, and commerce boomed as the new rulers encouraged lively trade at their coastal ports. Italian merchants—the Genoese, Pisans, and Venetians—were the most active, but others—Byzantines and Muslim traders—participated as well. Enlightened lordship dictated that the mixed population of the states—Muslims, to be sure, but also Jews, Greek Orthodox Christians, Monophysite Christians, and others—be

tolerated for the sake of production and trade. Most Europeans had gone home after the First Crusade; those left behind were obliged to coexist with the inhabitants that remained. Eastern and Western Christians learned to share shrines, priests, and favorite monastic charities—and to remain silent, or to become violent only locally and sporadically, over their many differences.

The main concerns of the crusader states' rulers were military, and these could be guaranteed as well by a woman as by a man. Thus Melisende (r.1131–1152), oldest daughter of King Baldwin II of Jerusalem, was declared ruler along with her husband, Fulk, formerly count of Anjou, and their infant son. Taking the reins of government into her own hands after Fulk's death, she named a constable to lead her army and made sure that the greatest men in the kingdom sent her their vassals to do military service. Vigorously asserting her position as queen, she found supporters in the church, appointed at least one bishop to his see, and created her own chancery, where her royal acts were drawn up.

But vassals alone, however well commanded, were not sufficient to defend the fragile Crusader States, nor were the stone castles and towers that bristled in the country-side. Knights had to be recruited from Europe from time to time, and a new and militant kind of monasticism developed in the Levant: the Knights Templar. Vowed to poverty and chastity, the Templars devoted themselves to war at the same time. They defended the town garrisons of the Crusader States and ferried money from Europe to the Holy Land. Even so, they could not prevent a new Turkic leader, Zangi, from taking Edessa in 1144. The slow but steady shrinking of the Crusader States began at that moment. The Second Crusade (1147–1149), called in the wake of Zangi's victory, came to a disastrous end. After only four days of besieging the walls of Damascus, the crusaders, whose leaders could not keep the peace among themselves, gave up and went home.

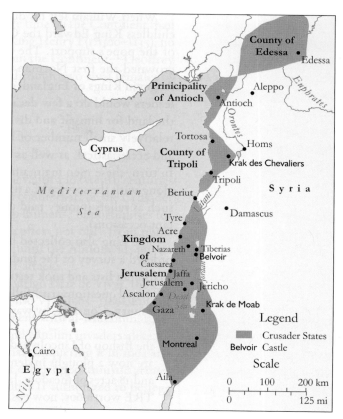

Map 5.4: The Crusader States, c.1140

England under Norman Rule

A more long-lasting conquest took place in England. England had been linked to the Continent by the Vikings, who settled in its eastern half, and in the eleventh century it had been further tied to Scandinavia under the rule of Cnut (see above, p. 138). Nevertheless, the country was drawn inextricably into the Continental orbit only with the conquest of Duke William of Normandy. (See Map 5.3.)

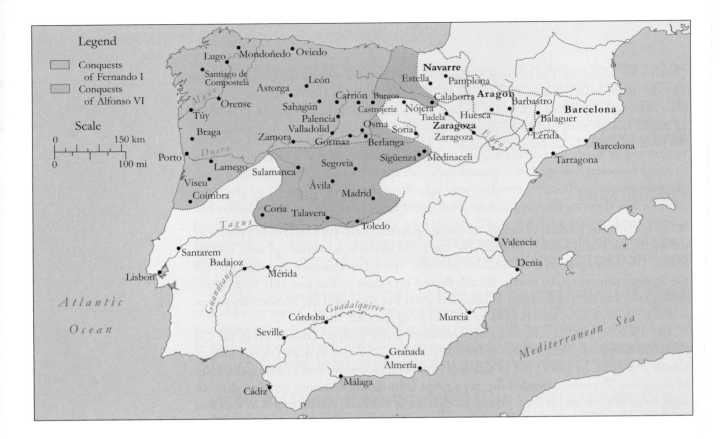

Map 5.5: Spain at the Death of Alfonso VI (1109)

Genealogy 5.4 (facing page): The Capetian Kings of France

Praising the King of France

Not all rulers had opportunities for grand conquest. How did they maintain themselves? The example of the kings of France reveals the possibilities. Reduced to battling a few castles in the vicinity of the Ile-de-France, the Capetian kings nevertheless wielded many of the same instruments of power as their conquering contemporaries: vassals, taxes, commercial revenues, military and religious reputations. Louis VI the Fat (r. 1108–1137), so heavy that he had to be hoisted onto his horse by a crane, was nevertheless a tireless defender of royal power. (See Genealogy 5.4: The Capetian Kings of France.)

Louis's virtues were amplified and broadcast by his biographer, Suger (1081–1151), the abbot of Saint-Denis, a monastery just outside Paris. A close associate of the king, Suger was his chronicler and propagandist. When Louis set himself the task of consolidating his rule in the Ile-de-France, Suger portrayed the king as a righteous hero. He was more than a lord with rights over the French nobles as his vassals; he was a peacekeeper with the God-given duty to fight unruly strongmen. Careful not to claim that Louis was head of the church, which would have scandalized the papacy and its supporters, Suger nevertheless emphasized Louis's role as vigorous protector of the faith and insisted on the sacred importance of the royal dignity. When Louis died in 1137, Suger's notion of the might and right of the king of France reflected reality in an extremely small area. Nevertheless, Louis laid the groundwork for the gradual extension of royal power. As the lord of vassals,

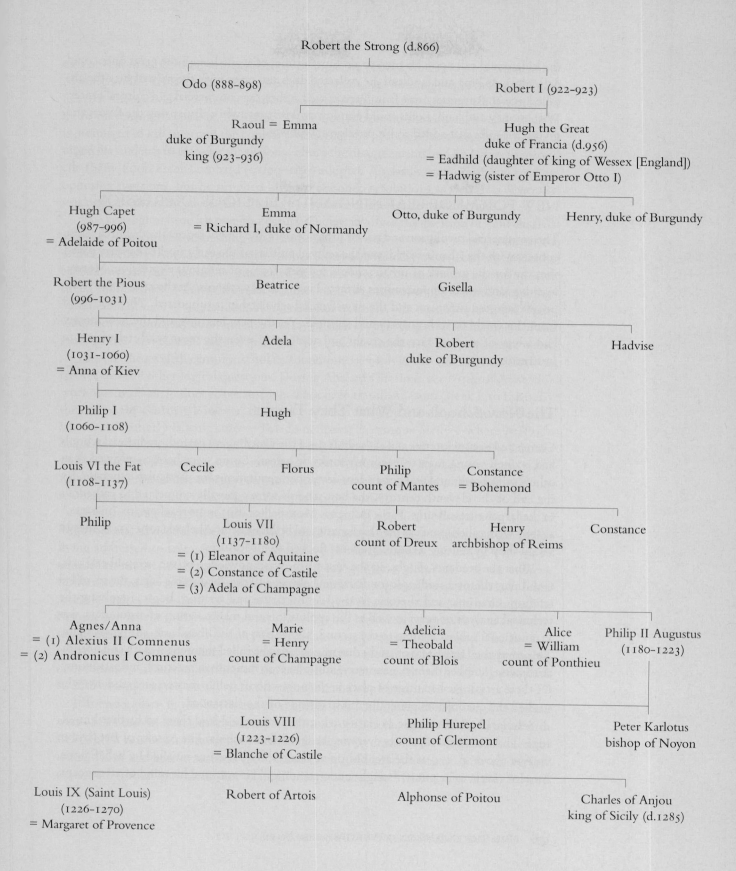

Robert the Strong (d.866)

Odo (888–898) Robert I (922–923)

Raoul = Emma Hugh the Great
duke of Burgundy duke of Francia (d.956)
king (923–936) = Eadhild (daughter of king of Wessex [England])
 = Hadwig (sister of Emperor Otto I)

Hugh Capet Emma Otto, duke of Burgundy Henry, duke of Burgundy
(987–996) = Richard I, duke of Normandy
= Adelaide of Poitou

Robert the Pious Beatrice Gisella
(996–1031)

Henry I Adela Robert Hadvise
(1031–1060) duke of Burgundy
= Anna of Kiev

Philip I Hugh
(1060–1108)

Louis VI the Fat Cecile Florus Philip Constance
(1108–1137) count of Mantes = Bohemond

Philip Louis VII Robert Henry Constance
 (1137–1180) count of Dreux archbishop of Reims
 = (1) Eleanor of Aquitaine
 = (2) Constance of Castile
 = (3) Adela of Champagne

Agnes/Anna Marie Adelicia Alice Philip II Augustus
= (1) Alexius II Comnenus = Henry = Theobald = William (1180–1223)
= (2) Andronicus I Comnenus count of Champagne count of Blois count of Ponthieu

Louis VIII Philip Hurepel Peter Karlotus
(1223–1226) count of Clermont bishop of Noyon
= Blanche of Castile

Louis IX (Saint Louis) Robert of Artois Alphonse of Poitou Charles of Anjou
(1226–1270) king of Sicily (d.1285)
= Margaret of Provence

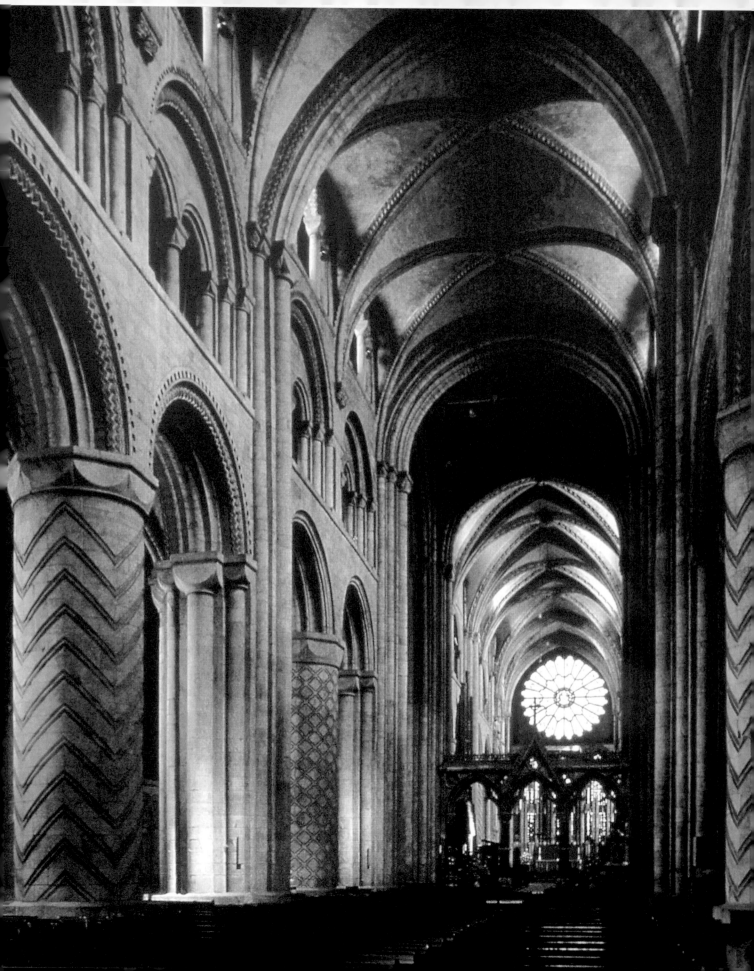

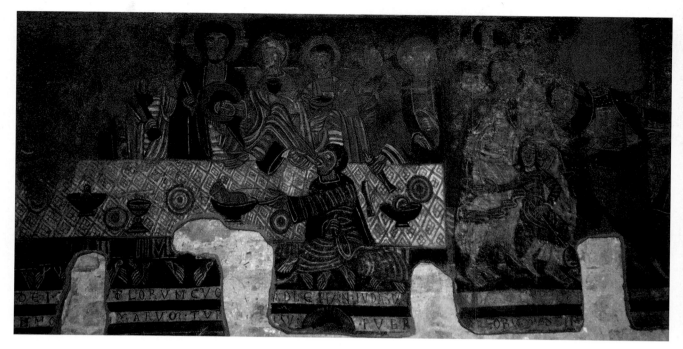

patterned textures. At Durham Cathedral (built between 1093 and 1133 in the north of England), the stone itself is a warm yellow/pink color, given added zest by piers incised with diamond or zig-zag patterns. (See Plate 5.3.) By contrast, the entire length of the vault of Sant Tomàs de Fluvià, a tiny monastic church in the County of Barcelona, was covered with paintings, a few of which remain today; Plate 5.4 shows the Last Supper. Pisa's famous leaning tower is in fact a Romanesque bell tower; here (Plate 5.5) the decoration is on the exterior, where the bright Italian sun heightens the play of light and shadow.

The church of Saint-Lazare of Autun (1120–1146) may serve as an example of a "typical" Romanesque church, though in fact the most typical aspect of that style is its extreme variety. Striking is the "barrel" or "tunnel" vault whose ribs, springing from the top of the piers, mark the long church into sections called bays. There are three levels. The first is created by the arches that open onto the side aisles of the church. The second is the gallery (or triforium), which consists of a decorative band of columns and arches. The third is the clerestory, where small windows puncture the walls. (See Plate 5.6 on p. 185.)

As at many Romanesque churches, the portals and the capitals (the "top hats" on the columns) at Autun were carved with complex scenes representing sacred stories. The story of the "Raising of Lazarus," patron saint of the church (Saint-Lazare = Lazarus), was once depicted on a tympanum (a half-circle) over the north transept door, the main entrance to the church. (For an Ottonian depiction of the scene, see Plate 4.2 on p. 142.) Although the Autun Lazarus was destroyed in the eighteenth century, a figure of Eve that remains today (see Plate 5.7 on p. 186) was once on the lintel (a horizontal beam just under the tympanum), probably right beneath Christ's feet as he performed his miracle.

The plan of Autun shown in Figure 5.2 on p. 187 indicates the placement of many of the church's carvings. It also shows that the church was in the form of a basilica (a long straight building) intersected, near the choir, by a transept. The chevet (or apse), the far

Plate 5.4: Sant Tomàs de Fluvià, The Last Supper, Painted Vault (early 12th cent.). Sant Tomàs was one of many monastic and parish churches in the county of Barcelona richly decorated with paintings in the twelfth century. Here Christ is at the Last Supper with his apostles. The depiction closely follows John 13:23 when Jesus announces that one of his disciples will betray him: "Now there was leaning on Jesus's bosom one of his disciples [John].... [John asked], 'Lord, who is it?' Jesus answered, 'He it is to whom I shall reach bread dipped.' And when he had dipped the bread, he gave it to Judas." To the right of the table a new scene begins: Jesus' disciple Peter cuts off the ear of the servant of the high priest who has come with Judas to betray him. Christ then utters the famous words from Matt. 26:52, "Put your sword back into its place; for all who take the sword will perish by the sword." Then, according to Luke 22:51, Jesus touched the servant's ear and healed him.

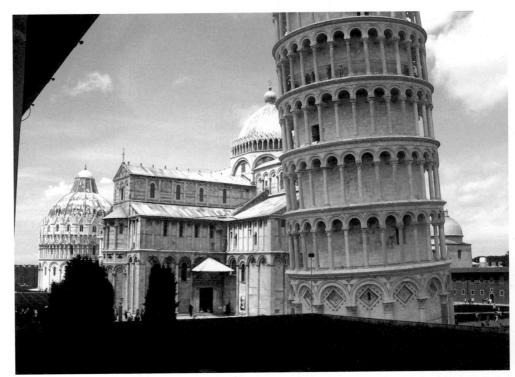

Plate 5.5: Cathedral Complex, Pisa (11th–12th cent.). The tower is part of a large complex that was meant to celebrate Pisa's emergence as a great political, economic, and military power. In this photograph, taken from the upper porch of the hospital (13th cent.), the cathedral (begun in 1064) is just behind and to the left of the tower (which started to lean in 1174, during construction). Behind that, and further to the left, is the baptistery (begun in 1152).

Plate 5.6 (facing page): Saint-Lazare of Autun, Nave (1120–1146). In this view down the nave, reminiscent of what medieval worshippers would have seen as they entered from the north and looked down the nave to the west, a great organ obscures the windows that once allowed in the light of the setting sun.

eastern part of the church, had space for pilgrims to visit the tomb of Lazarus, which held the precious bones of the saint.

Not all medieval people agreed that such opulent decoration pleased or praised God, however. At the end of the eleventh century, the new commercial economy and the profit motive that fueled it led many to reject wealth and to embrace poverty as a key element of the religious life. The Carthusian order, founded by Bruno (d. 1101), one-time bishop of Cologne, represented one such movement. La Grande Chartreuse, the chief house of the order, was built in an Alpine valley, lonely and inaccessible. Each monk took a vow of silence and lived as a hermit in his own small hut. Only occasionally would the monks join the others for prayer in a common oratory. When not engaged in prayer or meditation, the Carthusians copied manuscripts: for them, scribal work was a way to preach God's word with the hands rather than the mouth. Slowly the Carthusian order grew, but each monastery was limited to only twelve monks, the number of Christ's Apostles.

And yet even the Carthusians dedicated their lives above all to prayer. By now new forms of musical notation had been elaborated to allow monks—and other musicians—to see graphically the melody of their chants. In Plate 5.8 on p. 188, a manuscript from a Carthusian monastery in Lyon, France, the scribe used a red line to show the pitch of F (you can see the letter F at the left of each red line) and a yellow line for the C above that. The notes, square-headed and precisely placed, can easily be transcribed (by a musicologist who knows their conventions) onto a modern five-line staff.

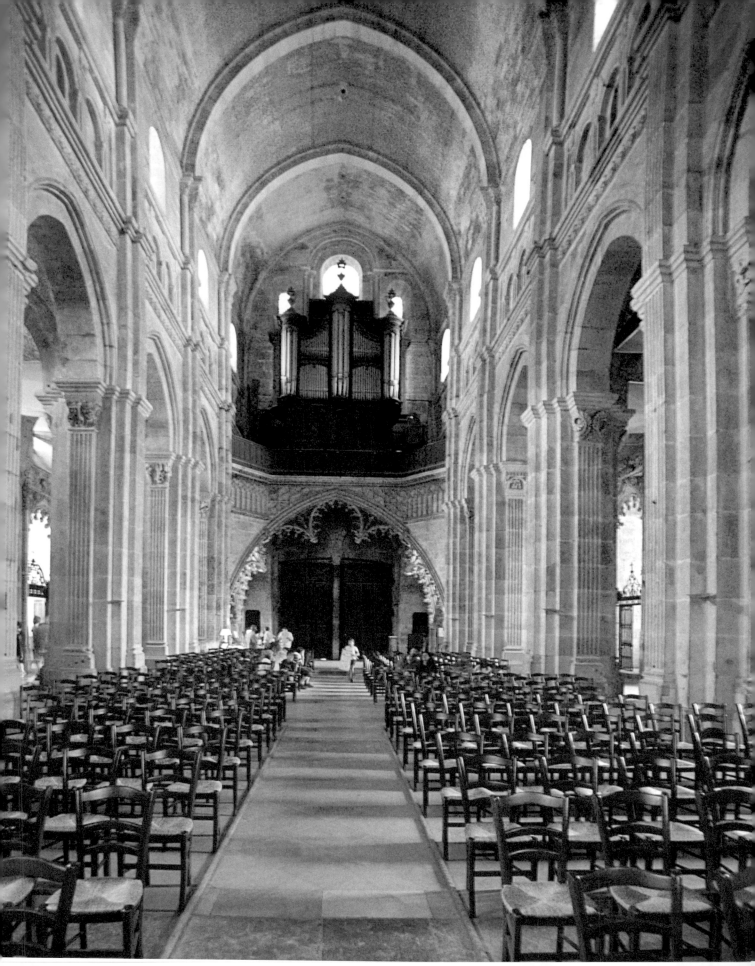

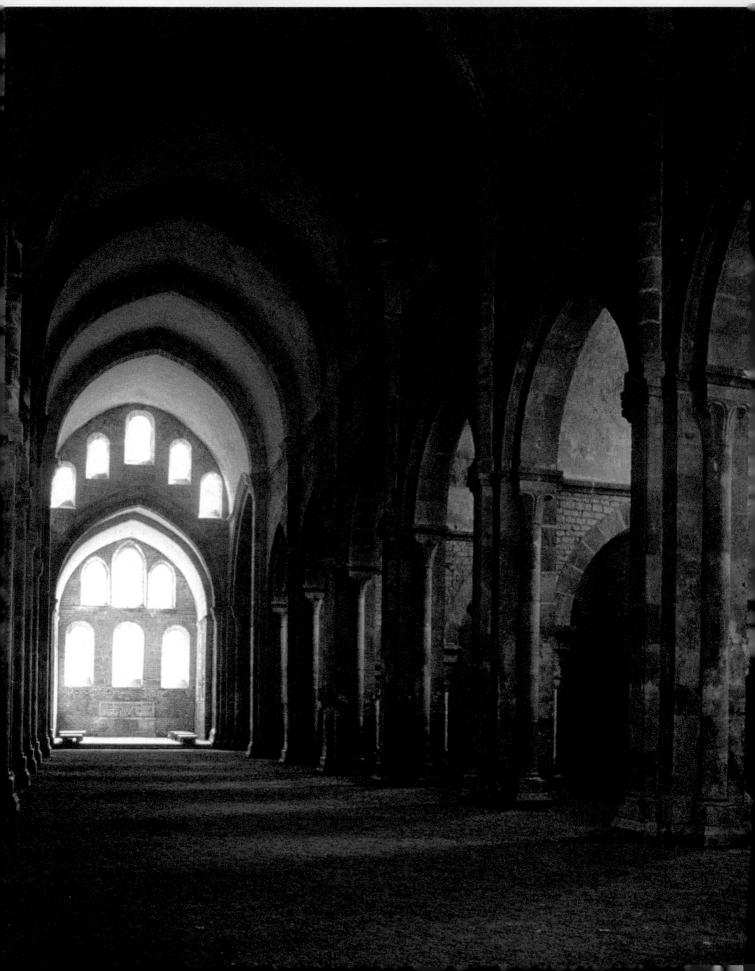

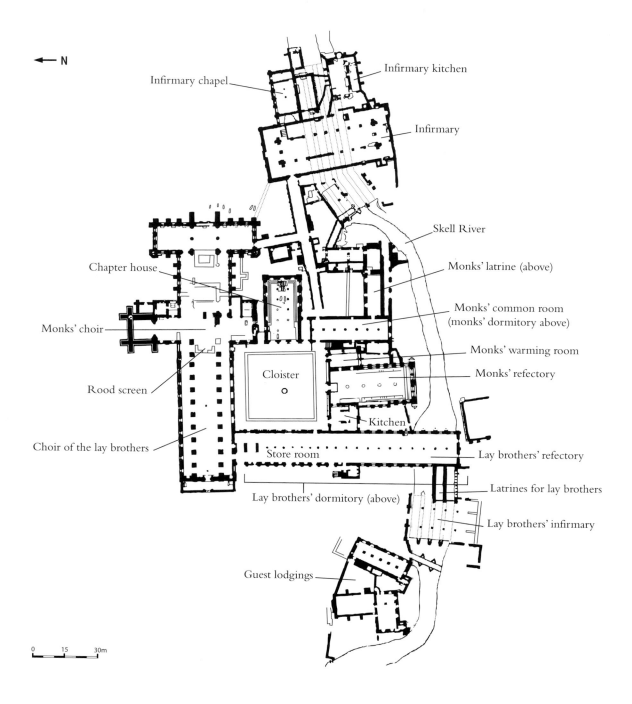

N

Infirmary chapel

Infirmary kitchen

Infirmary

Skell River

Monks' latrine (above)

Monks' common room
(monks' dormitory above)

Monks' warming room

Monks' refectory

Chapter house

Monks' choir

Rood screen

Cloister

Kitchen

Lay brothers' refectory

Choir of the lay brothers

Store room

Latrines for lay brothers

Lay brothers' dormitory (above)

Lay brothers' infirmary

Guest lodgings

0 15 30m

to the humanity of Christ and to his mother, Mary. While pilgrims continued to stream to the tombs and reliquaries of saints, the Cistercians dedicated all their churches to the Virgin Mary (for whom they had no relics) because for them she signified the model of a loving mother. Indeed, the Cistercians regularly used maternal imagery to describe the nurturing care provided to humans by Jesus himself. The Cistercian God was approachable, human, protective, even mothering.

Plate 5.10 (facing page): Jael, Humility, and Judith (*c.*1140). In this early manuscript of the extremely popular *Mirror of Virgins*, exemplary women triumph over evil. Humility (in Latin, *humilitas*, a feminine noun) was the key virtue of the monastic life. Before she killed Holofernes, enemy of the Israelites, Judith prayed to God, reminding him that "the prayer of the humble and the meek hath always pleased thee" (Judith 9:16).

Were women simply metaphors for pious male monks? Or did they too partake in the new religious fervor of the twelfth century? The answer is that women's reformed monasteries proliferated at the same time as men's. Furthermore, monks and priests undertook to teach and guide women religious far more fully than they had done before. In the *Speculum Virginum (Mirror of Virgins)*, written in the form of a dialogue between a male religious advisor (Peregrinus) and a "virgin of Christ" (Theodora), exhortations to virtue were complemented by images. Some presented, as if in a "mirror," vices that should be avoided. Others gave examples of female heroines to be admired and imitated. In Plate 5.10, three tall and triumphant women stand on dead or defeated enemies. On the left is Jael, who killed the Israelites' enemy leader, and on the right is Judith, who did the same. In the middle, the model for both, is Humility striking Pride in the breast. Clearly the cloistered twelfth-century virgin was justified in considering herself, as Peregrinus said, "an example of disdain for the present life and a model of desire for heavenly things."[14]

★ ★ ★ ★ ★

In the twelfth century, Europe was coming into its own. Growing population and the profitable organization of the countryside promoted cities, trade, and wealth. Townspeople created new institutions of self-regulation and self-government. Kings and popes found new ways to exert their authority and test its limits. Scholars mastered the knowledge of the past and put it to use in classrooms, royal courts, papal offices, and the homes of the sick. Monks who fled the world ended up in positions of leadership; the great entrepreneurs of the twelfth century were the Cistercians; Saint Bernard was the most effective preacher of the Second Crusade.

The power of communities was recognized in the twelfth century: the guilds and communes depended on this recognition. So too did the new theology of the time. In his theological treatise *Why God Became Man*, Saint Anselm put new emphasis on Christ's humanity: Christ's sacrifice was that of one human being for another. The Cistercians spoke of God's mothering. Historians are in this sense right to speak of the importance of "humanism"—with its emphasis on the dignity of human beings, the splendor of the natural world, and the nobility of reason—in the twelfth century. Yet the stress on the loving bonds that tied Christians together also led to the persecution of others, like Jews and Muslims, who lived outside the Christian community. In the next century European communities would become more ordered, regulated, and incorporated. By the same token, they became even more exclusive.

fruct´ ſpectet utiq̛. T Attendo quidé qd́ excollatione diſſimiliu ſa
niſ intellectib̛ magnú poſueriſ inctantmú ⁊ qdda pſpicuú odíſ
intuentuú ſpeculú S; adhec quiſ ẏdone? Quid antiq̛ colubro
forti̱ inmalicia aſtutia quid ſubtili? cui furie pſcripte cópen
dent. qſ oīſ uincere. eox̃ é pcipue. qſ armat ſex uiriliſ ⁊ menſ
ſubnixa ſapientie. P An ignoraſ ut omittá milia femmarum
ſublege ꝉ ſub gra uireſ hoſticaſ eneruantiú qd iudith in oloſerne
que dicé poſſum̃ totú infernú qſi q̇ nihil ſupnú habeat́ quid
iahel in ſiſara madianttarú pncipe fecerut́ que ualentia
ſex infirmioriſ nihil aliud é ꞑ qd humilitaſ ſemp pualet
ſupbie inquaciq̛, ſcox̃ pfeſſione:

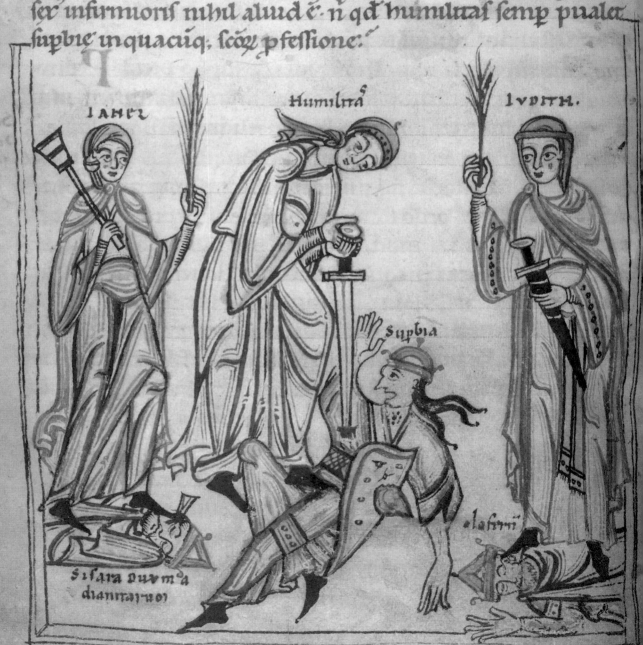

IAHEL Humilitas IVDITH.

Supbia

SISARA DUX M̃a
diantitax̃ꝰor olaſerni

CHAPTER FIVE KEY EVENTS

1049–1054	Papacy of Leo IX
1066	Norman Conquest of England by William of Normandy
1071	Battle of Manzikert
1073–1085	Papacy of Gregory VII
1075–1122	Investiture Conflict
1081–1118	Reign of Alexius I Comnenus
1085	Conquest of Toledo by Alfonso VI
1086	Domesday Book
1094	Al-Andalus under Almoravid (Berber) control
1096–1099	The First Crusade
1097	Establishment of a commune at Milan
1099–1291	Crusader States in the Holy Land
1122	Concordat of Worms
c.1140	Publication of Gratian's *Decretum*
1142	Death of Peter Abelard
1147–1149	The Second Crusade
1153	Death of Saint Bernard

NOTES

1 *Frederick of Hamburg's Agreement with Colonists from Holland*, in *Reading the Middle Ages: Sources from Europe, Byzantium, and the Islamic World*, ed. Barbara H. Rosenwein, 2nd ed. (Toronto: University of Toronto Press, 2014), p. 254.

2 *Chronicle of Saint Bertin*, quoted in *Histoire de la France urbaine*, vol. 2: *La ville médiévale* (Paris: Éditions du Seuil, 1980), p. 71, here translated from the French by the volume editor.

3 Henry I, *Privileges for the Citizens of London*, in *Reading the Middle Ages*, p. 257.

4 *Cluny's Foundation Charter*, in *Reading the Middle Ages*, p. 177.

5 Pope Gregory VII, *Admonition to Henry*, in *Power and the Holy in the Age of the Investiture Conflict: A Brief History with Documents*, ed. and trans. Maureen C. Miller (Boston: Bedford, 2005), p. 85.

6 *Roman Lenten Synod*, in *The Correspondence of Pope Gregory VII: Selected Letters from the Registrum*, ed. and trans. Ephraim Emerton (New York: Columbia University Press, 1969), p. 91.

7 Rabbi Eliezer b. Nathan, *O God, Insolent Men*, in *Reading the Middle Ages*, p. 268.

8 Ibn al-Athir, *The First Crusade*, in *Reading the Middle Ages*, p. 277.

9 *Domesday Book*, in *Reading the Middle Ages*, p. 287.

10 Abelard, *Glosses on Porphyry*, in *Reading the Middle Ages*, p. 289.

11 *Constantine the African's translation of Johannitius's Isagoge*, in *Reading the Middle Ages*, p. 291.

12 Saint Bernard, *Apologia*, in *Reading the Middle Ages*, p. 300.

13 Bernard of Clairvaux, *On the Song of Songs*, vol. 1, trans. Kilian Walsh, Cistercian Fathers Series 4 (Kalamazoo, MI: Cistercian Publications, 1977), p. 58.

14 *Speculum Virginum*, trans. Barbara Newman, in *Listen, Daughter: The* Speculum Virginum *and the Formation of Religious Women in the Middle Ages*, ed. Constant J. Mews (New York: Palgrave Macmillan, 2001), p. 270.

FURTHER READING

Barber, Malcolm. *Crusader States*. New Haven, CT: Yale University Press, 2012.

Bell, Nicholas. *Music in Medieval Manuscripts*. Toronto: University of Toronto Press, 2001.

Burton, Janet, and Julie Kerr. *The Cistercians in the Middle Ages*. Woodbridge: Boydell, 2011.

Frankopan, Peter. *The First Crusade: The Call from the East*. Cambridge, MA: Harvard University Press, 2012.

Hamilton, Louis I. *A Sacred City; Consecrating Churches and Reforming Society in Eleventh-Century Italy*. Manchester: Manchester University Press, 2010.

Iogna-Prat, Dominique. *Order and Exclusion: Cluny and Christendom Face Heresy, Judaism, and Islam (1000–1150)*. Trans. Graham Robert Edwards. Ithaca, NY: Cornell University Press, 2002.

Lange, Christian, and Songül Mecit. *The Seljuqs: Politics, Society and Culture*. Edinburgh: Edinburgh University Press, 2011.

Little, Lester K. *Religious Poverty and the Profit Economy in Medieval Europe*. Ithaca, NY: Cornell University Press, 1978.

MacEvitt, Christopher. *The Crusades and the Christian World of the East: Rough Tolerance*. Philadelphia: University of Pennsylvania Press, 2008.

Messier, Ronald A. *The Almoravids and the Meanings of Jihad*. Santa Barbara, CA: Praeger, 2010.

Mews, Constant J. *Abelard and Heloise*. Oxford: Oxford University Press, 2005.

Miller, Maureen C. *Power and the Holy in the Age of the Investiture Conflict: A Brief History with Documents*. Boston: Bedford, 2005.

Noble, Thomas F.X. and John Van Engen, eds. *European Transformations: The Long Twelfth Century*. Notre Dame, IN: University of Notre Dame Press, 2012.

Robinson, Ian S. *Henry IV of Germany*. Cambridge: Cambridge University Press, 2000.

Rubenstein, Jay. *Armies of Heaven: The First Crusade and the Quest for Apocalypse*. New York: Basic Books, 2011.

Toman, Rolf, ed. *Romanesque: Architecture, Sculpture*. Cologne: Painting, 2010.

Unger, Richard W. *Beer in the Middle Ages and the Renaissance*. Philadelphia: University of Pennsylvania Press, 2004.

To test your knowledge of this chapter, please go to
www.utphistorymatters.com
for Study Questions.

SIX

INSTITUTIONALIZING ASPIRATIONS
(c. 1150–c. 1250)

THE LIVELY DEVELOPMENTS of early twelfth-century Europe were institutionalized in the next decades. Fluid associations became corporations. Rulers hired salaried officials to staff their administrations. Churchmen defined the nature and limits of religious practice. While the Islamic world largely went its own way, only minimally affected by European developments, Byzantium was carved up by its Christian neighbors.

THE ISLAMIC AND BYZANTINE WORLDS IN FLUX

Nothing could be more different than the fates of the Islamic world and of Byzantium at the beginning of the thirteenth century. The Muslims remained strong; the Byzantine Empire nearly came to an end.

Islam on the Move

Like grains of sand in an oyster's shell—irritating but also generative—the Christian states of the Levant and Spain helped spark new Islamic principalities, one based in the Maghreb, the other in Syria and Egypt. In the Maghreb, the Almohads, a Berber group espousing a militant Sunni Islam, combined conquest with a program to "purify" the morals of their fellow Muslims. In al-Andalus their appearance in 1147 induced some Islamic rulers to seek alliances with the Christian rulers to the north. But other Andalusian rulers joined forces with the Almohads, who replaced the Almoravids as rulers of the whole Islamic far west

property: over the course of five years, he paid out a great deal of money for royal writs; for journeys to line up witnesses and to visit various courts; for the expenses of his clerical staff; and for gifts to numerous officials. Yet it was all worthwhile in the end, for "*at length* by grace of the lord king and by the judgment of his court my uncle's land was adjudged to me."[3]

The whole system was no doubt originally designed to put things right after the civil war. Although these law-and-order measures were initially expensive for the king—he had to build many new jails, for example—they ultimately served to increase royal income and power. Fines came from condemned criminals and also from knightly representatives who failed to show up at the eyre when summoned; revenues poured in from the purchase of writs. The exchequer, as the financial bureau of England was called, recorded all the fines paid for judgments and the sums collected for writs. The amounts, entered on parchment leaves sewn together and stored as rolls, became the Receipt Rolls and Pipe Rolls, the first of many such records of the English monarchy and an indication that writing had become a tool to institutionalize royal rule in England.

Perhaps the most important outcome of this expanded legal system was the enhancement of royal power and prestige. The king of England touched (not personally but through men acting in his name) nearly every man and woman in the realm. However, the extent of royal jurisdiction should not be exaggerated. Most petty crimes did not end up in royal courts but rather in more local ones under the jurisdiction of a lord. Thus the case of Hugh Tree came before a manorial court run by officials of the monastery of Bec. They held that he was "in mercy [liable to a fine] for his beasts caught in the lord's garden."[4] He had to pay six pence to his lord (in this case the monastery); no money went to the king. This helps explain why manorial lords—barons, knights, bishops, and monasteries like Bec—held on tenaciously to their local prerogatives.

In addition to local courts were those run by and for the clergy. Had Hugh Tree committed murder, he would have come before a royal court. Had he been a homicidal cleric, however, he would have come before a church court, which could be counted on to give him a mild punishment. No wonder that churchmen objected to submitting to the jurisdiction of Henry II's courts. But Henry insisted—and not only on that point, but also on the king's right to have ultimate jurisdiction over church appointments and property disputes. The ensuing contest between the king and his appointed archbishop, Thomas Becket (1118–1170), became the greatest battle between the church and the state in the twelfth century. At a meeting held at Clarendon in 1164, Becket agreed, among other things, that clerics "cited and accused of any matter shall, when summoned by the king's justice, come before the king's court to answer there."[5] But Becket soon thereafter clashed with Henry over the rights of the church of Canterbury—Becket's church—to recover or alienate its own property. The conflict mushroomed to include control over the English church, its property, and its clergy. Soon the papacy joined, with Becket its champion. King and archbishop remained at loggerheads for six years, until Henry's henchmen murdered Thomas, unintentionally turning him into a martyr. Although Henry's role in the murder remained ambiguous, public outcry forced him to do public

penance for the deed. In the end, the struggle made both institutions stronger. In particular, both church and royal courts expanded to address the concerns of an increasingly litigious society.

DEFINING THE ROLE OF THE ENGLISH KING

Henry II and his sons Richard I the Lion-Heart (r.1189–1199) and John (r.1199–1216) were English kings with an imperial reach. Richard was rarely in England, since half of France was his to subdue (see Map 6.4, paying attention to the areas in various shades of peach). Responding to Saladin's conquest of Jerusalem, Richard went on the abortive Third Crusade (1189–1192), capturing Cyprus on the way and arranging a three-year truce with Saladin before rushing home to reclaim his territory from his brother, John, and the French king, Philip II (r.1180–1223). (His haste did him no good; he was captured by the duke of Austria and released only upon payment of a huge ransom, painfully squeezed out of the English people.)

When Richard died in battle in 1199, John took over. But if he began with an imperial reach, John must have felt a bit like the Byzantine emperor in 1204, for in that very year the king of France, Philip II, said that John had defied his overlordship—and promptly confiscated John's northern French territories. It was a purely military victory, and John set out to win the territories back by gathering money wherever and however he could in order to pay for an abler military force. He forced his barons and many members of the gentry to pay him "scutage"—a tax—in lieu of army service. He extorted money in the form of "aids"—the fees that his barons and other vassals ordinarily paid on rare occasions, such as the knighting of the king's eldest son. He compelled the widows of his barons and other vassals to marry men of his choosing or pay him a hefty fee to remain single. With the wealth pouring in from these effective but unpopular measures, John was able to pay for a navy and hire mercenary troops.

But all was to no avail. A broad coalition of German and Flemish armies led by Emperor Otto IV of Brunswick and masterminded by John was soundly defeated at the battle of Bouvines in 1214. It was a defining moment, not so much for English rule on the Continent (which would continue until the fifteenth century) as for England itself, where the barons—supported by many members of the gentry and the towns—organized, rebelled, and called the king to account. At Runnymede, just south of London, in June 1215, John was forced to agree to the charter of baronial liberties called Magna Carta, or "Great Charter," so named to distinguish it from a smaller charter issued around the same time concerning royal forests.

Magna Carta was intended to be a conservative document defining the "customary" obligations and rights of the nobility and forbidding the king to break from these without consulting his barons. Beyond this, it maintained that all free men in England had certain customs and rights in common that the king was obliged to uphold. "To no one will we sell, to no one will we refuse or delay right or justice."[6] In this way, Magna Carta documented the subordination of the king to written provisions; it implied that the king was

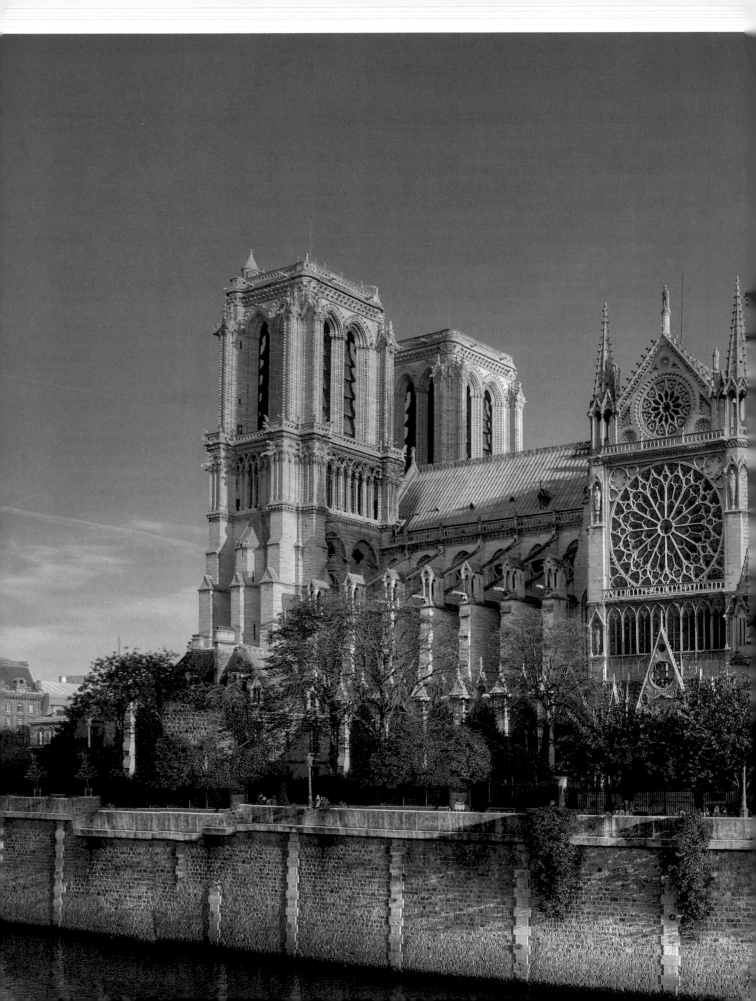

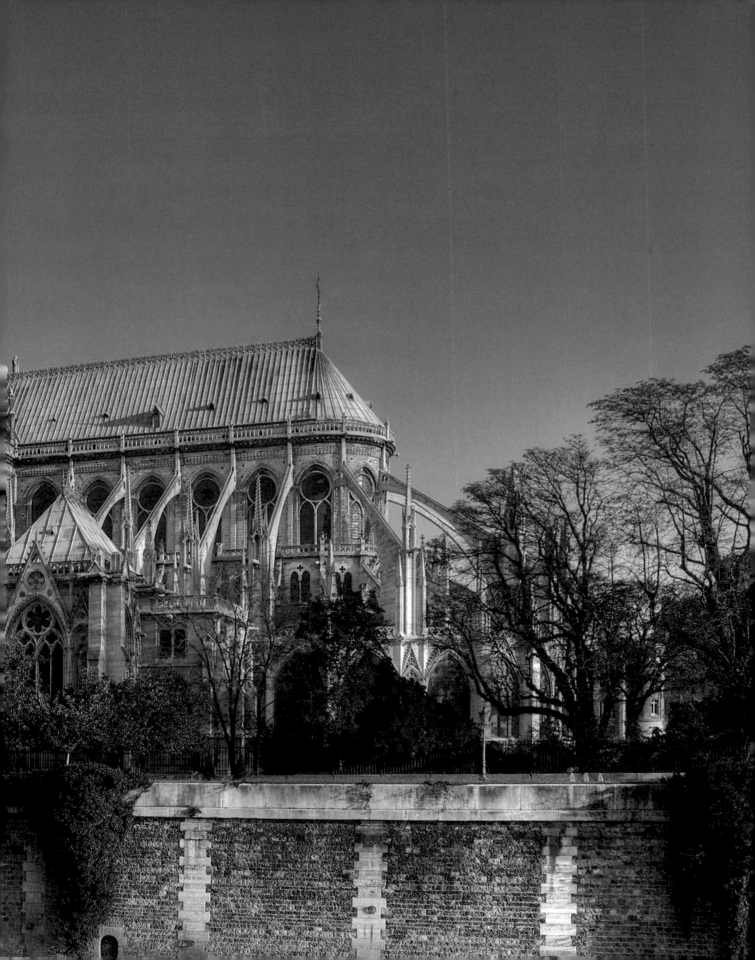

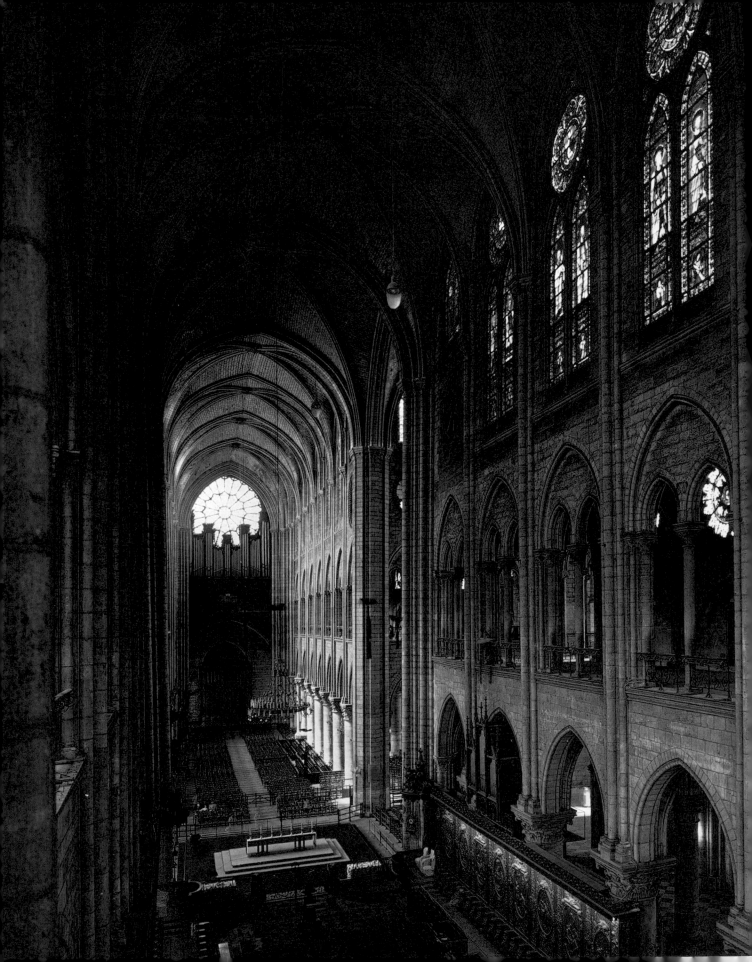

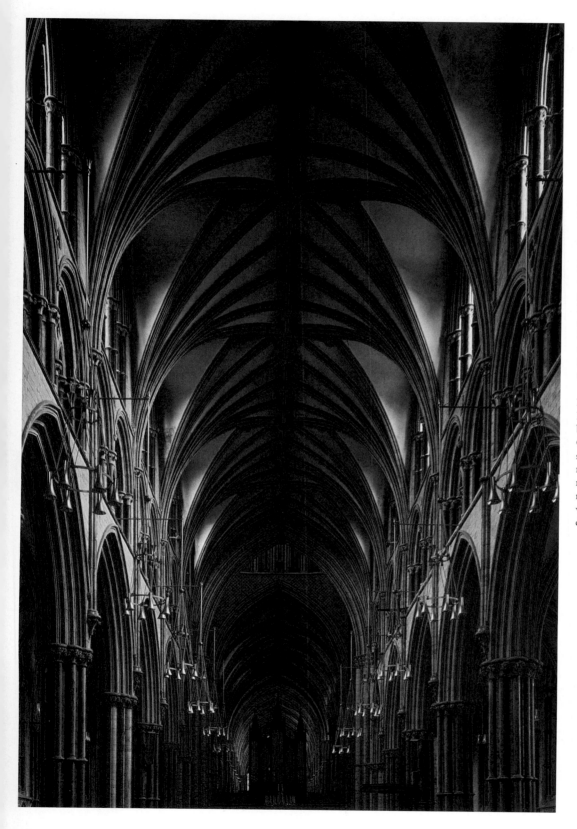

Plate 6.3 (facing page): Notre Dame of Paris, Interior (begun 1163). Compare this interior with that of Autun in Plate 5.6 (p. 185). Autun, a typical Romanesque church, has a barrel vault (though slightly pointed) and small windows at the top. By contrast, the Gothic cathedral of Notre Dame (shown here) has a pointed ribbed vault that soars above the nave, while light from large stained-glass windows suffuses the interior.

Plate 6.4: Lincoln Cathedral, Interior (choir begun 1192, nave begun 1225). Many English Gothic cathedrals emphasized surface ornament. Here the ribs, which spring from carved moldings on the walls of the nave, are splayed into fans on the vault. What other elements are decorative?

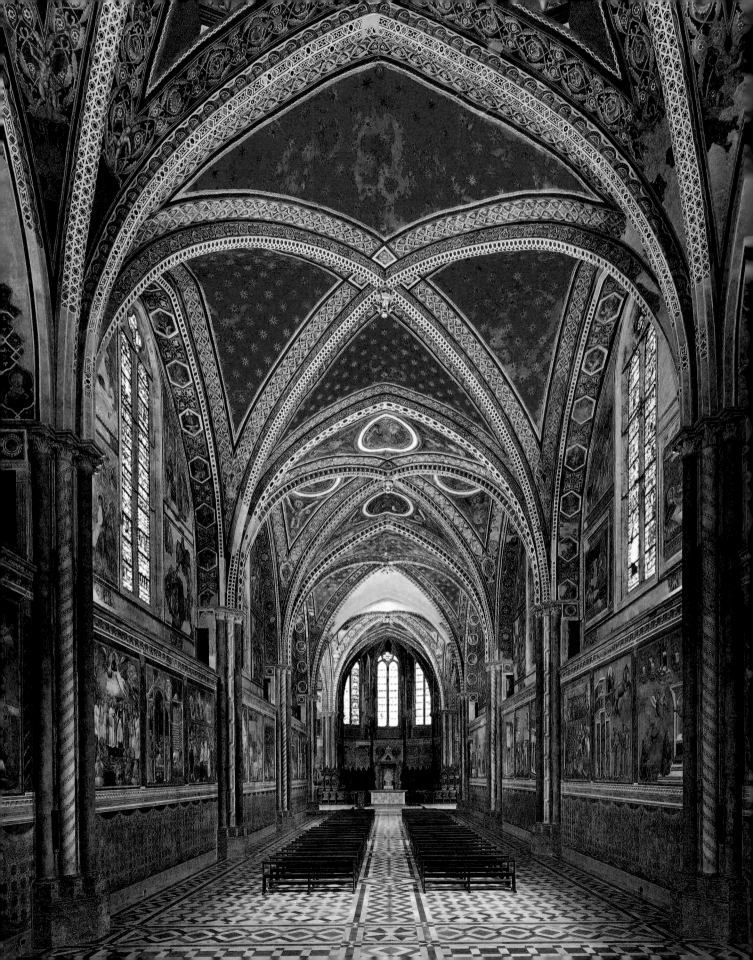

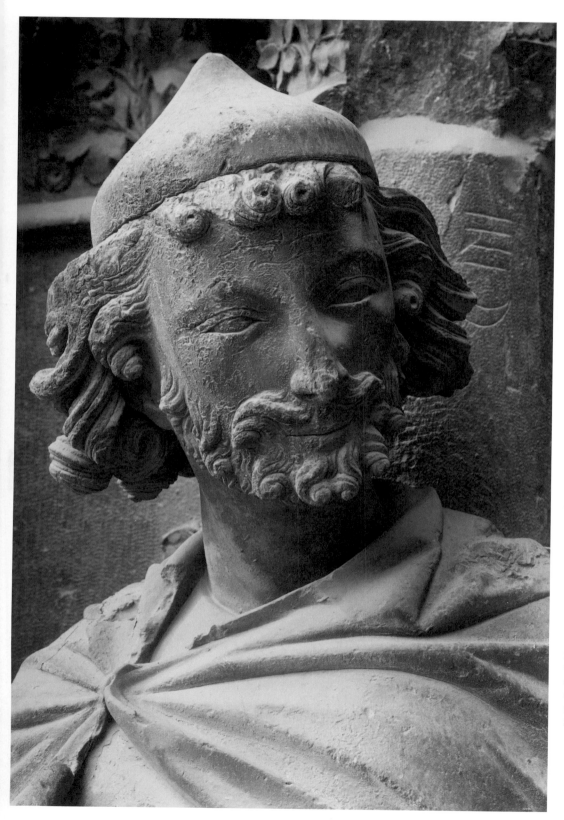

Plate 6.5 (facing page): San Francesco at Assisi (upper church; completed by 1253). Influenced by French Gothic, this church of the Franciscan Order in Assisi nevertheless asserts a different aesthetic. Compare it with Notre Dame in Plate 6.3, where the piers and ribs mark off units of space (called "bays"). By contrast, San Francesco presents a unified space. Notre Dame celebrated its soaring height; San Francesco balanced its height by its generous width. Unlike French Gothic, Italian Gothic churches gloried in their walls; at San Francesco they were decorated in the 1280s and 1290s with frescoes, the most famous of which illustrated the life and legend of Saint Francis (for whom see below, p. 231).

Plate 6.6: Reims Cathedral, West Portal, Saint Joseph (*c.*1240). Compare Saint Joseph on this Gothic portal with the portrayal of Eve on the Romanesque lintel at Autun in Plate 5.7. Forgetting, for the moment, the differences in subject matter, note the change in style: Eve's body adheres to the flat surface behind her and conforms to its shape. By contrast, Joseph breaks away from the column behind him and is carved fully in the round.

of what *Italian* architects meant by a Gothic church. It has high stained glass windows and a pointed, ribbed vault (see Plate 6.5.) But the focus is not on light and height but on walls, painted decoration, and well-proportioned space. With flying buttresses rare and portal sculpture unobtrusive, Italian Gothic churches convey a spirit of spare and quiet beauty.

Gothic art, both painting and sculpture, echoed and decorated the Gothic church. While Romanesque sculpture played upon a flat surface, Gothic figures were liberated from their background, turning, bending, and interacting. At Reims Cathedral the figure of Saint Joseph on the west portal, elegant and graceful, reveals a gentle smile. (See Plate 6.6.) Above his head is carved foliage of striking naturalness. Portals like this were meant to be "read" for their meaning. Joseph is not smiling for nothing; in the original arrangement of the portal he was looking at the figure of a servant while, further to his left, his wife, Mary, presented the baby Jesus in the temple. This was the New Testament story brought to life.

WORLDLY CONCERNS IN AND OUT OF CHURCH

The depiction of Joseph in the guise of proud father reflected a new and widespread sensibility among the educated elites: interest in the joys and woes of everyday life. This was as true at the basic level of bodily health as it was at the more rarified heights of religious behavior and belief. To care for the ill were doctors, trained in medical schools and ready to prescribe remedies according to the most up-to-date theories. To mold religious behavior and belief were churchmen, trained in both law and theology and determined to impose clear obligations on all Christians—and to rid Christendom of those who did not conform.

Caring for the Body

Around 1151, Peter the Venerable, the abbot of Cluny, wrote to a Doctor Bartholomew (probably the famous physician Bartholomew of Salerno) for help:

> For almost a year I have been repeatedly afflicted with the disease called catarrh [a head cold]; I have had it twice already, once in the summer and once in the winter or around that time. This year I came down with it at the end of summer and beginning of autumn. Prior to this, [because of business] … I was forced to postpone much longer than usual my customary bloodletting, which I normally have at the end of every second month. And because the disease that I mentioned came upon me during that delay in bloodletting, I did not dare to go ahead with it the way I normally would.[18]

In fact Peter had been advised by local doctors that he might lose his voice (and possibly even his life!) if he had his blood let. He held off for four months, and then tried bloodletting

again. It was no use: he lost his voice and coughed up phlegm for months thereafter. He needed advice. Should he let more blood or not? He ended his letter by politely excusing Bartholomew from making a house call himself; but would he send his student Bernard? Bartholomew wrote back to say that he was indeed dispatching Bernard. Meanwhile, even without seeing the patient, he had advice for Peter based on the very best knowledge of Galenic medicine as taught at Salerno. Peter should not proceed with bloodletting, Bartholomew said, because of Peter's unbalanced constitution. Galenic theory held that the physiological basis of human life rested on four humors: blood, yellow bile, phlegm, and black bile. Health depended on their balance. Bartholomew had observed on a previous visit that Peter had an excess of phlegm. It made little sense to drain the blood. The remedy, rather, was to apply heat and to use dry medications against the excess of phlegm, which was cold and wet.

When Bernard visited Peter, he no doubt gave similar advice. In doing so, he probably followed one of the advice manuals for good bedside manners that were beginning to proliferate at this time. In one of them, attributed to one "Archimatthaeus," the doctor was to enter the sickroom with a humble demeanor. Seated by the patient,

> ask him how he feels and reach out for his arm, and all that we shall say is necessary so that through your entire behavior you obtain the favor of the people who are around the sick. And because the trip to the patient has sharpened your sensitivity, and the sick rejoices at your coming or because he has already become stingy and has various thoughts about the fee, therefore by your fault as well as his the pulse is affected, is different and impetuous from the motion of the spirits.[19]

Here the doctor revealed himself to be both an astute politician (thinking about making a good impression) and a successful businessman (whose fee was hefty). But he was also a savvy physician who knew that his patient's pulse might be elevated not by his illness but from the emotions surrounding the doctor's visit itself.

The Fourth Lateran Council (1215)

Physicians like Bartholomew were professionals; increasingly, so too were the popes. Innocent III (1198–1216) studied theology at the University of Paris and trained in law at the University of Bologna. The mix allowed him to think that he ruled in the place of Christ the King; secular kings and emperors existed simply to help the pope, who was the real lawmaker—the maker of laws that would lead to moral reformation. The council that Innocent convened at the Lateran Palace at Rome in 1215 produced a comprehensive set of canons—most of them prepared by the pope's committees beforehand—to reform both clergy and laity. It defined Christianity—embracing some doctrines while rejecting others—and turned against Jews and Muslims with new vigor.

For laymen and -women perhaps the most important canons concerned the sacraments. The Fourth Lateran Council required Christians to take Communion—i.e., receive the Eucharist—at Mass and to confess their sins to a priest at least once a year. Marriage was declared a sacrament, and bishops were assigned jurisdiction over marital disputes. Forbidding secret marriages, the council expected priests to uncover evidence that might impede a marriage. There were many impediments: people were not allowed to marry their cousins, nor anyone related to them by godparentage, nor anyone related to them through a former marriage. Children conceived within clandestine or forbidden marriages were to be considered illegitimate; they could not inherit property from their parents, nor could they become priests.

Like the code of chivalry, the rules of the Fourth Lateran Council about marriage worked better on parchment than in life. Well-to-do London fathers included their bastard children in their wills. On English manors, sons conceived out of wedlock regularly took over their parents' land. The prohibition against secret marriages was only partially successful. Even churchmen had to admit that the consent of both parties made a marriage valid.

The most important sacrament was the Mass, the ritual in which the bread and wine of the Eucharist was transformed into the flesh and blood of Christ. In the twelfth century a newly rigorous formulation of this transformation declared that Christ's body and blood were truly present in the bread and wine on the altar. The Fourth Lateran Council not only adopted this as church doctrine but also explained it by using a technical term coined by twelfth-century scholars. The bread and wine were "transubstantiated": although the Eucharist continued to *look* like bread and wine, after the consecration during the Mass the bread became the actual body and the wine the real blood of Christ. The council's emphasis on this potent event strengthened the role of the priest, for only he could celebrate this mystery (the transformation of ordinary bread and wine into the flesh of Christ) through which God's grace was transmitted to the faithful.

The Embraced and the Rejected

As the Fourth Lateran Council provided rules for good Christians, it turned against all others. Some canons singled out Jews and heretics for special punitive treatment; others were directed against Byzantines and Muslims. These laws were of a piece with wider movements. With the development of a papal monarchy that confidently declared a single doctrine and the laws pertaining to it, dissidence was perceived as heresy, non-Christians seen as treacherous.

NEW GROUPS WITHIN THE FOLD

The Fourth Lateran Council prohibited the formation of new religious orders. It recognized that the trickle of new religious groups—the Carthusians is one example—of the

early twelfth century had become a torrent by 1215. Only a very few of the more recent movements were accepted into the church, among them the Dominicans, the Franciscans, and the Beguines.

Saint Dominic (1170–1221), founder of the Dominican order, had been a priest and regular canon (following the *Rule* of Saint Augustine) in the cathedral church at Osma, Spain. On an official trip to Denmark, while passing through southern France in 1203, Dominic and his companion, Diego, reportedly converted a heretic with whom they lodged. This was a rare success; most anti-heretic preachers were failing miserably around this time. Richly clad, riding on horseback, and followed by a retinue, they had no moral standing. Dominic, Diego, and their followers determined to reject material riches. Gaining a privilege from the pope to preach and teach, they went about on foot, in poor clothes, and begged for their food. They took the name "friars," after the Latin word for "brothers." Because their job was to dispute, teach, and preach, the Dominicans quickly became university men. Even in their convents (where they adopted the *Rule* of Saint Augustine), they established schools requiring their recruits to follow a formal course of studies. Already by 1206 they had established the first of many Dominican female houses. Most of these also followed the *Rule* of Saint Augustine, but their relationship to the Dominican Order was never codified. Married men and women associated themselves with the Dominicans by forming a "Tertiary" Order.

Unlike Dominic, Saint Francis (1181/1182–1226) was never a priest. Indeed, he was on his way to a promising career as a cloth merchant at Assisi when he experienced a complete conversion. Clinging to poverty as if, in his words, "she" were his "lady" (thus borrowing the vocabulary of chivalry), he accepted no money, walked without shoes, wore only one coarse tunic, and refused to be confined even in a monastery. He and his followers (who were also called "friars") spent their time preaching, ministering to lepers, and doing manual labor. In time they dispersed, setting up fraternal groups throughout Italy, France, Spain, the Crusader States, and later Germany, England, Scotland, Poland, and elsewhere. Always they were drawn to the cities. Sleeping in "convents" on the outskirts of the towns, the Franciscans became a regular part of urban community life as they preached to crowds and begged their daily bread. Early converts included women: in 1211 or 1212 Francis converted the young noblewoman Clare. She joined a community of women at San Damiano, a church near Assisi. Clare wanted the Damianites to follow the rule and lifestyle of the friars. But the church disapproved of the women's worldly activities, and the many sisters following Francis—by 1228 there were at least 24 female communities inspired by him in central and northern Italy—were confined to cloisters under the *Rule* of Saint Benedict. In the course of the thirteenth century laypeople, many of them married, formed their own Franciscan order, the "Tertiaries." They dedicated themselves to works of charity and to daily church attendance. Eventually the Franciscans, like the Dominicans, added learning and scholarship to their mission, becoming part of the city universities.

The Beguines were even more integral to town life. In the cities of northern France, the Low Countries, and Germany, these women worked as launderers, weavers, and spinners. (Their male counterparts, the "Beghards," were far less numerous.) Choosing to

live together in informal communities, taking no vows, and being free to marry if they wished, they dedicated themselves to simplicity and piety. If outwardly ordinary, however, inwardly their religious lives were often emotional and ecstatic. Some were mystics, seeking union with God. Mary of Oignies (1177–1213), for example, imagined herself with the Christ-child, who "nestled between her breasts like a baby…. Sometimes she kissed him as though He were a little child and sometimes she held Him on her lap as if He were a gentle lamb."[20]

DEFINING THE OTHER

The heretical groups that Dominic confronted in southern France were derisively called Albigensians or Cathars by the church. But they referred to themselves, among other things, as "good men" and "good women." Particularly numerous in urban, highly commercialized regions such as southern France, Italy, and the Rhineland, the good men were dissatisfied with the reforms achieved by the Gregorians and resented the church's newly centralized organization. Precisely what these dissidents believed may be glimpsed only with difficulty, largely through the reports of those who questioned and persecuted them. At a meeting in Lombers in 1165 to which some of them apparently voluntarily agreed to come, they answered questions put to them by the bishop of Lodève. Asked about the Eucharist, for example, "they answered that whoever consumed it worthily was saved, but the unworthy gained damnation for themselves; and they said that it could be consecrated [that is, transformed into Christ's body and blood] by a good man, whether clerical or lay." When questioned about whether "each person should confess his sins to priests and ministers of the church—or to any layman," they responded that it "would suffice if they confessed to whom they wanted." On this and other questions, then, the good men of Lombers had notions at variance with the doctrines that the post-Gregorian church was proclaiming. Above all, their responses downgraded the authority and prerogatives of the clergy. When the bishop at Lombers declared the good men heretics, "the heretics answered that the bishop who gave the sentence was the heretic and not they, that he was their enemy and a rapacious wolf and a hypocrite…."[21]

By the time that Dominic confronted the southern French heretics, the hostility of these dissidents toward church leaders had created the sense of a major threat. The church termed them all "dualists" who believed that the world was torn between two great forces, one good and the other evil. Dualism was well known to well-educated churchmen; for example, Saint Augustine (d.430) had briefly flirted with the dualists of his own day before decisively breaking with them. Moreover, some dualist groups flourished in the Byzantine Empire, which was increasingly being vilified in the West. Classifying heretics as such created a powerful new tool of persecution and coercion that came to be used by both ecclesiastical and secular rulers.

There is no doubt that some of the good men were dualists. But there were many shades of dualism—many "catharisms"—ranging from the innocuous notion that spiritual

things were pure and eternal, while materials things were not, to the radical claim that the devil had created the world and all that was in it, including man. The Christianity espoused by the church hierarchy itself had many dualist elements. In some ways, therefore, the issue of the good men's dualism overlooked the most important point for them: that their doctrine was largely a by-product of their determination to pursue poverty and simplicity—to live like the apostles—and to adhere literally to the teachings of Christ as contained in the Gospels.

Other heretical groups were condemned not on doctrinal grounds but because they allowed their lay members to preach, assuming for themselves the privilege of bishops. At Lyon (in southeastern France) in the 1170s, for example, a rich merchant named Waldo decided to take literally the Gospel message, "If you wish to be perfect, then go and sell everything you have, and give to the poor" (Matt. 19:21). The same message had inspired countless monks and would worry the church far less several decades later, when Saint Francis established his new order. But when Waldo went into the street and gave away his belongings, announcing, "I am not out of my mind, as you think,"[22] he scandalized not only the bystanders but the church as well. Refusing to retire to a monastery, Waldo and his followers, men and women called Waldensians, lived in poverty and went about preaching, quoting the Gospel in the vernacular so that everyone would understand them. But the papacy rejected Waldo's bid to preach freely; and the Waldensians—denounced, excommunicated, and expelled from Lyon—wandered to Languedoc, Italy, northern Spain, and the Mosel valley, just east of France.

EUROPEAN AGGRESSION WITHIN AND WITHOUT

Jews, heretics, Muslims, Byzantines, and pagans: all felt the heavy hand of Christian Europeans newly organized, powerful, and zealous. Meanwhile, even the undeniable Catholicism of Ireland did not prevent its takeover by England.

The Jews

Prohibited from joining guilds, Jews increasingly were forced to take the one job Christians could not have: lending on credit. Even with Christian moneylenders available (for some existed despite official prohibitions), lords borrowed from Jews. Then, relying on dormant anti-Jewish feeling, they sometimes "righteously" attacked their creditors. This happened in 1190 at York, for example, where local nobles orchestrated a brutal attack on the Jews of the city to rid themselves of their debts and the men to whom they owed money. Kings claimed the Jews as their serfs and Jewish property as their own. In England a special royal exchequer of the Jews was created in 1194 to collect unpaid debts due after the death of Jewish creditors. In France, Philip Augustus expelled the Jews from the Ile-de-France

in 1182, confiscating their houses, fields, and vineyards for himself. He allowed them to return—minus their property—in 1198.

Attacks against Jews were inspired by more than resentment against Jewish money or desire for power and control. They grew out of the codification of Christian religious doctrine. The newly rigorous definition of the Eucharist as the true body and blood of Christ meant to some that Christ, wounded and bleeding, lay upon the altar. Miracle tales sometimes reported that the Eucharist bled. Reflecting Christian anxieties about real flesh upon the altar, sensational stories, originating in clerical circles but soon widely circulated, told of Jews who secretly sacrificed Christian children in a morbid revisiting of the crucifixion of Jesus. This charge, called "blood libel" by historians, led to massacres of Jews in cities in England, France, Spain, and Germany. In this way, Jews became convenient and vulnerable scapegoats for Christian guilt and anxiety about eating Christ's flesh.

After the Fourth Lateran Council, Jews were easy to spot as well. The council required all Jews to advertise their religion by some outward sign, some special dress. Local rulers enforced this canon with zeal, not so much because they were anxious to humiliate Jews as because they saw the chance to sell exemptions to Jews eager to escape the requirement. Nonetheless, sooner or later Jews almost everywhere had to wear something to advertise their second-class status: in southern France and Spain they had to wear a round badge; in Vienna they were forced to wear pointed hats.

Crusades

Attacks against Jews coincided with vigorous crusades. A new kind of crusade was launched against the heretics in southern France; along the Baltic, rulers and crusaders redrew Germany's eastern border; and the Fourth Crusade was rerouted and took Constantinople.

Against the Albigensians in southern France, Innocent III demanded that northern princes take up the sword, invade Languedoc, wrest the land from the heretics, and populate it with orthodox Christians. This Albigensian Crusade (1209–1229) marked the first time the pope had offered warriors who were fighting an enemy within Christian Europe all the spiritual and temporal benefits of a crusade to the Holy Land. In the event, the political ramifications were more notable than the religious results. After twenty years of fighting, leadership of the crusade was taken over in 1229 by the Capetian kings. Southern resistance was broken and Languedoc was brought under the control of the French crown. (On Map 6.4, p. 206, the area taken over by the French crown corresponds more or less with the region of Toulouse.)

Like Spain's southern boundary, so too was Europe's northeast a moving frontier, driven ever farther eastward by crusaders and settlers. By the twelfth century, the peoples living along the Baltic coast—partly pagan, mostly Slavic- or Baltic-speaking—had learned to make a living and even a profit from the inhospitable soil and climate. Through fishing and trading, they supplied the rest of Europe and Rus' with slaves, furs, amber, wax, and dried fish. Like the earlier Vikings, they combined commercial competition with outright

raiding, so the Danes and the Saxons (i.e., the Germans in Saxony) both benefited and suffered from their presence. It was Saint Bernard (see p. 192) who, while preaching the Second Crusade in Germany, urged one to the north as well. Thus began the Northern Crusades, which continued intermittently until the early fifteenth century.

In key raids in the 1160s and 1170s, the king of Denmark and Henry the Lion, the duke of Saxony, worked together to bring much of the region between the Elbe and Oder Rivers under their control. They took some of the land outright, leaving the rest in the hands of the Baltic princes, who surrendered, converted, and became their vassals. Churchmen arrived: the Cistercians built their monasteries right up to the banks of the Vistula River, while bishops took over newly declared dioceses. In 1202 the "bishop of Riga"—in fact he had to bring some Christians with him to his lonely outpost amidst the Livs—founded a military/monastic order called the Order of the Brothers of the Sword. The monks soon became a branch of the Teutonic Knights (or Teutonic Order), a group originally founded in the Crusader States and vowed to a military and monastic rule like the Templars. The Knights organized crusades, defended newly conquered regions, and launched their own holy wars against the "Northern Saracens." By the end of the thirteenth century, they had brought the lands from Prussia to Estonia under their sway. (See Map 6.6.) Meanwhile German knights, peasants, and townspeople streamed in, colonists of

Map 6.6: German Settlement in the Baltic Sea Region, Twelfth to Fourteenth Centuries

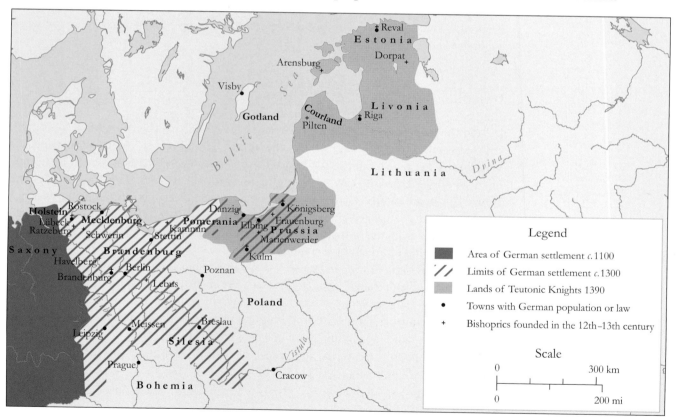

the new frontier. Although less well known than the crusades to the Levant, the Northern Crusades had more lasting effects, settling the Baltic region with a German-speaking population that brought its western institutions—cities, laws, guilds, universities, castles, manors, vassalage—with it.

Colonization was the unanticipated consequence of the Fourth Crusade as well. Called by Innocent III, who intended it to re-establish the Christian presence in the Holy Land, the crusade was diverted when the organizers overestimated the numbers joining the expedition. The small army mustered was unable to pay for the large fleet of ships that had been fitted out for it by the Venetians. Making the best of adversity, the Venetians convinced the crusaders to "pay" for the ships by attacking Zara (today Zadar), one of the coastal cities that Venice disputed with Hungary. Then, taking up the cause of one claimant to the Byzantine throne, the crusaders turned their sights on Constantinople. We already know the political results. The religious results were more subtle. Europeans disdained the Greeks for their independence from the pope; on the other hand, they considered Constantinople a treasure trove of the most precious of relics, including the True Cross. When, in the course of looting the city, one crusader, the abbot of a German Cistercian monastery, came upon a chest of relics, he "hurriedly and greedily thrust in both hands."[23] There was a long tradition of relic theft in the West; it was considered pious, a sort of holy sacrilege. Thus, when the abbot returned to his ship to show off his booty, the crusaders shouted, "Thanks be to God." In this sense Constantinople was taken so that the saints could get better homes.

Ireland

In 1169 the Irish king of Leinster, Diarmait Mac Murchada (Dermot MacMurrough), enlisted some lords and knights from England to help him first keep, then expand, his kingdom. The English fighters succeeded all too well; when Diarmait died in 1171, some of the English decided to stay, claiming Leinster for themselves. The king of England, Henry II, reacted swiftly. Gathering an army, he invaded Ireland in 1171. The lords of the 1169 expedition recognized his overlordship almost immediately, keeping their new territories, but now redefined as fiefs from the king. Most of the native Irish kings submitted in similar manner. The whole of one kingdom, Meath, was given to one of Henry's barons.

The English came to stay, and more—they came to put their stamp on the Irish world. It became "English Ireland": England's laws were instituted; its system of counties and courts was put in place; its notions of lordship (in which the great lords parceled out some of their vast lands to lesser lords and knights) prevailed. Small wonder that Gerald of Wales (d.1223) could see nothing good in native Irish culture: "they are uncultivated," he wrote, "not only in the external appearance of their dress, but also in their flowing hair and beards. All their habits are the habits of barbarians."[24]

★　　★　　★　　★　　★

In the fifty years before and after 1200, Europe, aggressive and determined, pushed against its borders. Whether gaining territory from the Muslims in Spain and Sicily, colonizing the Baltic region and Ireland, or creating a Latin empire at Constantinople, Europeans accommodated the natives only minimally. For the most part, they imposed, with enormous self-confidence, their institutions and their religion.

Self-confidence also led lords and ladies to pay poets to celebrate their achievements and bishops and townspeople to commission architects to erect towering Gothic churches in their midst. Similar certainties lay behind guild statutes, the incorporation of universities, the development of common law, and the Fourth Lateran Council's written definitions of Christian behavior and belief.

An orderly society would require institutions so fearlessly constructed as to be responsive to numerous individual and collective goals. But in the next century, while harmony was the ideal and sometimes the reality, discord was an ever-present threat.

CHAPTER SIX KEY EVENTS

1152–1190	Frederick Barbarossa (king of Germany and emperor from 1155)
1154–1189	King Henry II of England
1170	Murder of Thomas Becket
1171	Henry II conquers Ireland
1171–1193	Saladin's rule
1176	Battle of Legnano
1187	Battle of Hattin
1189–1192	Third Crusade
1194–1250	Frederick II
1198–1216	Pope Innocent III
1202–1204	Fourth Crusade
1204	Fall of Constantinople to Crusaders
1204	Philip II of France takes King John of England's northern French possessions
1212	Battle of Las Navas de Tolosa
1214	Battle of Bouvines
1215	Magna Carta
1215	Fourth Lateran Council
1226	Death of Saint Francis
1261	Constantinople again Byzantine
1273	Election of Rudolf of Habsburg as Holy Roman Emperor

NOTES

1 Henry's father, Geoffrey of Anjou, was nicknamed Plantagenet from the *genêt*, the name of a shrub ("broom" in English) that he liked. Historians sometimes use the sobriquet to refer to the entire dynasty, so Henry II was the first "Plantagenet" as well as the first "Angevin" king of England.

2 *The Assize of Clarendon*, in *Reading the Middle Ages: Sources from Europe, Byzantium, and the Islamic World*, ed. Barbara H. Rosenwein, 2nd ed. (Toronto: University of Toronto Press, 2014), p. 311.

3 *The Costs of Richard of Anstey's Law Suit*, in *Reading the Middle Ages*, p. 314.

4 *Proceedings for the Abbey of Bec*, in *Reading the Middle Ages*, p. 321.

5 *Constitutions of Clarendon*, in *Reading the Middle Ages*, p. 331.

6 *Magna Carta*, in *Reading the Middle Ages*, p. 340.

7 *The Laws of Cuenca*, in *Reading the Middle Ages*, p. 315.

8 *Diet of Besançon*, in *Reading the Middle Ages*, p. 335.

9 *The Chronicle of Salimbene de Adam*, ed. and trans. Joseph L. Baird, Giuseppe Baglivi, and John Robert Kane, Medieval & Renaissance Texts & Studies 40 (Binghamton, NY: MRTS, 1986), p. 5.

10 Bernart de Ventadorn, *When I see the lark*, in *Reading the Middle Ages*, p. 348.

11 Ibid., pp. 348–49.

12 La Comtessa de Dia, *I have been in heavy grief*, in *Reading the Middle Ages*, p. 349.

13 *The Priest Who Peeked*, in *Reading the Middle Ages*, p. 352.

14 Bertran de Born, *Half a sirventés I'll sing*, in *Reading the Middle Ages*, p. 351.

15 Chrétien de Troyes, *Lancelot*, in *Reading the Middle Ages*, p. 360.

16 Ibid., p. 362.

17 *Guild Regulations of the Parisian Silk Fabric Makers*, in *Reading the Middle Ages*, p. 322.

18 Peter the Venerable, *Letter to Doctor Bartholomew*, in *Reading the Middle Ages*, p. 342.

19 *Advice from "Archimatthaeus,"* in *Reading the Middle Ages*, p. 346.

20 Jacques de Vitry, *The Life of Mary of Oignies*, in *Reading the Middle Ages*, p. 372.

21 Edition of the text in Pilar Jiménez Sánchez, *L'évolution doctrinale du catharisme, XIIe–XIIIe siècle*, 3 vols., Ph.D. Diss, University of Toulouse II, 2001, Annex 1: Actes de Lombers.

22 *The Chronicle of Laon*, in *Reading the Middle Ages*, p. 369.

23 Gunther of Pairis, *Hystoria Constantinopolitana*, in *The Capture of Constantinople*, ed. and trans. Alfred J. Andrea (Philadelphia: Scholarly Book Services, 2007), p. 111.

24 Gerald of Wales, *The History and Topography of Ireland*, trans. John O'Meara (London: Penguin, 1982), p. 102.

FURTHER READING

Abulafia, David. *Frederick II: A Medieval Emperor*. London: Oxford University Press, 1988.

Angold, Michael. *The Byzantine Empire, 1025–1204*. 2nd. ed. London: Longman, 1997.

Baldwin, John. *The Government of Philip Augustus: Foundations of French Royal Power in the Middle Ages*. Berkeley: University of California Press, 1986.

Bartlett, Robert. *England under the Norman and Angevin Kings, 1075–1225*. Oxford: Oxford University Press, 2000.

———. *The Making of Europe: Conquest, Colonization and Cultural Change, 950–1350*. Princeton, NJ: Princeton University Press, 1993.

Christiansen, Eric. *The Northern Crusades*. 2nd ed. London: Penguin, 1997.

Clanchy, Michael T. *From Memory to Written Record, 1066–1307*. 3rd ed. Oxford: John Wiley & Sons, 2012.

Cobb, Paul M. *Usama ibn Munqidh: Warrior-Poet of the Ages of Crusades*. Oxford: Oneworld, 2005.

Duggan, Anne. *Thomas Becket*. London: Arnold, 2004.

Eddé, Anne-Marie. *Saladin*. Translated by Jane Marie Todd. Cambridge, MA: Belknap Press, 2011.

Frame, Robin. *Colonial Ireland*. Dublin: Four Courts Press, 2012.

———. *The Political Development of the British Isles, 1100–1400*. Oxford: Oxford University Press, 1990.

Gaunt, Simon, and Sarah Kay, eds. *The Troubadours: An Introduction*. Cambridge: Cambridge University Press, 1999.

Haverkamp, Alfred. *Medieval Germany, 1056–1273*. Trans. Helga Braun and Richard Mortimer. Oxford: Oxford University Press, 1988.

Lawrence, C.H. *The Friars: The Impact of the Early Mendicant Movement on Western Society*. London: Longman, 1994.

Moore, R.I. *The War on Heresy*. Cambridge, MA: Belknap Press, 2012.

Mayr-Harting, Henry. *Religion, Politics and Society in Britain 1066–1272*. Harlow, U.K.: Pearson, 2011.

Pegg, Mark Gregory. *The Corruption of Angels: The Great Inquisition of 1245–1246*. Princeton, NJ: Princeton University Press, 2001.

Şenocak, Neslihan. *The Poor and the Perfect: The Rise of Learning in the Franciscan Order, 1209–1310*. Ithaca, NY: Cornell University Press, 2012.

Taylor, Claire. *Heresy, Crusade and Inquisition in Medieval Quercy*. Woodbridge: Boydell, 2011.

Tyerman, Christopher. *God's War: A New History of the Crusades*. Cambridge, MA: Belknap Press, 2006.

Vauchez, André. *Francis of Assisi: The Life and Afterlife of a Medieval Saint*. Trans. Michael F. Cusato. New Haven, CT: Yale University Press, 2012.

To test your knowledge of this chapter, please go to
www.utphistorymatters.com
for Study Questions.

SEVEN

DISCORDANT HARMONIES (c.1250–c.1350)

IN THE SHADOW of a great Mongol empire that, for about a century, stretched from the East China Sea to the Black Sea and from Moscow to the Himalayas, Europeans were bit players in a great Eurasian system tied together by a combination of sheer force and open trade routes. Taking advantage of the new opportunities for commerce and evangelization offered by the mammoth new empire, Europeans ventured with equal verve into experiments in their own backyards: in government, thought, and expression. Above all, they sought to harmonize disparate groups, ideas, and artistic modes. At the same time, unable to force everything into unified and harmonious wholes and often confronted instead with discord and strife, the directing classes—both secular and ecclesiastical—tried to purge their society of deviants of every sort.

THE MONGOL HEGEMONY

The Mongols, like the Huns and Seljuks before them, were pastoralists. Occupying the eastern edge of the great steppes that stretch west to the Hungarian plains, they herded horses and sheep while honing their skills as hunters and warriors. Believing in both high deities and slightly lower spirits, the Mongols were also open to other religious ideas, easily assimilating Buddhism, Islam, and even some forms of Christianity. Their empire, in its heyday stretching about 4,000 miles from east to west, was the last to be created by the nomads from the steppes.

The Contours of the Mongol Empire

The Mongols formed under the leadership of Chinghis (or Genghis) Khan (*c.*1162–1227). Fusing together various tribes of mixed ethnic origins and traditions, Chinghis created a highly disciplined, orderly, and sophisticated army. Impelled out of Mongolia in part by new climatic conditions that threatened their grasslands, the Mongols were equally inspired by Chinghis's vision of world conquest. All of China came under their rule by 1279; meanwhile, the Mongols were making forays to the west as well. They took Rus' in the 1230s, invaded Poland and Hungary in 1241, and might well have continued into the rest of Europe, had not unexpected dynastic disputes and insufficient pasturage for their horses drawn them back east. In the end, the borders of their European dominion rolled back east of the Carpathian Mountains.

Something rather similar happened in the Islamic world, where the Mongols took Seljuk Rum, the major power in the region, by 1243. They then moved on to Baghdad (putting an end to the caliphate there in 1258) and Syria (1259–1260), threatening the fragile Crusader States a few miles away. Yet a few months later the Mongols withdrew their troops from Syria, probably (again) because of inadequate grasslands and dynastic problems. The Mamluks of Egypt took advantage of the moment to conquer Syria. This

Map 7.1: The Mongol Empire, *c.*1260–1350

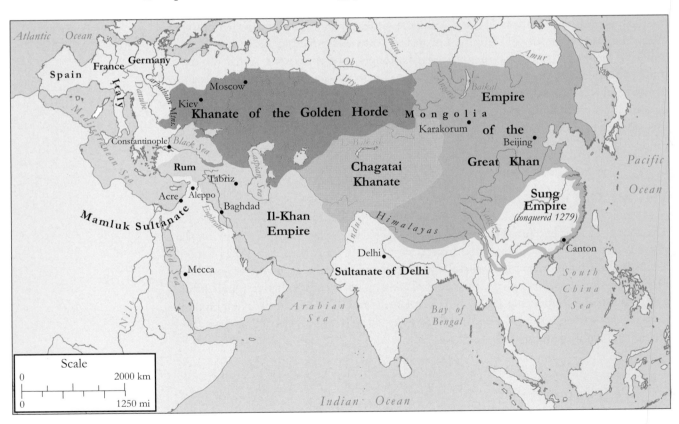

effectively ended the Mongol push across the Islamic world. It was the Mamluks, not the Mongols, who took Acre in 1291, snuffing out the last bit of the original Crusader States.

By the middle of the thirteenth century, the Mongol Empire had taken on the contours of a settled state. (See Map 7.1.) It was divided into four regions, each under the rule of various progeny of Chinghis. The westernmost quadrant was dominated by the rulers of Rus', the so-called Golden Horde ("horde" derived from the Turkic word for "court"). Settled along the lower Volga River valley, the Mongols of the Golden Horde combined traditional pastoralism with more settled activities. They founded cities, fostered trade, and gradually gave up their polytheism in favor of Islam. While demanding regular and exactly calculated tribute, troops, and recognition of their overlordship from the indigenous Rus rulers, they nevertheless allowed the princes of Rus' considerable autonomy. Their policy of religious toleration allowed the Orthodox Church to flourish, untaxed, and willing in turn to offer up prayers for the soul of the Mongol khan (ruler). Kiev-based Rus', largely displaced by the Mongols, gave way to the hegemony of northern Rus princes centered in the area around Moscow. As Mongol rule fragmented, in the course of the fifteenth century, Moscow-based Russia emerged.

From Europe to China

The Mongols taught Europeans to think globally. Once settled, the Mongols sent embassies west, welcomed Christian missionaries, and encouraged European trade. For their part, Europeans initially thought that the Mongols must be Christians; news of Mongol onslaughts in the Islamic world gave ballast to the myth of a lost Christian tribe led by a "Prester John" and his son "King David." Even though Europeans soon learned that the Mongols were not Christians, they dreamed of new triumphs: they imagined, for example, that Orthodox Christians under the Golden Horde would now accept papal protection (and primacy); they flirted with the idea of a Mongol-Christian alliance against the Muslims; and they saw the advent of the "new" pagans as an opportunity to evangelize. Thus in the 1250s the Franciscan William of Rubruck traveled across Asia to convert the Mongols in China; on his way back he met some Dominicans determined to do the same. European missions to the East became a regular feature of the West's contact with the Mongol world.

Such contact was further facilitated by trade. European caravans and ships crisscrossed the Mongol world, bringing silks, spices, ceramics, and copper back from China, while exporting slaves, furs, and other commodities. (See Map 7.2.) The Genoese, who allied with the Byzantines to overthrow the Latin Empire of Constantinople in 1261, received special trading privileges from both the newly installed Byzantine emperor, Michael VIII Paleologus (r.1259–1282), and the khans of the Golden Horde. Genoa, which set up a permanent trading post at Caffa (today Feodosiya), on the Black Sea, was followed by Venice, which established its own trade-stations at Tana and Tabriz. These were sites well poised to exploit overland routes. Other European traders and missionaries traveled

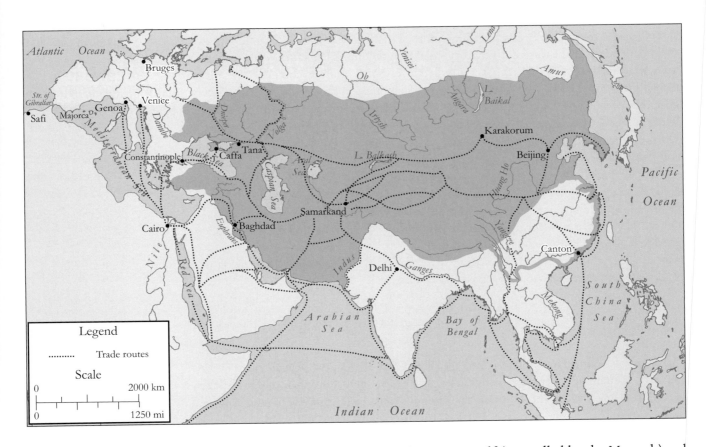

Map 7.2: Mongol-European Trade Routes, *c.*1350

arduous sea routes, setting sail from the Persian Gulf (controlled by the Mongols) and rounding India before arriving in China. Marco Polo (1254–1324) was the most famous of the travelers to the East only because he left a fascinating travel book. His descriptions of the fabulous wealth of the orient fired up new adventurers. In a sense, the Mongols initiated the search for exotic goods and missionary opportunities that culminated in the European "discovery" of a new world, the Americas.

THE MATURATION OF THE EUROPEAN ECONOMY

The pull of the East on the trade of the great Italian maritime cities was part of a series of shifts in Europe's commercial patterns. Another one, even more important, was toward the Atlantic. At the same time, new roads and bridges within Europe made land trade both possible and profitable. The need for large-scale payments meant the introduction of new sorts of coins. Europeans now had access to material goods of every sort, but wealth also heightened social tensions, especially within the cities.

New Routes

The first ships to ply the Atlantic's waters in regular trips were the galleys of Genoese entrepreneurs. By the 1270s they were leaving the Mediterranean via the Strait of Gibraltar, stopping to trade at various ports along the Spanish coast, and then making their way north to England and northern France. (See Map 7.3 on p. 246.) In the western Mediterranean, Majorca, recently conquered by the king of Aragon, sent its own ships to join the Atlantic trade at about the same time. Soon the Venetians began state-sponsored Atlantic expeditions using new-style "great galleys" that held more cargo yet required fewer oarsmen. Eventually, as sailing ships—far more efficient than any sort of galley—were developed by the Genoese and others, the Atlantic passage replaced older overland and river routes between the Mediterranean and Europe's north.

Equally important for commerce were new initiatives in North Africa. As the Almohad Empire collapsed, weak successor states allowed Europeans new elbow room. Genoa had outposts in the major Mediterranean ports of the Maghreb and new ones down the Atlantic coast, as far south as Safi (today in Morocco). Pisa, Genoa's traditional trade rival, was entrenched at Tunis. Catalonia and Majorca, by now ruled by the king of Aragon, found their commercial stars rising fast. Catalonia established its own settlements in the port cities of the Maghreb; Majorcans went off to the Canary Islands. Profits were enormous. Besides acting as middlemen, trading goods or commodities from northern Europe, the Italian cities had their own products to sell (Venice had salt and glass products, Pisa had iron) in exchange for African cotton, linen, spices, and, above all, gold. In the mid-thirteenth century, Genoa and Florence were minting coins from gold panned on the upper Niger River, while Venice began minting gold ducats in 1284.

At the same time as Genoa, Pisa, Venice, Majorca, and Catalonia were forging trade networks in the south, some cities in the north of Europe were creating their own marketplace in the Baltic Sea region. Built on the back of the Northern Crusades, the Hanseatic League was created by German merchants, who, following in the wake of Christian knights, hoped to prosper in cities such as Danzig (today Gdansk, in Poland), Riga, and Reval (today Tallinn, in Estonia). Lübeck, founded by the duke of Saxony, formed the Hansa's center. Formalized through legislation, the association of cities agreed that

> Each city shall ... keep the sea clear of pirates.... Whoever is expelled from one city because of a crime shall not be received in another ... If a lord besieges a city, no one shall aid him in any way to the detriment of the besieged city.[1]

There were no mercantile rivalries here, unlike the competition between Genoa and Pisa in the south. But there was also little glamor. Pitch, tar, lumber, furs, herring: these were the stuff of northern commerce.

The opening of the Atlantic and the commercial uniting of the Baltic were dramatic developments. Elsewhere the pace of commercial life quickened more subtly. By 1200 almost all the cities of pre-industrial Europe were in existence. By 1300 they were connected

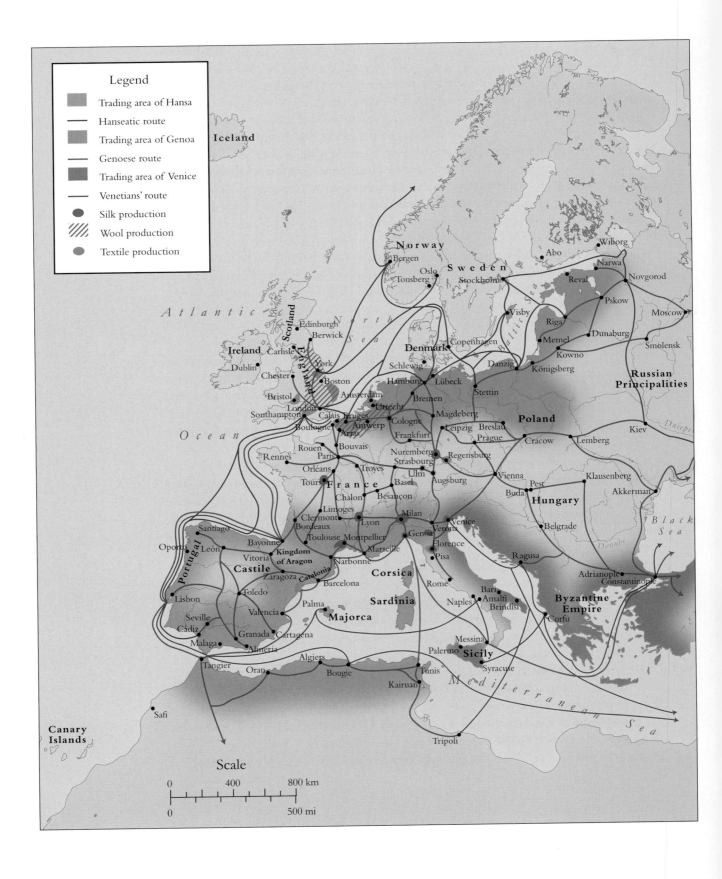

Legend

- Trading area of Hansa
- Hanseatic route
- Trading area of Genoa
- Genoese route
- Trading area of Venice
- Venetians' route
- Silk production
- Wool production
- Textile production

Iceland

Atlantic

Ocean

North Sea

Norway
Bergen
Oslo
Tonsberg

Sweden
Stockholm

Baltic Sea

Abo
Wiborg
Narwa
Reval
Novgorod
Pskow
Moscow
Riga
Dunaburg
Smolensk
Memel
Kowno
Königsberg
Danzig
Stettin

Russian Principalities

Denmark
Copenhagen
Schlewig
Hamburg
Lübeck
Bremen
Magdeberg

Kiev

Dnieper

Poland
Breslau
Leipzig
Prague
Cracow
Lemberg

Scotland
Edinburgh
Berwick

Ireland
Dublin
Carlisle
Chester
England
York
Boston
Bristol
London
Southampton
Calais
Bruges
Boulogne
Amsterdam
Utrecht
Antwerp
Arras
Cologne
Frankfurt
Bouvais
Rouen
Rennes
Paris
Nuremberg
Strasbourg
Regensburg
Vienna
Klausenberg
Akkerman

Orléans
Troyes
Ulm
Augsburg
Pest
Buda
Tours
France
Châlon
Basel
Besançon
Limoges
Lyon
Milan
Hungary
Belgrade
Clermont
Bordeaux
Toulouse
Montpellier
Marseille
Verona
Venice
Genoa
Florence
Pisa

Black Sea

Santiago
Bayonne
Kingdom of Aragon
Vitoria
León
Oporto
Castile
Zaragoza
Catalonia
Barcelona
Narbonne
Corsica
Rome
Ragusa
Adrianople
Constantinople

Lisbon
Portugal
Toledo
Palma
Sardinia
Naples
Bari
Amalfi
Brindisi
Byzantine Empire
Corfu

Seville
Cádiz
Granada
Valencia
Cartagena
Majorca
Malaga
Almeria
Algiers
Palermo
Messina
Sicily
Syracuse
Tangier
Oran
Bougie
Tunis
Kairuan
Tripoli

Mediterranean Sea

Safi

Canary Islands

Scale

0 400 800 km

0 500 mi

by a spider's web of roads that brought even small towns of a few thousand inhabitants into wider networks of trade. To be sure, some old trading centers declined: the towns of Champagne, for example, had been centers of major fairs—periodic but intense commercial activity. By the mid-thirteenth century the fairs' chief functions were as financial markets and clearing houses. On the whole, however, urban centers grew and prospered. As the burgeoning population of the countryside fed the cities with immigrants, the population of many cities reached their medieval maximum: in 1300 Venice and London each had perhaps 100,000 inhabitants, Paris an extraordinary 200,000. Many of these people became part of the urban labor force, working as apprentices or servants; but others could not find jobs or became disabled and could not keep them. The indigent and sick posed new challenges for urban communities. To be sure, rich townspeople and princes alike supported the building of new charitable institutions: hospices for the poor, hospitals for the sick, orphanages, refuges for penitent prostitutes. But in big cities the numbers that these could serve were woefully inadequate. Beggars (there were perhaps 20,000 in Paris alone) became a familiar sight, and not all prostitutes could afford to be penitent.

New Money

Map 7.3 (facing page):
European Trade Routes, c.1300

Workers were paid in silver pennies; the burgeoning economy demanded a lot of coins. Silver mines were discovered and exploited to provide them. At Freiburg, in northern Germany, such mines meant a jump in the number of mints from nine (in 1130) to twenty-five in 1197. Small workshop mints, typical before the thirteenth century, gave way to mint factories run by profit-minded entrepreneurs. Princes added to their power by making sure that the coins of one mint under their control would prevail in their region. Thus the bishops of Maguelonne, who also were the counts of Melgueil, issued coins that supplanted most of the others in southern France.

But large-scale transactions required larger coins than pennies. Between the early thirteenth and mid-fourteenth centuries, new, heavier silver coins were struck. Under Doge Enrico Dandolo (r. 1192–1205), Venice began to strike great silver coins, *grossi* ("big ones" in Italian), in order to make convenient payments for the Fourth Crusade. (To be sure, Venice's little silver coins, the *piccoli*, continued to be minted.) Soon Venice's commercial rival Genoa produced similarly large coins, and the practice quickly spread to other cities in northern Italy, Tuscany, and southern France. In 1253, Rome doubled the size of the *grossi*, a coinage model that was followed in Naples and Sicily. The practice of minting these heavy silver coins spread northward.

Heavy silver was one answer to the problem of paying for large transactions. Gold coins were another. They were certainly common in the Islamic and Mediterranean worlds. In Europe before the mid-thirteenth century, though, they were limited to the regions that bordered on those worlds, like Sicily and Spain. Gold panned on the upper Niger River in Africa and wrested from mines in Hungary helped infuse Europe with the precious metal. In 1252 Genoa and Florence struck gold coins for the first time. The practice spread,

profiting above all Italy and East Central Europe. In fact, the kings of Hungary and Bohemia formed an alliance to control the flow of gold, enhance their purchasing power, and increase trade.

New Inter-city Conflicts

The most commercialized regions were the most restive. This was certainly true in Flanders, where the urban population had grown enormously since the twelfth century. Flemish cities depended on England for wool to supply their looms and on the rest of Europe to buy their finished textiles. But Flemish workers were unhappy with their town governments, run by wealthy merchants, the "patricians," whose families had held their positions for generations. When, in the early 1270s, England slapped a trade embargo on Flanders, discontented laborers, now out of work, struck, demanding a role in town government. While most of these rebellions resulted in few political changes, workers had better luck early in the next century, when the king of France and the count of Flanders went to war. The workers (who supported the count) defeated the French forces at the battle of Courtrai in 1302. Thereafter the patricians, who had sided with the king, were at least partly replaced by artisans in the apparatus of Flemish town governments. In the early fourteenth century, Flemish cities had perhaps the most inclusive governments of Europe.

Map 7.4 (facing page): Piacenza, Late Thirteenth Century

Similar population growth and urban rebellions beset the northern Italian cities. (See Map 7.4 for the ballooning of the walls at Piacenza, a fair measure of its expanding population. Each successive wall meant in large measure the dismantling of the older one.) Italian cities were torn into factions that defined themselves not by loyalties to a king or a count (as in Flanders) but rather by adherence to either the pope or the emperor. "Outsiders," they nevertheless affected inter-urban politics. City factions often fought under the party banners of the Guelfs (papal supporters) or the Ghibellines (imperial supporters), even though for the most part they were waging very local battles. As in the Flemish cities, the late thirteenth century saw a movement by the Italian urban lower classes to participate in city government. The *popolo* ("people") who demanded the changes was in fact made up of many different groups, including crafts and merchant guildsmen, fellow parishioners, and even members of the commune. The *popolo* acted as a sort of alternative commune within the city, a sworn association dedicated to upholding the interests of its members. Armed and militant, the *popolo* demanded a say in matters of government, particularly taxation.

While no city is "typical," the case of Piacenza may serve as an example. Originally dominated by nobles, the commune of Piacenza granted the *popolo*—led by a charismatic nobleman from the Landi family—a measure of power in 1222, allowing the *popolo* to take over half the governmental offices. A year later the *popolo* and the nobles worked out a plan to share the election of their city's *podestà*, or governing official. Even so, conflict flared up periodically: in 1224, 1231, and again in 1250, when a grain shortage provoked protest:

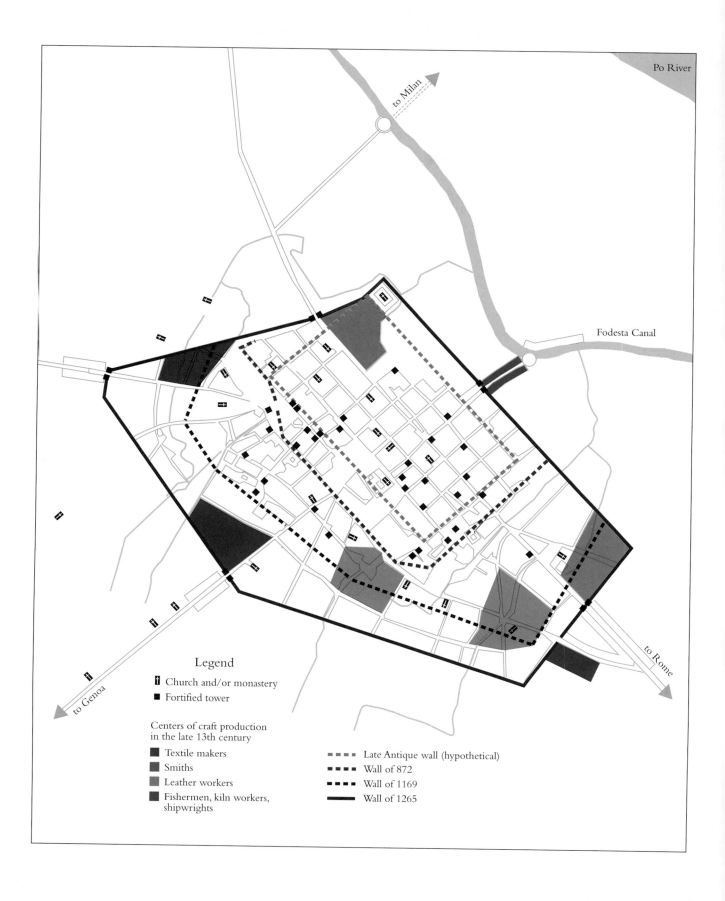

Po River

to Milan

Fodesta Canal

to Genoa

to Rome

Legend

✝ Church and/or monastery

■ Fortified tower

Centers of craft production
in the late 13th century

■ Textile makers

■ Smiths

■ Leather workers

■ Fishermen, kiln workers,
shipwrights

- - - Late Antique wall (hypothetical)
- - - Wall of 872
- - - Wall of 1169
──── Wall of 1265

In 1250 the common people of Piacenza saw that they were being badly treated regarding foodstuffs: first, because all the corn [grain] that had been sent from Milan, as well as other corn in Piacenza, was being taken to Parma ... [and] second because the Parmesans were touring Piacentine territory buying corn from the threshing floors and fields.... The Parmesans could do this in safety because Matteo da Correggio, a citizen of Parma, was podestà of Piacenza.[2]

In this case, too, members of noble families took the lead in the uprising, but this time the *popolo* of Piacenza divided into factions, each supporting a different competing leader. Eventually one came to the fore—Alberto Scotti, from a family deeply immersed in both commerce and landholding. In 1290 he took over the city, gaining the grand title of "defender and rector of the commune and the society of merchants and craft guilds and of all the *popolo*."[3] He was, in short, a lord, a *signore* (pl. *signori*). Map 7.4 shows some of the features of Piacenza in his day: concentrated centers of craft production, a new wall built in 1265 to enclose most of the population, an impressive number of churches and monasteries, and a generous sprinkling of private towers put up by proud and often warring members of the nobility.

A similar evolution—from commune to the rule of the *popolo* and then to the rule of a *signore*—took place in cities throughout northern Italy and in much of Tuscany as well. It was as if the end of imperial rule in Italy, marked by the fall of Frederick II, ironically brought in its train the creation of local monarchs—the *signori*, who maintained order at the price of repression. By 1300 the commune had almost everywhere given way to the *signoria* (a state ruled by a *signore*), with one family dominating the government.

XENOPHOBIA

Urban discord was fairly successfully defused in Flanders, fairly well silenced in Italy. In neither instance was pluralism valued. Europeans had no interest in hearing multiple voices; rather, they were eager to purge and purify themselves of the pollutants in their midst.

Driving the Jews from the Ile-de-France in the twelfth century (see p. 233) was a dress rehearsal for the expulsions of the thirteenth. In England during the 1230s and 1250s, local lords and municipal governments expelled the Jews from many cities. At the same time, King Henry III (r.1216–1272) imposed unusually harsh taxes on them. (For the English kings of this period, see Genealogy 6.1 on p. 202.) By the end of Henry's reign, the Jews were impoverished and their numbers depleted. There were perhaps 3,000 Jews in all of England when King Edward I (r.1272–1307) drew up the *Statute of the Jewry* in 1275, stipulating that they end the one occupation that had been left open to them: moneylending. They were expected to "live by lawful trade and by their labor."[4] But, as the Jews responded in turn, they would be forced to buy and sell at higher prices than Christians, and thus would sell nothing. Fifteen years later Edward expelled them from England entirely.

The story was similar in France. (For the French kings, see Genealogy 8.1 on p. 291.) King Louis IX (r.1226–1270), later canonized as Saint Louis, reportedly could not bear to look at a Jew and worried that their "poison" might infect his kingdom. In 1242, he presided over the burning of two dozen cartloads of the ancient rabbinic Bible commentaries known as the Talmud. Actively promoting the conversion and baptism of Jews, Louis offered converts pensions, new names, and an end to special restrictions. His grandson, Philip IV ("The Fair") (r.1285–1314), gave up on conversion and expelled the Jews from France in 1306. By contrast with England, the French Jewish population had been large; after 1306, perhaps 125,000 French men, women, and children became refugees in the Holy Roman Empire, Spain, and Italy. The few who were later allowed to return were wiped out in popular uprisings in the early 1320s.

Some anti-Jewish movements linked the Jews with lepers. Occupying a profoundly ambivalent place in medieval society, lepers were both revered and despised. Saint Louis used to feed the lepers who came to him, and he supported *leprosaria*, houses to care for them. Saint Francis was praised for ministering to lepers and was admired for kissing them on their hands and mouths. Yet at the same time, lepers were thought to be tainted by horrible sin; they were made to carry a bell as they moved about to alert everyone to their ominous presence; their rights to private property were restricted; and, through rituals of expulsion, they were condemned to live apart from normal people, never "to eat or drink in any company except that of lepers."[5] In the south of France in the 1320s, lepers were accused of horrific crimes: of poisoning the wells and streams, like Jews, to whom they gave consecrated hosts for their wicked rites. Hauled in by local officials, the lepers were tortured, made to confess, and then burned.

Only by comparison with lepers does the revulsion against beggars seem mild. Like leprosy, poverty too was thought to have its social uses. Certainly the mendicants like the Franciscans and Dominicans, who went about begging, were understood to be exercising the highest vocation. And even involuntary beggars were thought (and expected) to pray for the souls of those who gave them alms. Nevertheless the sheer and unprecedented number of idle beggars led to calls for their expulsion.

No group, however, suffered social purging more than heretics. Beginning in the thirteenth century, church inquisitors, aided by secular authorities, worked to find and extirpate heretics from Christendom. The inquisition was a continuation (and expansion) of the Albigensian Crusade by other means. Working in the south of France, the mid-Rhineland, and Italy, the inquisitors began their scrutiny in each district by giving a sermon and calling upon heretics to confess. Then the inquisitors granted a grace period for heretics to come forward. Finally, they called suspected heretics and witnesses to inquests, where they were interrogated:

Asked if she had seen Guillaume [who was accused of being a heretic] take communion [at Mass] or doing the other things which good and faithful Christians are accustomed to do, [one of Guillaume's neighbors] responded that for the past twelve years she had lived in the village of Ornolac and she had never seen Guillaume take communion.[6]

Often imprisonment, along with both physical and mental torture, was used to extract a confession. Then penalties were assigned. Bernard Gui, an inquisitor in Languedoc from 1308 to 1323, gave out 633 punishments; nearly half involved imprisonment. A few heretics were required to go on penitential pilgrimages. Forty-one people (6.5 per cent of those punished by Bernard) were burned alive. Many former heretics were forced to wear crosses sewn to their clothing, rather like Jews, but shamed by a different marker.

STRENGTHENED MONARCHS AND THEIR ADAPTATIONS

The impulse behind "purification" was less hatred than the exercise of power. Expelling the Jews meant confiscating their property and calling in their loans while polishing an image of zealous religiosity. Burning lepers was one way to gain access to the assets of *leprosaria* and claim new forms of hegemony. Imprisonment and burning put heretics' property into the hands of secular authorities. Yet even as kings and other great lords manipulated the institutions and rhetoric of piety and purity for political ends, they learned how to adapt to, mollify, and use—rather than stamp out—new and up-and-coming classes. As their power increased, they came to welcome the broad-based support that representative institutions afforded them.

All across Europe, from Spain to Poland, from England to Hungary, rulers summoned parliaments. Growing out of ad hoc advisory sessions that kings and other rulers held with the most powerful people in their realms, parliaments became solemn and formal assemblies in the thirteenth century, moments when rulers celebrated their power and where the "orders"—clergy, nobles, and commons—assented to their wishes. Eventually parliaments became organs through which groups not ordinarily at court could articulate their interests.

The orders (or "estates") were based on the traditional division of society into those who pray, those who fight, and those who work. Unlike modern classes, defined largely by economic status, medieval orders cut across economic boundaries. The clerics, for example, included humble parish priests as well as archbishops; the commons included wealthy merchants as well as impoverished peasants. That, at least, was the theory. In practice, rulers did not so much command representatives of the orders to come to court as they summoned the most powerful members of their realm, whether clerics, nobles, or important townsmen. Above all they wanted support for their policies and tax demands.

Spanish *Cortes*

The *cortes* of the Spanish kingdoms of Castile and León were among the earliest representative assemblies called to the king's court and the first to include townsmen. (For these kingdoms, see Map 7.5, but by the date of that map, *c.*1300, Castile and León had been

united (1230) and was known as Castile.) As the *reconquista* pushed southward across the Iberian peninsula, Christian kings called for settlers to occupy the new frontiers. Enriched by plunder, fledgling villages soon burgeoned into major commercial centers. Like the cities of Italy, Spanish towns dominated the countryside. Their leaders—called *caballeros villanos*, or "city horsemen," because they were rich enough to fight on horseback—monopolized municipal offices. In 1188, when King Alfonso IX (r. 1188–1230) summoned townsmen to the *cortes* for the first time on record, the city *caballeros* served as their representatives, agreeing to Alfonso's plea for military and financial support and for help in consolidating his rule. Once convened at court, these wealthy townsmen joined bishops and noblemen in formally counseling the king and assenting to royal decisions. Beginning with Alfonso X (r. 1252–1284), Castilian monarchs regularly called on the *cortes* to participate in major political and military decisions and to assent to new taxes to finance them.

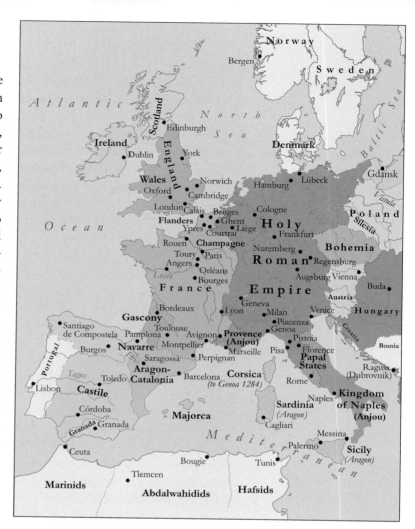

Map 7.5: Western Europe, c. 1300

Local Solutions in the Empire

In 1356 the so-called Golden Bull freed imperial rule from the papacy but at the same time made it dependent on the German princes. The princes had always had a role in ratifying the king and emperor; now seven of them were given the role and title of "electors." When a new emperor was to be chosen, each prince knew in which order his vote would be called, and a majority of votes was needed for election.

After the promulgation of the Golden Bull, the royal and imperial level of administration was less important than the local. Yet every local ruler had to deal with the same two classes on the rise: the townsmen (as in Castile and elsewhere) and a group particularly important in Germany, the ministerials. The ministerials were legally serfs whose services—collecting taxes, administering justice, and fighting wars—were so honorable as to garner them both high status and wealth. By 1300 they had become "nobles" in every way but one: marriage. In the 1270s at Salzburg, for example, the archbishop required his ministerials to swear that they would marry within his lordship or at least get his permission to marry a woman from elsewhere. Apart from this indignity (which itself was not always imposed), the ministerials, like other nobles,

profited from German colonization to become enormously wealthy landowners. Some held castles, and many controlled towns. They became counterweights to the territorial princes who, in the wake of the downfall of the Staufen, had expected to rule unopposed. In Lower Bavaria in 1311, for example, when the local duke was strapped for money, the nobles, in tandem with the clergy and the townsmen, granted him his tax but demanded in return recognition of their collective rights. The privilege granted by the duke was a sort of Bavarian Magna Carta. By the middle of the fourteenth century, princes throughout the Holy Roman Empire found themselves negotiating periodically with various noble and urban leagues.

English Parliament

In England, the consultative role of the barons at court had been formalized by the guarantees of Magna Carta. When Henry III (r. 1216–1272) was crowned at the age of nine, a council consisting of a few barons, professional administrators, and a papal legate governed in his name. Although not quite "rule by parliament," this council set a precedent for baronial participation in government. Once grown up and firmly in the royal saddle, Henry so alienated barons and commoners alike by his wars, debts, favoritism, and lax attitude toward reform that the barons threatened rebellion. At Oxford in 1258, they forced Henry to dismiss his foreign advisers (he had favored the Lusignans, from France). He was henceforth to rule with the advice of a Council of Fifteen, chosen jointly by the barons and the king, and to limit the terms of his chief officers. Yet even this government was riven by strife, and civil war erupted in 1264. At the battle of Lewes in the same year, the leader of the baronial opposition, Simon de Montfort (c. 1208–1265), routed the king's forces, captured the king, and became England's *de facto* ruler.

By Simon's time the distribution of wealth and power in England had changed from the days of Magna Carta. Well-to-do merchants in the cities could potentially buy out most knights and even some barons many times over. Meanwhile, in the rural areas, the "knights of the shire" as well as some landholders below them were rising in wealth and standing. These ancestors of the English gentry were politically active: the knights of the shire attended local courts and served as coroners, sheriffs, and justices of the peace, a new office that gradually replaced the sheriff's. The importance of the knights of the shire was clear to Simon de Montfort, who called a parliament in 1264 that included them; when he summoned another parliament in 1265, he added, for the first time ever, representatives of the towns—the "commons." Even though Simon's brief rule ended that very year and Henry's son Edward I (r. 1272–1307) became a rallying point for royalists, the idea of representative government in England had emerged, born of the interplay between royal initiatives and baronial revolts. Under Edward, parliament met fairly regularly, a by-product of the king's urgent need to finance his wars against France, Wales, and Scotland. "We strictly require you," he wrote in one of his summonses to the sheriff of Northamptonshire,

to cause two knights from [Northamptonshire], two citizens from each city in the same county, and two burgesses from each borough, of those who are especially discreet and capable of laboring, to be elected without delay, and to cause them to come to us [at Westminster].[7]

French Monarchs and the "Estates"

French King Louis IX, unlike Henry III, was a born reformer. He approached his kingdom as he did himself: with zealous discipline. As an individual, he was (by all accounts) pious, dignified, and courageous. He attended church each day, diluted his wine with water, and cared for the poor and sick (we have already seen his devotion to lepers). Hatred of Jews and heretics followed as a matter of course. Twice Louis went on crusade, dying on the second expedition.

Generalized and applied to the kingdom as a whole, Louis's discipline meant doling out proper justice to all. As the upholder of right in his realm, Louis pronounced judgment on some disputes himself—most famously under an oak tree in the Vincennes forest, near his palace. This personal touch polished Louis's image, but his wide-ranging administrative reforms were more fundamentally important for his rule. Most cases that came before the king were not, in fact, heard by him personally but rather by professional judges in the *Parlement*, a newly specialized branch of the royal court.[8] Louis also created a new sort of official, the *enquêteurs*: like the *missi dominici* of Charlemagne's day, they traveled to the provinces to hear complaints about the abuses of royal administrators. At the same time, Louis made the seneschals and *baillis*, local officials created by Philip Augustus, more accountable to the king by choosing them directly. They called up the royal vassals for military duty, collected the revenues from the royal estates, and acted as local judges. For the administration of the city of Paris, which had been lax and corrupt, Louis found a solution in the joint rule of royal officials and citizens.

There were discordant voices in France, but they were largely muted and unrecognized. Paris may have been governed by a combination of merchants and royalists, but at the level of the royal court no regular institution spoke for the different orders. This began to change only under Louis's grandson, Philip IV the Fair (r.1285–1314). When Philip challenged the reigning pope, Boniface VIII (1294–1303), over rights and jurisdictions (see below for the issues), he felt the need to explain, justify, and propagandize his position. Summoning representatives of the French estates—clergy, nobles, and townspeople—to Paris in 1302, Philip presented his case in a successful bid for support. In 1308 he called another representative assembly, this time at Tours, to ratify his actions against the Templars—the crusading order that had served as *de facto* bankers for the Holy Land. Philip had accused the Templars of heresy, arrested their members, and confiscated their wealth. He wanted the estates to applaud him, and he was not disappointed. These assemblies, ancestors of the French Estates General, were convened sporadically until the

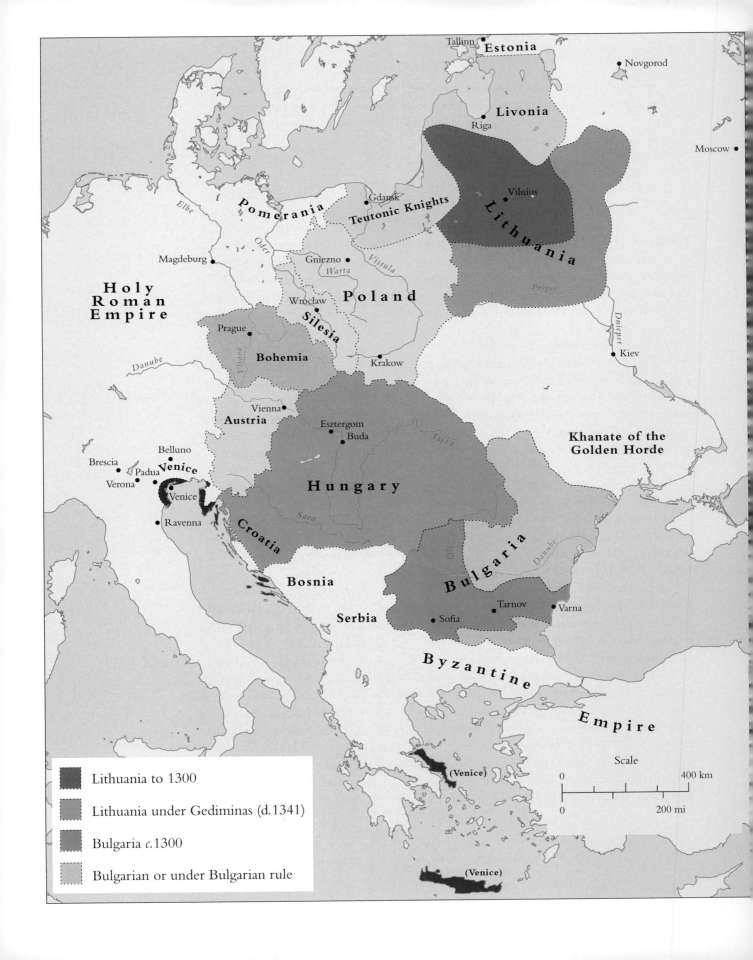

Tallinn **Estonia**

Novgorod

Livonia

Riga

Moscow

Lithuania

Vilnius

Pomerania

Gdansk **Teutonic Knights**

Elbe

Magdeburg *Oder* Gniezno *Vistula*

Warta

Holy Roman Empire

Wrocław **Poland**

Pripet

Silesia

Prague **Bohemia**

Vltava

Krakow

Kiev

Dnieper

Danube

Vienna

Austria

Esztergom

Buda

Tisza

Khanate of the Golden Horde

Belluno

Brescia **Venice**

Padua

Verona Venice

Hungary

Ravenna

Sava

Olt

Croatia

Bosnia

Bulgaria

Danube

Serbia

Tarnov Varna

Sofia

Byzantine

(Venice)

Empire

Scale

0 400 km

0 200 mi

(Venice)

(Venice)

Lithuania to 1300

Lithuania under Gediminas (d. 1341)

Bulgaria *c.* 1300

Bulgarian or under Bulgarian rule

Revolution of 1789 overturned the monarchy. Yet representative institutions were never fully or regularly integrated into the pre-revolutionary French body politic.

New Formations in East Central Europe

Like a kaleidoscope—the shards shuffling before falling into place—East Central Europe was shaken by the Mongol invasions and then stabilized in a new pattern. (See Map 7.6.) In Hungary, King Béla IV (r.1235–1270) complained that the invaders had destroyed his kingdom: "most of the kingdom of Hungary has been reduced to a desert by the scourge of the Tartars," he wrote, begging the pope for help.[9] But the greatest danger to his power came not from the outside but from the Hungarian nobles, who began to build castles for themselves—in a move reminiscent of tenth-century French castellans. The nobles eventually elected an Angevin—Charles Robert, better known as Carobert (r.1308–1342)—to be their king. Under Carobert, Hungary was very large, even though the region controlled by the king was quite small.

Bulgaria and Poland experienced similar fragmentation in the wake of the Mongols. At the end of the twelfth century, Bulgaria had revolted against Byzantine rule and established the Second Bulgarian Empire. Its ruler, no longer harking back to the khans, took the title tsar, Slavic for "emperor." He wanted his state to rival the Byzantines in other ways as well. In the early thirteenth century, for example, when crusaders had taken Constantinople and Byzantine power was at a low ebb, Tsar Ivan Asen II (r.1218–1241) expanded his hegemony over neighboring regions. Making a bid for enhanced prestige, he seized the relics of the popular Byzantine saint Paraskeve and brought them to his capital city. She became the patron saint of Bulgaria, where she was known as Saint Petka: "The great Tsar Ivan Asen," wrote Petka's admiring biographer, "heard about the miracles of the saint and strongly desired to transport the body of the saint to his land. … He wanted neither silver nor precious stones, but set off with diligence and carried the saintly body to his glorious [imperial city of] Tarnov."[10] It was a great triumph. But the Mongol invasions hit Bulgaria hard, and soon its neighbors were gnawing away at its borders. Meanwhile, its nobles—the boyars—began to carve out independent regional enclaves for themselves. Nevertheless, by the early fourteenth century agreements with the Byzantines and Mongols brought territories both north and south back under Bulgarian control.

In Poland, as one author put it, "as soon as the pagans [the Mongols] entered this land, and did much in it that was worthy of lament, and after the celebrated Duke [Henry II] was killed, this land was dominated by knights, each of whom seized whatever pleased him from the duke's inheritances."[11] The author was abbot of a monastery in Silesia, which in his day—the mid-thirteenth century—was ruled by a branch of the Piast ducal dynasty, as were other Polish territories. He looked back with nostalgia to the days of Henry II, when one Piast duke ruled over all. In fact, a centralized Poland was gradually reconstructed, not least by Casimir III the Great (r.1333–1370), but this time it looked eastward to Rus' and Lithuania rather than westward to Silesia and Bohemia.

Map 7.6 (facing page): East Central Europe, *c.*1300

It made sense to veer in Lithuania's direction: there Duke Gediminas (r.*c.*1315/1316–1341), while he himself had not formally converted, favored Christian missionaries and encouraged merchants from Germany and Rus' to settle in his duchy and build churches representing both Roman and Byzantine forms of worship. Declaring war against the Teutonic Knights, he took Riga and pressed yet farther eastward and southward. By the time of his death, Lithuania was the major player in Eastern Europe. Gediminas's heirs (known as the Jagiellon dynasty) expanded still further into Rus'.

On the other, western edge of East Central Europe, Bohemia, too, became a power-house. Taking advantage of the weak position of the German emperors, Bohemia's rulers now styled themselves "king." Ottokar II (r.1253–1278) and his son Vaclav II (r.1283–1305) welcomed settlers from Germany and Flanders and took advantage of newly discovered silver mines to consolidate their rule. Charles IV (r.1347–1378) even became Holy Roman Emperor. At the same time, however, Czech nobles, who had initially worked as retainers for the dukes and depended on ducal largesse, now became independent lords who could bequeath both castles and estates to their children.

Despite their differences, the polities of East Central Europe *c.*1300 were all (some more, some less so) starting to resemble Western European states. They had begun to rely on written laws and administrative documents; their nobles were becoming landlords and castellans; their economies were increasingly urban and market-oriented; their constitutions were defined by charters reminiscent of Magna Carta; and their kings generally ruled with the help of representative institutions of one sort or another. All—except for Lithuania until Gediminas's death—were officially Christian, and even Lithuania under Gediminas supported Christian institutions like monasteries, churches, and friaries. Universities, the symbolic centers of Western European culture, were transplanted east-ward in quick succession: one was founded at Prague in 1348, another at Krakow in 1364, and a third at Vienna in 1365.

THE CHURCH MILITANT, HUMILIATED, AND REVAMPED

On the surface, the clash between Philip the Fair and Boniface VIII seemed yet one more episode in the ongoing struggle between medieval popes and rulers for power and authority. But by the end of the thirteenth century the tables had turned: the kings had more power than the popes, and the confrontation between Boniface and Philip was one sign of the dawning new principle of national sovereignty.

The Road to Avignon

The issue that first set Philip and Boniface at loggerheads involved the English king Edward I as well: taxation of the clergy. Eager to finance new wars, chiefly against one another

but also elsewhere (Edward, for example, conquered Wales and tried, unsuccessfully, to subdue Scotland), both monarchs needed money. When the kings financed their wars by taxing the clergy along with everyone else (as if they were going on crusade), Boniface reacted. In the bull *Clericis laicos* (1296), he declared that all clerics who paid and all laymen who imposed payments without prior authorization from the pope "shall, by the very act, incur the sentence of excommunication."[12]

Reacting swiftly, the kings soon forced Boniface to back down. But in 1301, testing his jurisdiction in southern France by arresting Bernard Saisset, the bishop of Pamiers, on a charge of treason, Philip precipitated another crisis. Boniface responded with outrage, but we already know (see p. 255) how Philip adroitly rallied public opinion in his favor by calling the Estates together. After Boniface issued the bull *Unam sanctam* (1302), which declared that "it is altogether necessary to salvation for every human being to be subject to the Roman Pontiff,"[13] Philip's agents invaded Boniface's palace at Anagni (southeast of Rome) to capture the pope, bring him to France, and try him for heresy. Although the citizens of Anagni drove the agents out of town, Philip's power could not be denied. A month later, Boniface died, and the next two popes quickly pardoned Philip and his agents.

The papacy was never quite the same thereafter. In 1309, forced from Rome by civil strife, the popes settled at Avignon, a Provençal city administered by the Angevins of Naples but very much under the influence of the French crown. There they remained until 1377. The Avignon Papacy, largely French, established a sober and efficient organization that took in regular revenues and gave the papacy more say than ever before in the appointment of churchmen and the distribution of church benefices and revenues. Its authority grew: it became the unchallenged judge of sainthood. And the Dominicans and Franciscans became its foot soldiers in the evangelization of the world and the purification of Christendom. These were tasks that required realistic men. When a group of Franciscans objected to their fellows building convents and churches within the cities, the popes condemned them. The Spirituals, as they were called, cultivated a piety of poverty and apocalypticism, believing that Saint Francis had ushered in a new Age of the Holy Spirit. But the popes interpreted the Franciscan rule differently. They advocated the repression of the Spirituals and even had a few burned at the stake.

In some ways, the papacy had never been as powerful as it was at Avignon. On the other hand, it was mocked and vilified by contemporaries, especially Italians, whose revenues suffered from the popes' exile from Rome. Petrarch (Francesco Petrarca, 1304–1374), one of the great literary figures of the day, called the Avignon Papacy the "Babylonian Captivity," referring to 2 Kings 25:11, when the ancient Hebrews were exiled and held captive in Babylonia. Pliant and accommodating to the rulers of Europe, especially the kings of France, the popes were slowly abandoning the idea of leading all of Christendom and were coming to recognize the right of secular states to regulate their internal affairs.

Following page:

Plate 7.1: Chalice (*c.*1300). This gilded silver chalice, one of a pair made in the Rhineland, graphically shows the connection between the wine of the Eucharist and Christ's blood. On a large knob just below the cup, the goldsmith has placed medallions stamped with Christ's head alternating with rosettes that represent the five wounds of Christ. Each rosette sprouts a vine tendril that spreads its leaves on the base of the chalice, reminding communicants of the grapes that were pressed into the wine.

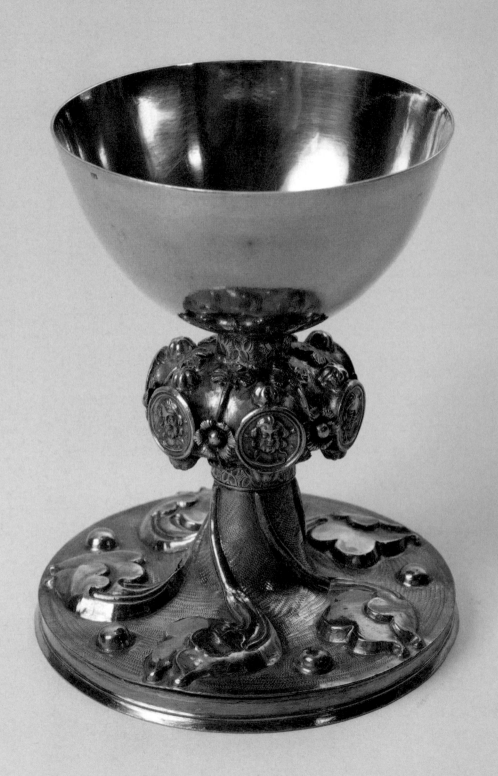

Lay Religiosity

Secular states, yes; but their populations took religion very seriously. With the doctrine of transubstantiation (see p. 230), Christianity became a religion of the body: the body of the wafer of the Mass, the body of the communicant who ate it, and equally the body of the believers who celebrated together in the feast of Corpus Christi (the Body of Christ). Eucharistic piety was already widespread in the most urbanized regions of Europe, when Juliana of Mont Cornillon (1193–1258), prioress of a convent in the Low Countries, announced that Christ himself wanted a special day set aside to celebrate his Body and Blood. Taken up by the papacy and promulgated as a universal feast, Corpus Christi was adopted throughout Western Europe. Cities created new processions for the day. Fraternities dedicated themselves to the Body of Christ, holding their meetings on the feast day, focusing their regular charity on bringing the *viaticum* (or final Eucharist) to the dying. Dramas were elaborated on the theme. Artists decorated the chalices used in the Mass with symbols that made the connection between the wine and the very blood that Christ had shed on the cross. (See Plate 7.1.)

Along with new devotion to the flesh of Christ came devotion to his mother. In the hands of the Sienese painter Pietro Lorenzetti (*c.*1280/90–1348), for example, Mary's life took on lively detail. In Plate 7.2, an altarpiece depicting the Birth of the Virgin, two servants—one probably the midwife—tenderly wash the infant Mary. Her mother, clearly modeled on the mistress of a well-to-do Italian household, sits up in bed, gazing at the child with dreamy eyes, while, in another room, a little serving boy whispers news of the birth to the expectant father.

Both publicly, in feasts dedicated to the major events in Mary's life, and privately, in small and concentrated images made to be contemplated by individual viewers, the Virgin was the focus of intense religious feeling. As mother of God, she was popularly carved to show the Godhead in her very womb. Called "Vièrges Ouvrantes" in French (literally: virgins that open) and Shrine Madonnas in English, these objects were often used as aids to private devotion. (See Plate 7.3, Seeing the Middle Ages: A Shrine Madonna.)

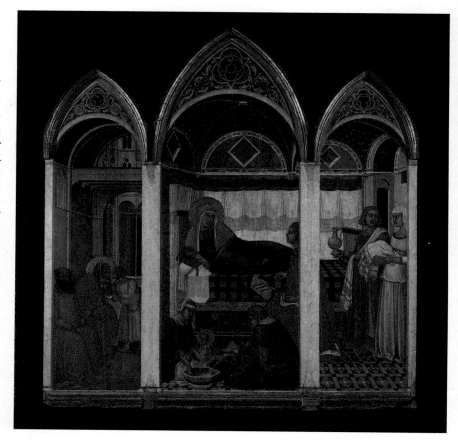

Plate 7.2: Pietro Lorenzetti, *Birth of the Virgin* (1342). This painted altarpiece creates an architectural space of real depth in which figures of convincing solidity act and interact; compare them with Saint Joseph in Plate 6.6, p. 227. Note how the ribs, rose windows, and arches of a Gothic church are used here as both decorative and unifying elements.

SEEING THE MIDDLE AGES

An outgrowth of the cult of the Virgin Mary, Shrine Madonnas became very popular throughout Europe in the later Middle Ages. Large ones stood on church altars; smaller versions, like the one here, which is about 14.5 inches high, were used as aids to private prayer and devotion. Certainly this example—from the Rhine Valley region and perhaps owned by a nun at a convent in Cologne—offers much to contemplate. Closed, it depicts at first glance a simple scene: Mary nursing the Christ Child. But Mary wears a crown, signaling that she is no ordinary mother but rather Queen of Heaven, while Christ holds a dove, the symbol of the Holy Spirit. That the statue is "about" the harmony of flesh

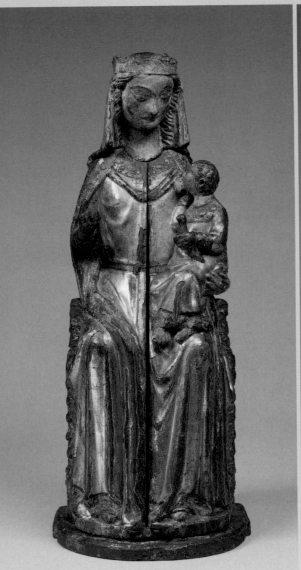
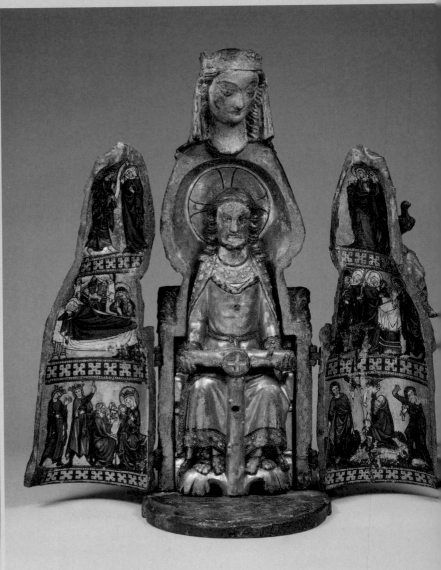

Plate 7.3: A Shrine Madonna (*c.*1300)

and spirit becomes clear when the Virgin's body is opened, revealing a seated God the Father holding a cross. The original sculpture would have included (where there are now only holes) the figure of the crucified Christ on the cross and, above him, a dove signifying the Holy Spirit. The three together—the Father, the Son, and the Holy Spirit—formed the Trinity, called, in this form, the Throne of Mercy. Flanking Christ's throne are six painted scenes of his infancy.

The statue embodies an idea that was echoed in contemporary prayers, hymns, and poetry: that Mary was not just the mother of Christ but the bearer of the entire Trinity. "Hail, mother of piety and of the whole Trinity," went one popular prayer. The Shrine Madonna physically placed the Trinity in Mary's very womb. Just as her inward parts consisted of a large central area flanked by three "compartments" on each side (the painted depictions of Christ's infancy), so, too, late medieval representations divided the womb into seven cells: a large one at the center and three small cells on each side. In Guido da Vigevano's fourteenth-century diagram of the female anatomy, for example, the uterus looks rather like a Christmas tree—or like the open Madonna.

However, Guido's conception was not nearly as complex as the Rhineland Madonna. For the side cells of *her* innards were painted with narratives that made her seem much like an "open book." On the left are, reading from top to bottom, the Annunciation (when the angel Gabriel told Mary she would give birth to God's son), the Nativity (Christ's birth), and the Adoration of the Magi. On the right are the Visitation (when the pregnant Virgin visited the equally pregnant Saint Elizabeth, mother of John the Baptist), the Presentation in the Temple (when Joseph and Mary brought Jesus to the temple to be "consecrated to the Lord"), and the Annunciation to the Shepherds. Like viewers of the fourteenth century, we are reminded not only of Christ's human beginnings on earth but also, in glancing at the central throne, of his equally divine nature. Moreover, the "cells" are in dialogue with one another across that central image. For example, the scene of the Nativity, which shows Mary stretched out on the bed on which she will give birth to Jesus, is directly opposite the Presentation, which depicts Christ lifted over an altar as he is given to Simeon. Thus the birth of Christ is paired with Christ as the "bread of life," the Eucharist of the altar. In these ways, the Shrine Madonna literally holds the Trinity in all its complexity in her very womb.

Guido da Vigevano, "The Seven Cells of the Uterus" (1345). One of many anatomical drawings in a book that offered extracts from Galen's medical works, this page represents the uterus as a self-contained organ.

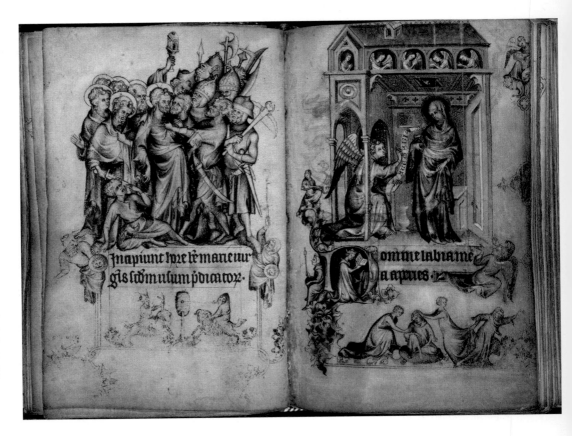

Plate 7.4: *Hours of Jeanne d'Evreux* (*c.*1325–1328). Meant for private devotion, this Book of Hours was lavishly illustrated, probably by Jean Pucelle (*c.*1300–1355). Scenes from the life of Christ, the Virgin, and King Louis IX (Jeanne's great-grandfather) contrast with delicate illustrations at the foot of each page. On the left-hand side of the two pages illustrated here is Christ's Betrayal, the moment when Judas brings soldiers and priests to capture Jesus, while Peter cuts off the ear of Malchus, the high priest's slave. This horrific moment is juxtaposed on the right with the promise of the Annunciation. Below, in delicate line-drawings, the frivolity of the world is highlighted: on the left a man on a ram and another on a goat practice jousting with a barrel; on the right, young people play a game of "frog in the middle."

Books of Hours—small prayer books for laymen and (especially) -women—almost always included images of the Virgin for worshippers to contemplate. In Plate 7.4, on the right-hand side, Jeanne d'Evreux (1301–1371), queen of France and the original owner of this Book of Hours, is shown kneeling in prayer within the initial D. This is the first letter of "Domine," "Lord," the opening word of the first prayer of the Office of the Virgin Mary. Above Jeanne is the Annunciation, when Gabriel tells Mary that she will bear the Savior.

That worship could be a private matter was part of larger changes in the ways in which people negotiated the afterlife while here on earth. The doctrine of Purgatory, informally believed long before it was declared dogma in 1274, held that the Masses and prayers of the living could shorten the purgative torments that had to be suffered by the souls of the dead. Soon families were endowing special chapels for themselves, private spaces for offering private Masses on behalf of their own members. High churchmen and wealthy laymen and -women insisted that they and members of their family be buried within the walls of the church rather than outside of it, reminding the living—via their effigies— to pray for them. Typical is the tomb of Robert d'Artois (d.1317), commissioned by his mother, Countess Mahaut d'Artois (in northern France). (See Plate 7.5.)

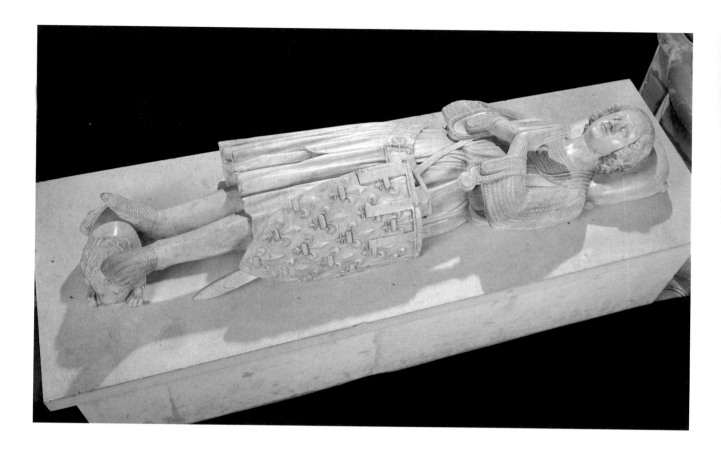

THE SCHOLASTIC SYNTHESIS AND ITS FRAYING

Widespread religiosity went hand-in-hand with increasing literacy. In some rural areas, schools for children were attached to monasteries or established in villages. In the south of France, where the church still feared heresy, preachers made sure that they taught children how to read along with the tenets of the faith. In the cities, all merchants and most artisans had some functional literacy: they had to read and write to keep accounts, and, increasingly, they owned religious books for their private devotions. In France, Books of Hours were most fashionable; Psalters were favored in England.

The broad popularity of the friars fed the institutions of higher education. Franciscans and Dominicans now established convents and churches *within* cities; their members attended the universities as students, and many went on to become masters. By the time the other theologians at the University of Paris saw the danger to their independence, the friars were too entrenched to be budged. Besides, the friars—men like Thomas Aquinas (*c.*1225–1274) and Bonaventure (*c.*1217–1274)—were unarguably the greatest of the scholastics, the scholars who mastered the use of logic to summarize and reconcile all knowledge and use it in the service of contemporary society.

Plate 7.5: Tomb and Effigy of Robert d'Artois (1317). Although Robert was only seventeen years old when he died, the sculptor of his tomb effigy, Jean Pépin de Huy, gave him a sword and buckler (the accoutrements of a knight) and placed a tame lion at his feet (the symbol of his power). At the same time, his prayerful pose and the lion alert viewers to the life to come: his uplifted hands signify Robert's piety, while the lion (mother lions were believed to waken their still-born cubs to life by their roars) recalls the hope of resurrection.

The Motet

Plate 7.6 (facing page):
The Motet *S'Amours* (*c.*1300).
Like the composer of
S'Amours, the artist of this
page (painted not long after
the music itself was written)
weaves together three separate
stories. In the S of the word
"S'Amours," which is sung
by the disconsolate lover (the
top voice), the artist presents,
by contrast with the text,
two very contented lovers
petting both animals and each
other. To the right of this
happy scene is the initial A,
the first letter of the word
"Au," which is sung by the
victorious lover of the middle
voice. Again ironically, *this*
figure is sad and lonely. By
reversing the moods of the
two voices with his pictures,
is the artist commenting
on the fickleness of love?
Beneath the "Ecce" of the
third voice is a hunting scene,
complete with stag, hound,
and hawk. The hunt was
often used as a metaphor for
amorous relations.

Already by the tenth century, the chant in unison had been joined by a chant of many voices: polyphony. Initially voice met voice in improvised harmony, but in the twelfth century polyphony was increasingly composed as well. In the thirteenth century its most characteristic form was the motet. Created at Paris, probably in the milieus of the university and the royal court, the motet harmonized the sacred with the worldly, the Latin language with the vernacular.

Two to four voices joined together in a motet. The most common sort from the second half of the thirteenth century had three voices. The lowest, often taken from a liturgical chant, generally consisted of one or two words, suggesting that it was normally played on an instrument (such as a vielle or lute) rather than sung. The second and third voices had different texts and melodies, sung simultaneously. The form allowed for the mingling of religious and secular motives. Very likely motets were performed by the clerics who formed the entourages of bishops or abbots—or by university students—for their entertainment and pleasure. In the motet *S'Amours*, whose opening music is pictured in Plate 7.6, the top voice complains (in French): "If Love had any power, I, who have served it all my life with a loyal heart, should surely have noticed." By contrast, the middle voice, also singing in French, rejoices in Love's rewards: "At the rebirth of the joyous season, I must begin a song, for true Love, whom I desire to serve, has given me a reason to sing." Meanwhile the lowest voice sings the Latin word "Ecce"—"Behold!"[15]

Complementing the motet's complexity was the development of new schemes to indicate rhythm. The most important, that of Franco of Cologne in his *Art of Measurable Song* (*c.*1260), used different shapes to mark the number of beats for which each note should be held. (See Figure 7.1; the music in Plate 7.6 uses a similar rhythmic system.) Allowing for great flexibility and inventiveness in composition, Franco's scheme became the basis of modern musical notation.

Figure 7.1: Single Notes and Values of Franconian Notation

Name and shape of note		Value (in beats)	Modern equivalent
Duplex long		6	
Perfect long		3	
Imperfect long		2	
Breve		1	
Semibreve			
Minor + major		$1/3 + 2/3$	
Three minor		$1/3 + 1/3 + 1/3$	

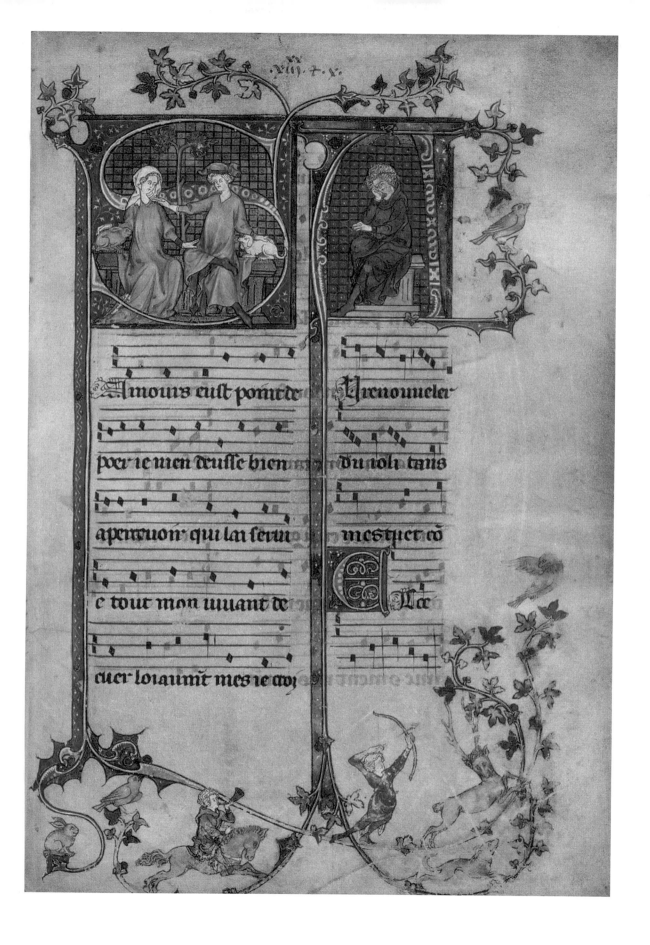

New Currents in Art

Flexibility and inventiveness describe the art of Franco's time as well. It had new patrons to serve: the urban elite. In the Paris of Saint Louis's day, for example, wealthy merchants coveted illuminated law books and romances; rich students prized illustrated Bibles as essential fashion accessories; churchmen wanted beautiful service books; the royal family wanted lavishly illustrated Bibles, Psalters, and Books of Hours; and the nobility aspired to the same books as their sovereigns. The old-fashioned *scriptoria* that had previously produced books, with scribes and artists working in the same place, gave way to specialized workshops, often staffed by laypeople. Some workshops produced the raw materials: the ink, gold leaf, or parchment; others employed scribes to copy the texts; a third kind was set up for the illuminators; and a fourth did nothing but bind the finished books. This was not mass production, however, and the styles of different artists are clear, if subtle. In Plate 7.7, the artist of one workshop has made the apostle John conform to the shape of an S, his body out of joint yet utterly elegant. But another Parisian artist working at about the same time, in a different shop and on a different book, painted a thinner John, almost ramrod straight, with a flaming head of hair. (See Plate 7.8.)

Meanwhile, in Italy, sculptors, also working in shops, were melding the sort of Gothic naturalism exemplified by Saint Joseph of Reims in Plate 6.6 (on p. 227) with the classical style of Roman sculpture we saw on the Roman sarcophagus relief of Meleager in Plate 1.4 (on p. 15 of *A Short History of the Middle Ages*, Vol. I). For the Duomo of Siena, for example, Nicola Pisano (d. before 1284) and his assistants created a baptistery pulpit composed of eight panels. The Adoration of the Magi, the panel shown in Plate 7.9, has the same dense crowds as the Meleager sarcophagus. Today all the color is gone, but originally Nicola painted the backgrounds and gilded the hemlines with gold, emphasizing details that brought the event "to life," melding the everyday world of thronging people and animals with the mystery of the divine incarnation.

Within a half-century the weighty, natural forms of the sculptors found a home in painting as well, above all in the paintings of Giotto (1266/1267–1337). In one of his commissions to decorate the private chapel of the richest man in Padua, for example, Giotto filled the walls with frescoes narrating humanity's redemption through Christ, culminating in the Final Judgment. (See Plate 7.10 on p. 274.) Throughout, Giotto experimented with the illusion of depth, weight, and volume, his figures expressing unparalleled emotional intensity as they reacted to events in the world-space created by painted frames. In the *Raising of Lazarus*, a story told in John 11:1–46 and depicted in Plate 7.11, we see the moment just after Christ has performed his miracle: Lazarus stands up, white as a sheet after four days in the grave, still bound in his winding sheet, his eyes still unseeing. Compare this depiction of the story with the one in Plate 4.2 (p. 142). As in the Ottonian portrayal, some of the Jews hold their noses and Mary and Martha bow down before Christ. But in Giotto's fresco, the figures interact as well as gesture; they operate within a fully realized landscape; and Lazarus's miracle does not undo the order of nature: he still looks dead.

maligno positus e Et scim̄
qm filius dei uenit et dedit
nob sensū ut cognoscam̄ uer
dm̄ z simul in uero filio eius.
Hic e uerus ds z uita etn̄a. Fi
lioli custodite uos a simula
cris amen. Explic̄ epla iohis .i.

Enior Incipit
electe dn̄e secd̄a
tnatis eius
qs ego diligo
i uitate z no
ego solus sz z os q cognouit
iutate xp iutate q pmanet
in nob et nobcū erit in etn̄u
sit uobiscū gra m̄ia pax a do
pre z a xpo ihu filio pris iu
tate z caritate Gauisus sum
ualde qm inueni de filiis tuis
ambulantes i uitate sic m̄a
datu accepim̄ a pre. Et nc rogo
te dn̄a no taq̄m mandatu
nouū scribens tibi sz qd hu
muis ab initio ut diligam̄
alterutru. Et hec e caritas ut
ambulem̄ secdm mandata e
hoc e eni mandatu ut quead
modū audistis ab initio in
eo ambuletis. qm multi se
ductores exierūt i mundo qi
no zfitetur ihm xpm uenisse
i carne: hic e seductor z antixpc̄

uidere nos metipos ne pdatis
qd opati estis: sz ut mcedē ple
nā accipiatis. Om̄is quirece
dit z no pmanet in doctina xpi
dm̄ no ht. Qui pmanet i doc
tina xpi hic z filiu z prem ht.
siquis uenit ad uos z hanc
doctinam n̄ affert nolite eū re
cipe in domū nec aue ei dix
tis. Qui eni dicit ei aue zmu
nicat opibz eius malignis. Et
ceptixi nob ut in die dn̄i n̄ri
ihtu xpi no esim̄ z amini plu
ra habn̄s uob scribe: nolui p car
tā z atram̄tū. spero eni me
futurū ad uos z os ad os loq̄
ut gaudiū urm sit plenū
Salutat te filii sororis tue e
lecte amen. Explic̄ epla iohis .ij.

Enior scd̄o tua.
gaio kmo q
ego diligo in
uitate kme
de oibz oro
ne facio pspere te ingredi
z ualere sicut pspe agit aia
tua. Gauisus su ualde ue
nientibz fribz z testimoniū
phibentibz uitati tue: sicut
tu i uitate ambulas. maio
rem hac no habeo letitia qm
ut audia filios meos in uer

G. om̄nis
trsgrediens
z n̄ pmans
i doctina x. zc.

G. spo n
uenire ad
uos. z os
ad os loq.

G. ita oio ht
G. karan .i.
letitiam. no
karin. idest
gram. R. ma
iorem horum
nullam inuenitur

non habeo gratiam que tu great eccl̄ie nullam inuenitur

Plate 7.8: Saint John, "Aurifaber" Bible (mid-13th cent.). An artist working at another workshop at about the same time as the artist of Plate 7.7 produced a very different Saint John, hardly curved at all. He stands in a miniature church, while beneath him is his symbol, an eagle holding a book.

Plate 7.9 (facing page): Nicola Pisano, Pulpit (1266–1268). *The Adoration of the Magi*, the scene on this panel of the Siena pulpit, was a very traditional Christian theme but here the sculptor, Nicola Pisano, has imagined it as a crowd scene and filled it with little details—like the camels—to make it "come to life."

Following page:

Plate 7.10: Giotto, Scrovegni Chapel, Padua (1304–1306). Giotto organized the Scrovegni Chapel paintings like scenes in a comic book, to be read from left to right, with the Last Judgment over the entryway.

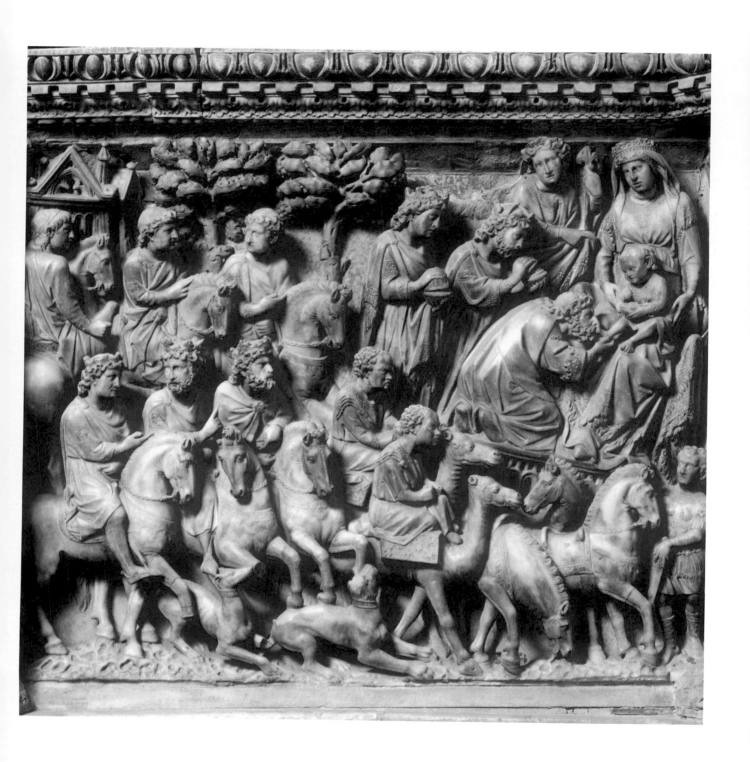

Just as Italian art was influenced by northern Gothic style, so in turn the new Italian currents went north. In France, for example, illuminators for the royal court made miniature spaces for figures in the round, creating illusions of depth. Have another look at the *Hours of Jeanne d'Evreux* (Plate 7.4 on p. 264). In the picture of Christ's Betrayal on the left-hand side, the old S-shape figures are still favored, but the soldiers who crowd around Christ are as dense and dramatic as the crowd that reacts to Lazarus in Giotto. On the right-hand page Mary, surprised by the angel of the Annunciation, sits in a space as deep as the landscape in Plate 7.11. Influenced perhaps by the look of ancient sculpted figures, relics from antiquity, the artist painted in *grisaille*, a bare gray highlighted by light tints of color.

Plate 7.11: Giotto, *Raising of Lazarus*, Scrovegni Chapel (1304–1306). Giotto brought to painting the sensibilities of a sculptor. Just as Nicola Pisano's figures (see Plate 7.9) had depth, weight, and roundness, so did Giotto's painted ones. And just as Nicola used telling details to humanize scenes from the Bible, Giotto's painting suggests the weight of the tomb cover and the varying emotions of the people at the scene.

CHAPTER SEVEN KEY EVENTS

1188	King Alfonso IX (r.1188–1230) summons townsmen to the *cortes*
1222	*Popolo* at Piacenza wins role in government
c.1225–1274	Thomas Aquinas
1226–1270	King Louis IX (Saint Louis) of France
1230s	Mongols conquer Rus'
1252	Genoa and Florence begin minting gold coins
1265	Commons included in English Parliament
1266/1267–1337	Giotto
1279	Mongols conquer China
1284	Gold ducats first minted at Venice
1290	Jews expelled from England
1291	End of the Crusader States
1309–1377	Avignon Papacy (so-called Babylonian Captivity)
1315–1317	Great Famine
1321	Death of Dante
1341	Death of Lithuanian Duke Gediminas
1356	Golden Bull promulgated in Germany

NOTES

1 *Decrees of the [Hanseatic] League*, in *Reading the Middle Ages: Sources from Europe, Byzantium, and the Islamic World*, ed. Barbara H. Rosenwein, 2nd ed. (Toronto: University of Toronto Press, 2014), p. 400.

2 *The Ghibelline Annals of Piacenza*, in *Reading the Middle Ages*, p. 398.

3 Quoted in Riccardo Rao, *Signori di popolo. Signoria cittadina e società comunale nell'Italia nord-occidentale, 1275–1350* (Milan: FrancoAngeli, 2011), p. 42.

4 *Statute of the Jewry*, in *Reading the Middle Ages*, p. 414.

5 *Sarum manual*, in *Reading the Middle Ages*, p. 413.

6 Jacques Fournier, *Episcopal Register*, in *Reading the Middle Ages*, pp. 405–6.

7 *Summons of Representatives of Shires and Towns to Parliament*, in *Reading the Middle Ages*, p. 423.

8 Despite the similarity between the terms *Parlement* and Parliament, both deriving from French *parler*, "to talk," the two institutions were different. The former was the central French court of law, the latter the English representative institution. It is true that the English Parliament did hear legal cases, but it also discussed foreign affairs, published royal statutes, and (above all) granted taxes to the king.

9 Béla IV, *Letter to Pope Innocent IV*, in *Reading the Middle Ages*, p. 382.

10 *The Short Life of St Petka (Paraskeve) of Tarnov*, in *Reading the Middle Ages*, p. 396.

11 *The Henryków Book*, in *Reading the Middle Ages*, p. 385.

12 Boniface VIII, *Clericis laicos*, in *Reading the Middle Ages*, p. 424.

13 Boniface VIII, *Unam sanctam*, in *Reading the Middle Ages*, p. 426.

14 Dante, *Inferno, Canto V (Paolo and Francesca)*, in *Reading the Middle Ages*, p. 434.

15 *The Montpellier Codex*, part IV: *Text and Translations*, trans. Susan Stakel and Joel C. Relihan, in *Recent Researches in the Music of the Middle Ages and Early Renaissance* 8 (Middleton, WI: A-R Editions, 1985), p. 81.

16 Athanasius I, *Letter*, in *Reading the Middle Ages*, p. 401.

FURTHER READING

Abulafia, David, ed. *Italy in the Central Middle Ages*. Short Oxford History of Italy. Oxford: Oxford University Press, 2004.

Given, James B. *Inquisition and Medieval Society: Power, Discipline, and Resistance in Languedoc*. Ithaca, NY: Cornell University Press, 1997.

Glick, Leonard B. *Abraham's Heirs: Jews and Christians in Medieval Europe*. Syracuse, NY: Syracuse University Press, 1999.

Jackson, Peter. *The Mongols and the West, 1221–1410*. Harlow: Pearson, 2005.

Jobson, Adrian. *The First English Revolution: Simon de Montfort, Henry III and the Barons' War*. London: Bloomsbury, 2012.

Jones, P.J. *The Italian City-State: From Commune to Signoria*. Oxford: Oxford University Press, 1997.

Jordan, William Chester. *The French Monarchy and the Jews: From Philip Augustus to the Last Capetians*. Philadelphia: University of Pennsylvania Press, 1989.

Kitsikopoulos, Harry, ed. *Agrarian Change and Crisis in Europe, 1200–1500*. New York: Routledge, 2012.

Klápště, Jan. *The Czech Lands in Medieval Transformation*. Ed. Philadelphia Ricketts. Trans. Sean Mark Miller and Kateřina Millerová. Leiden: Brill, 2012.

Martin, Janet. *Medieval Russia, 980–1584*. Cambridge: Cambridge University Press, 1995.

Mundill, Robin R. *England's Jewish Solution: Experiment and Expulsion, 1262–1290*. Cambridge: Cambridge University Press, 1998.

Nirenberg, David. *Communities of Violence: Persecution of Minorities in the Middle Ages*. Princeton, NJ: Princeton University Press, 1996.

O'Callaghan, Joseph F. *The Cortes of Castile-León, 1188–1350*. Philadelphia: University of Pennsylvania Press, 1989.

Pegg, Mark Gregory. *The Corruption of Angels: The Great Inquisition of 1245–1246*. Princeton, NJ: Princeton University Press, 2001.

Rubin, Miri. *Corpus Christi: The Eucharist in Late Medieval Culture*. Cambridge: Cambridge University Press, 1991.

Spufford, Peter. *Money and Its Use in Medieval Europe*. Cambridge: Cambridge University Press, 1988.

Strayer, Joseph R. *The Reign of Philip the Fair*. Princeton, NJ: Princeton University Press, 1980.

The Black Death

The Black Death (1346–1353), so named by later historians looking back on the disease, was caused by *Yersinia pestis*, the bacterium of the plague. Its symptoms, as an eye witness reported, included "tumorous outgrowths at the roots of thighs and arms and simultaneously bleeding ulcerations, which, sometimes the same day, carried the infected rapidly out of this present life."[1]

New research on the DNA of the microbe suggests that the disease began in China, arriving in the West along well-worn routes of trade with the Mongols. Caffa, the Genoese trading post on the northern shore of the Black Sea, was hit in 1347. From there the plague traveled to Europe and the Middle East, immediately striking Constantinople and Cairo and soon leaving the port cities for the hinterlands. In early 1348 the citizens of Pisa and Genoa, fierce rivals on the seas, were being felled without distinction by the disease. Early spring of the same year saw the Black Death at Florence; two months later it had hit Dorset in England. Dormant during the winter, it revived the next spring to infect French ports and countryside, moving on swiftly to Germany. By 1351 it was at Moscow, where it stopped for a time, only to recur in ten- to twelve-year cycles throughout the fourteenth century. (Only the attack of 1346–1353 is called the Black Death.) The disease continued to strike, though at longer intervals, until the eighteenth century. Typical was the experience of Esteve Beyneyc, a well-to-do burgher at Limoges (in southern France), who in 1426 drew up a grim list of his children's and wife's recent deaths:

> Mathivot, my son, was born Sunday evening the 16th day of the month of August in the year 1424. And Mathieu de Julien held him [over the baptismal font as godfather]. And his godmother was Valeria, my niece.... And he went to Paradise Friday morning, the 30th day of the month of August in the year 1426. And there was in that year great mortality. And at that same time my wife, his mother—may God pardon her—died there, and many [other] people. Valeria, my daughter, was born on Friday the 16th day of the month of June in the year 1424. And my son Guilhoumot held her [over the baptismal font]. And she went to Paradise on Wednesday, the 24th day of the month of July in the year 1426. And there was then great mortality.[2]

The effect on Europe's population was immediate and devastating. At Paris, by no means the city hardest hit, about half the population died, mainly children and poor people. In eastern Normandy, perhaps 70 to 80 per cent of the population succumbed. At Bologna, even the most robust—men able to bear arms—were reduced by 35 per cent in the course of 1348. Demographic recovery across Europe began only in the second half of the fifteenth century.

Deaths, especially of the poor, led to acute labor shortages in both town and country. In 1351, King Edward III (r.1327–1377) of England issued the *Statute of Laborers*, forbidding workers to take pay higher than pre-plague wages and fining employers who offered more. Similar laws were promulgated—and flouted—elsewhere. In the countryside, landlords

Plate 8.1 (facing page): Corpses Confront the Living (*c.*1441). This unusual illustration shows not only the physical confrontations between the dead and the living but also verbal exchanges written on scrolls in front of each protagonist. For example, the king (top right), proudly faces the viewer and boasts, "I am the king and the emperor and a lover of delights." But the corpse calls his bluff: "Once you ruled over nations; now you are conquered by worms."

needed to keep their profits up even as their workforce was decimated. They were obliged to strike bargains with enterprising peasants, furnishing them, for example, with oxen and seed; or they turned their land to new uses, such as pasturage. In the cities, the guilds and other professions recruited new men, survivors of the plague. Able to marry and set up households at younger ages, these *nouveaux riches* helped reconstitute the population. Although many widows were now potentially the heads of households, deeply rooted customs tended to push them either into new marriages (in northern Europe) or (in southern Europe) into the house of some male relative, whether brother, son, or son-in-law.

The plague affected both desires and sentiments. Upward mobility in town and country meant changes in consumption patterns, as formerly impoverished groups found new wealth. They chose silk clothing over wool, beer over water. In Italy, where a certain theoretical equality within the communes had restrained consumer spending, cities passed newly toughened laws to restrict finery. In Florence in 1349, for example, a year after the plague first struck there, the town crier roamed the city shouting out new or renewed prohibitions: clothes could not be adorned with gold or silver; capes could not be lined with fur; the wicks of funeral candles had to be made of cotton; women could wear no more than two rings, only one of which could be set with a precious stone; and so on. As always, such sumptuary legislation affected women more than men.

Small wonder that eventually death became an obsession and a cult. A newly intense interest in the macabre led to new artistic themes. Plate 8.1 shows one side of a manuscript folio that illustrated the various people whom death would visit sooner or later. In each of the four frames Death, personified by a corpse (outlined by its coffin and covered with the lizards, snakes, worms, maggots, and frogs that were consuming its flesh), confronts a living person. A pope is in the first box, an emperor in the next, below left is a knight, below right a burgher. On the other side of the folio page (not shown here) the corpses meet a young woman, a young man, an astrologer, and a shepherd.

Similarly, in the artistic and literary genre known as the Dance of Death, life itself became a dance with death, as men and women from every class were escorted—sooner or later—to the grave by ghastly skeletons. Blaming their own sins for the plague, penitent pilgrims, occasionally bearing whips to flagellate themselves, crowded the roads. Rumors flew, accusing the Jews of causing the plague by poisoning the wells. The idea spread from southern France and northern Spain (where, as we have seen [p. 251], similar charges had already been leveled in the 1320s) to Switzerland, Strasbourg, and throughout Germany. At Strasbourg more than 900 Jews were burned in 1349, right in their own cemetery.

Upheavals of War

"And westward, look! Under the Martian Gate," wrote the English poet Geoffrey Chaucer (c.1340–1400) in *The Canterbury Tales*, continuing,

Arcita and his hundred knights await,
And now, under a banner of red, march on.
And at the self-same moment Palamon
Enters by Venus' Gate and takes his place
Under a banner of white, with cheerful face.
You had not found, though you had searched the earth,
Two companies so equal in their worth.[3]

Chaucer's association of war with "cheer" and "valor" was a central conceit of chivalry, giving a rosy tint to the increasingly "total" wars that engulfed even civilian populations in the fourteenth and fifteenth centuries. In the East, the Ottoman Turks took the Byzantine Empire by storm; in the West, England and France fought a bitter Hundred Years' War. Dynastic feuds and princely encroachments marked a tumultuous period in which the map of Europe was remade.

THE OTTOMAN EMPIRE

The establishment of a new Islamic empire—the Ottoman—just south of the Danube River marked an astonishing transformation of Europe's southeast. (See Map 8.1.) It began very gradually in the thirteenth century, as Turkish tribal leaders carved out ephemeral principalities for themselves in the interstices between Mongol-ruled Rum and the Byzantine Empire. At the beginning of the fourteenth century, Othman (d.1324/1326), after whom the Ottomans were named, took the lead. (See the list of Ottoman Emirs and Sultans on p. 343.) About 150 years later the chronicler Ashikpashazade, looking back on Othman's achievements, stressed his wisdom, his cunning, and, above all, his legitimacy by right of *jihad*: "What does the sultan [the last Seljuk ruler of Rum] have to do with it?" the chronicler has Othman ask those who want the sultan's permission before appointing a religious leader. "It is true that the sultan endowed me with this banner. But it is I who carried the banner into battle with the infidels!"[4]

Attracting other Turkish princes to fight alongside him, Othman carved out a principality in Byzantium's backyard. But rather than unite in the face of these developments, rival factions within the Byzantine state tried to make use of the Ottomans. It was as ally to one claimant for the Byzantine throne that Ottoman troops arrived in Gallipoli in 1354. They remained long after their welcome had run out. In the 1360s they took Thrace, and then, under the energetic leadership of Bayezid I (r.1389–1402), they conquered much of the Balkans, taking Serbia (at the battle of Kosovo) in 1389 and Bulgaria in 1393.

To the east, the Ottoman advance was aided by the weakening of Mongol power, which began in China with the overthrow of the khanate there. To be sure, the Ottomans were halted by Timur the Lame (Tamerlane) (1336–1405), a warrior leader from the region of Samarkand, who saw himself as restoring the Mongol Empire. But with Timur's death, the Ottomans slowly regained their hold, in part because of the superiority of their elite

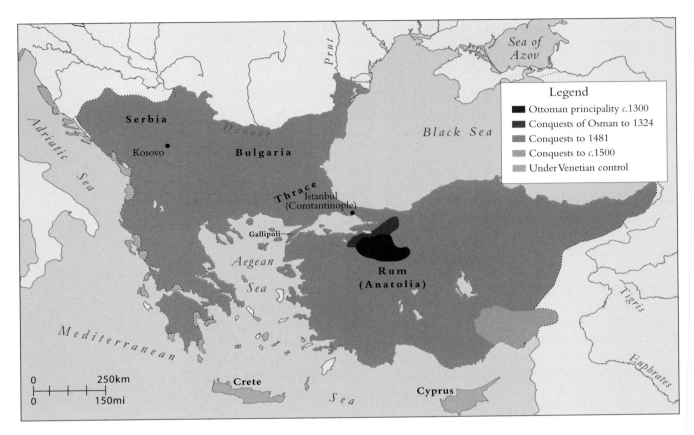

Legend
■ Ottoman principality *c.*1300
■ Conquests of Osman to 1324
■ Conquests to 1481
■ Conquests to *c.*1500
□ Under Venetian control

Map 8.1: The Ottoman Empire, *c.*1500

troops, the janissaries, professional soldiers of slave origin. Adopting the new military hardware of the west—cannons and harquebuses (heavy matchlock guns)—the Ottomans retook Anatolia and the Balkans. Under Mehmed II the Conqueror (r.1444–1446, 1451–1481), their cannons accomplished what former sieges had never done, breaching the thick walls of Constantinople in 1453 and bringing the Byzantine Empire to an end.

The new Ottoman state had come to stay. Its rise was due to its military power and the weakness of its neighbors. But its longevity—it did not begin to decline until the late seventeenth century—was due to more complicated factors. Building on a theory of absolutism that echoed similar ideas in the Christian West, the Ottoman rulers acted as the sole guarantors of law and order; they considered even the leaders of the mosques to be their functionaries, soldiers without arms. Prospering from taxes imposed on their relatively well-to-do peasantry, the new rulers spent their money on roads to ease troop transport and a navy powerful enough to oust the Italians from their eastern Mediterranean outposts. Eliminating all signs of rebellion (which meant, for example, brutally putting down Serb and Albanian revolts), the Ottomans created a new world power.

The Ottoman state eventually changed Europe's orientation. Europeans could—and did—continue to trade in the Mediterranean. But on the whole they preferred to treat

the Ottomans as a barrier to the Orient. Not long after the fall of Constantinople, as we shall see, the first transatlantic voyages began as a new route to the East.

THE HUNDRED YEARS' WAR

Although in the seventeenth century English rulers would set their sights on the Americas and the Indies, between 1350 and 1500 they were still preoccupied with older claims. The Hundred Years' War (in fact fought sporadically over more than a century, from 1337 to 1453) was the English king's bid to become ruler of France. Beyond this dynastic dispute were England's long-standing claims to Continental lands, many of which had been confiscated by Philip II of France and the rest by Philip VI in 1337. (See Map 8.2, paying particular attention to English possessions in 1337.) Beyond that were Flemish–English economic relations, to which English prosperity and taxes were tied. Ultimately, the war was not so much between England and France as between two conceptions of France: one, a centralized monarchy, the other, an association of territories ruled by counts and dukes.

As son of Isabella, the last living child of French king Philip the Fair, Edward III of England was in line for the French throne when Charles IV died in 1328. The French nobles awarded it, instead, to Philip VI, the first Valois king of France. (See Genealogy 8.1: Kings of France and England and the Dukes of Burgundy during the Hundred Years' War.) Edward's claims led to the first phase of the Hundred Years' War. Looking back on it, the chronicler Froissart tried to depict its knightly fighters as gallant protagonists:

> As soon as Lord Walter de Manny discovered … that a formal declaration of war had been made … he gathered together 40 lances [each lance being a knight, a servant, and two horses], good companions from Hainaut and England … [because] he had vowed in England in the hearing of ladies and lords that, "If war breaks out between my lord the king of England and Philip of Valois who calls himself king of France, I will be the first to arm himself and capture a castle or town in the kingdom of France."[5]

In fact knights like Walter de Manny and his men were outmoded; the real heroes of the war were the longbowmen—non-knightly fighters who, by wielding a new-style bow and arrows that flew far and penetrated deeply, gave English troops the clear advantage. By 1360, the size of English possessions in southern France was approximately what it had been in the twelfth century. (Look at Map 8.2 again, this time considering "English Possessions in 1360," and compare it with Map 6.4 on p. 206.)

English successes were nevertheless short-lived. Harrying the border of Aquitaine, French forces chipped away at it in the course of the 1380s. Meanwhile, sentiments for peace were gaining strength in both England and France; a treaty to put an end to the fighting for a generation was drawn up in 1396. Yet the "generation" was hardly grown when Henry V (r.1413–1422) came to the throne and revived England's Continental claims. Demanding nearly all of the land that the Angevins had held in the twelfth century, he

Following pages:

Map 8.2: The First Phase of the Hundred Years' War, 1337–1360

Genealogy 8.1: Kings of France and England and the Dukes of Burgundy during the Hundred Years' War

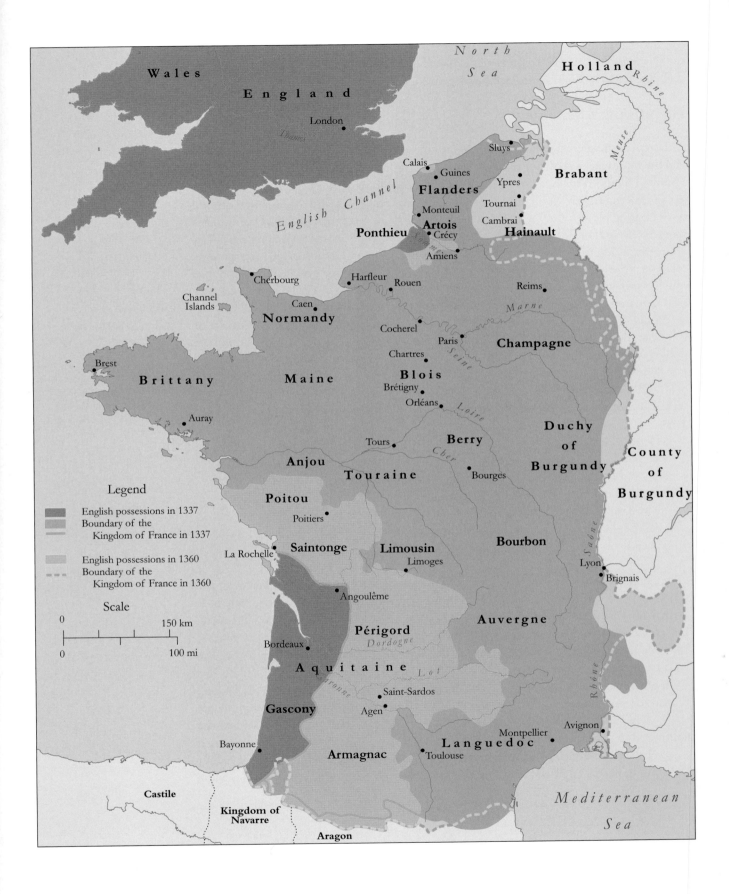

North Sea

Holland

Rhine

Wales

England

London

English Channel

Calais
Guines
Sluys

Flanders
Ypres

Brabant

Monteuil
Artois
Crécy
Tournai
Cambrai

Ponthieu
Amiens

Hainault

Meuse

Cherbourg
Harfleur
Rouen
Reims

Channel
Islands
Caen

Normandy
Cocherel
Marne

Brest

Chartres
Paris

Champagne

Brittany
Maine
Blois
Seine

Brétigny
Orléans

Auray
Tours
Berry
Loire

Duchy
of
Burgundy

County
of
Burgundy

Anjou
Cher

Touraine
Bourges

Poitou

Poitiers

Limousin
Bourbon

Saintonge
Limoges

Lyon

La Rochelle
Brignais

Saône

Angoulême

Auvergne

Périgord
Dordogne

Bordeaux

Aquitaine
Lot

Rhône

Gascony
Garonne
Saint-Sardos

Avignon

Bayonne
Agen
Montpellier
Languedoc

Armagnac
Toulouse

Castile

Kingdom of
Navarre

Aragon

*Mediterranean
Sea*

Legend

English possessions in 1337
Boundary of the
 Kingdom of France in 1337

English possessions in 1360
Boundary of the
 Kingdom of France in 1360

Scale

0 150 km

0 100 mi

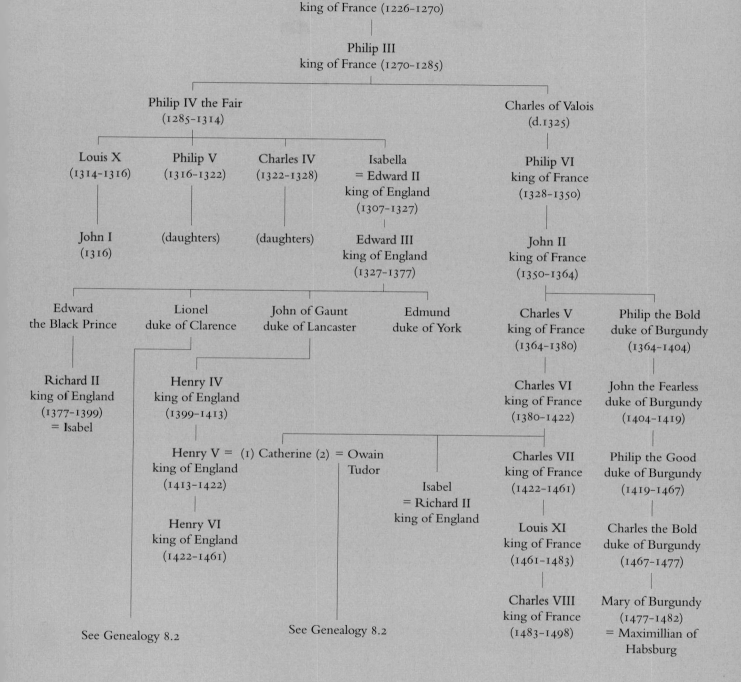

Louis IX (Saint Louis)
king of France (1226-1270)

Philip III
king of France (1270-1285)

Philip IV the Fair
(1285-1314)

Charles of Valois
(d.1325)

Louis X
(1314-1316)

Philip V
(1316-1322)

Charles IV
(1322-1328)

Isabella
= Edward II
king of England
(1307-1327)

Philip VI
king of France
(1328-1350)

John I
(1316)

(daughters)

(daughters)

Edward III
king of England
(1327-1377)

John II
king of France
(1350-1364)

Edward
the Black Prince

Lionel
duke of Clarence

John of Gaunt
duke of Lancaster

Edmund
duke of York

Charles V
king of France
(1364-1380)

Philip the Bold
duke of Burgundy
(1364-1404)

Richard II
king of England
(1377-1399)
= Isabel

Henry IV
king of England
(1399-1413)

Charles VI
king of France
(1380-1422)

John the Fearless
duke of Burgundy
(1404-1419)

Henry V =
king of England
(1413-1422)

(1) Catherine (2) = Owain
Tudor

Isabel
= Richard II
king of England

Charles VII
king of France
(1422-1461)

Philip the Good
duke of Burgundy
(1419-1467)

Henry VI
king of England
(1422-1461)

Louis XI
king of France
(1461-1483)

Charles the Bold
duke of Burgundy
(1467-1477)

See Genealogy 8.2

See Genealogy 8.2

Charles VIII
king of France
(1483-1498)

Mary of Burgundy
(1477-1482)
= Maximillian of
Habsburg

struck France in 1415 in a concerted effort to conquer both cities and countryside. Soon Normandy was Henry's, and, determined to keep it, he forced all who refused him loyalty into exile, confiscating their lands and handing the property over to his own followers. (See Map 8.3.)

Henry's plans were aided by a new regional power: Burgundy. A marvel of shrewd marriage alliances, canny purchases, and outright military conquests, the Duchy of Burgundy forged by Philip the Bold (r.1364–1404) was a cluster of principalities with one center at Dijon (the traditional Burgundy) and another at Lille, in the north (the traditional Flanders). The only unity in these disparate regions was provided by the dukes themselves, who traveled tirelessly from one end of their duchy to the other, participating in elaborate ceremonies—lavish entry processions into cities, wedding and birth festivities, funerals—and commissioning art and music that both celebrated and justified their power. (See Map 8.4.)

Map 8.3 (facing page): English and Burgundian Hegemony in France, *c.*1430

Like the kings of France, Philip the Bold was a Valois, but his grandson, Philip the Good (r.1419–1467), decided to link his destiny with England, long the major trading partner of Flanders. Thus, with the support of the Burgundians, the English easily marched into Paris, inadvertently helped by the French king, Charles VI (r.1380–1422), whose frequent bouts of insanity created a vacuum at the top of France's leadership. The Treaty of Troyes (1420) made Henry V the heir to the throne of France.

Had Henry lived, he might have made good his claim. But he died in 1422, leaving behind an infant son to take the crown of France under the regency of the duke of Bedford. Meanwhile, with Charles VI dead the same year, Charles VII, the French "dauphin," or crown prince, was disheartened by defeats. Only in 1429 did his mood change: Jeanne d'Arc (Joan of Arc), a sixteen-year-old peasant girl from Domrémy (part of a small enclave in northern France still loyal to the dauphin), arrived at Chinon, where Charles was holed up, to convince him and his theologians that she had been divinely sent to defeat the English. As she wrote in an audacious letter to the English commanders, "The Maid [as she called herself] has come on behalf of God to reclaim the blood royal. She is ready to make peace, if you [the English] are willing to settle with her by evacuating France."[6]

In effect, Jeanne inherited the moral capital that had been earned by the Beguines and other women mystics. When the English forces laid siege to Orléans (the prelude to their moving into southern France—see Map 8.3), Jeanne not only wrote the letter to the English quoted above but was allowed to join the French army. Its "miraculous" defeat of the English at Orléans (1429) turned the tide. "Oh! What an honor for the feminine sex!" wrote the poet Christine de Pisan (*c.*1364–*c.*1431), continuing,

> It is obvious that God loves it
> That all those vile people,
> Who had laid the whole kingdom to waste—
> By a woman this realm is now made safe and sound,
> Something more than five thousand men could not have done—
> And those traitors purged forever![7]

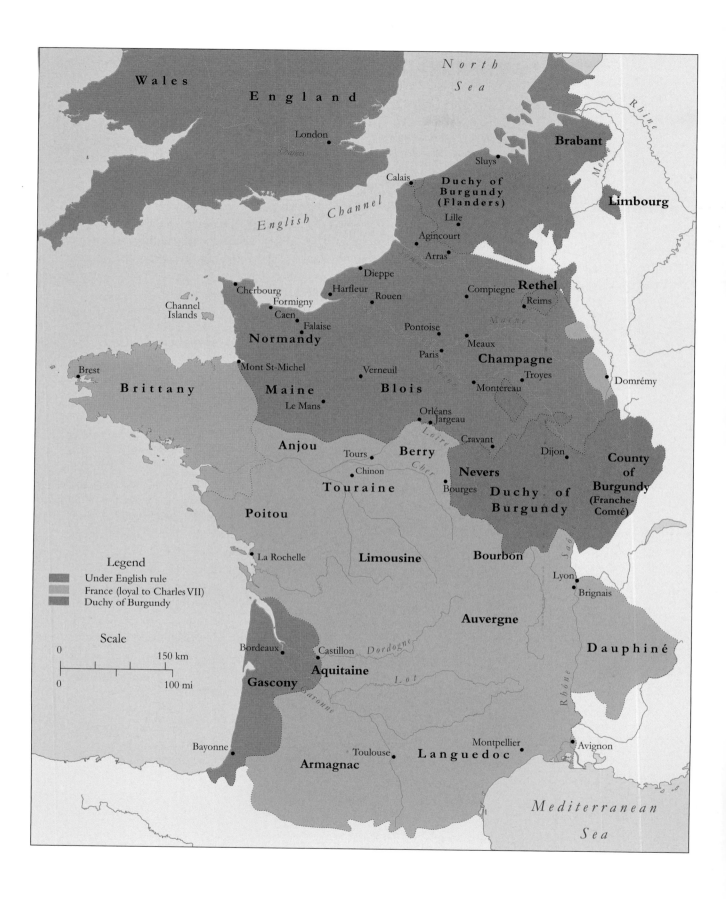

Wales

E n g l a n d

North Sea

London

Brabant

Calais

Sluys

Duchy of
Burgundy
(Flanders)

Limbourg

English Channel

Lille

Agincourt

Arras

Dieppe

Cherbourg

Formigny

Harfleur

Rouen

Compiegne

Rethel

Reims

Channel
Islands

Caen

Falaise

Pontoise

Meaux

Normandy

Paris

Champagne

Brest

Mont St-Michel

Verneuil

Troyes

Domrémy

Brittany

Maine

Blois

Montereau

Le Mans

Orléans
Jargeau

Cravant

Dijon

Anjou

Tours

Berry

Dauphiné

Chinon

Touraine

Bourges

Nevers

**County
of
Burgundy
(Franche-
Comté)**

Poitou

**Duchy of
Burgundy**

La Rochelle

Limousine

Bourbon

Lyon

Brignais

Legend

Under English rule
France (loyal to Charles VII)
Duchy of Burgundy

Auvergne

Dauphiné

Scale

0

150 km

Bordeaux

Castillon

Dordogne

0

100 mi

Aquitaine

Lot

Gascony

Bayonne

Montpellier

Avignon

Toulouse

Languedoc

Armagnac

*Mediterranean
Sea*

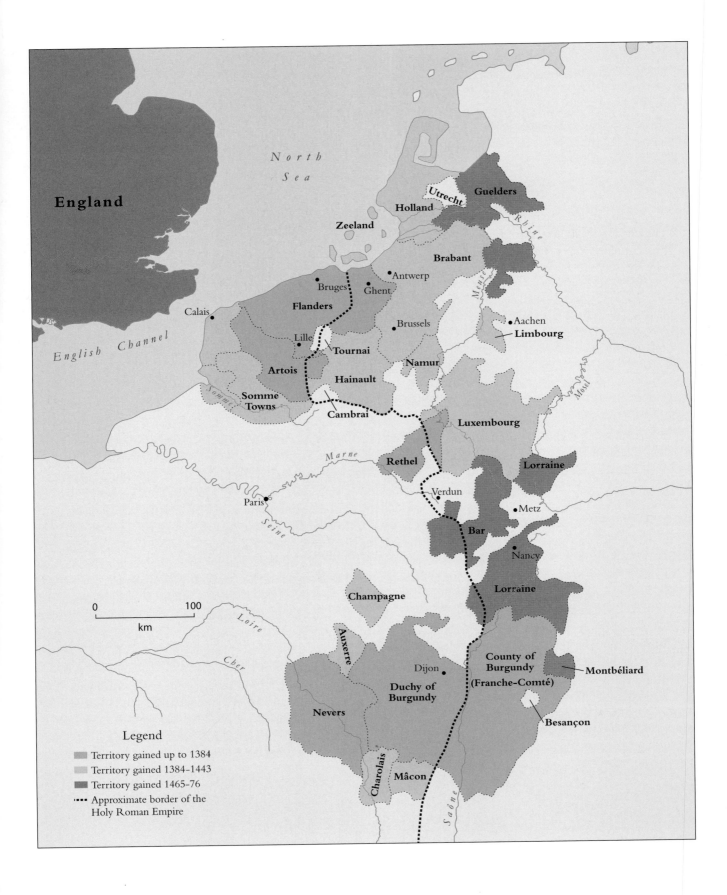

England

North
Sea

Guelders

Utrecht

Holland

Zeeland

Brabant

Antwerp

Bruges

Ghent

Flanders

Aachen

Brussels

Limbourg

Calais

English Channel

Lille

Tournai

Namur

Artois

Hainault

Cambrai

Luxembourg

Somme
Towns

Rhine

Meuse

Mosel

Marne

Rethel

Lorraine

Verdun

Metz

Paris

Seine

Bar

Nancy

Lorraine

Champagne

County of
Burgundy
(Franche-Comté)

Montbéliard

0 100

km

Loire

Cher

Auxerre

Dijon

Duchy of
Burgundy

Besançon

Nevers

Legend

Charolais

Mâcon

Saône

Territory gained up to 1384

Territory gained 1384–1443

Territory gained 1465–76

Approximate border of the
Holy Roman Empire

Soon thereafter Jeanne led Charles to Reims, deep in English territory, where he was anointed king. Captured by Burgundians in league with the English in 1430, Jeanne was ransomed by the English and tried as a heretic the following year. Found guilty, she was famously burned, eventually becoming a symbol of martyrdom as well as triumphant French resistance.

In fact it took many more years, indeed until 1453, for the French to win the war. One reason for the French triumph was their systematic use of gunpowder-fired artillery: in one fifteen-month period around 1450, the French relied heavily on siege guns such as cannons to capture more than seventy English strongholds. Diplomatic relations helped the French as well: after 1435, the duke of Burgundy abandoned the English and supported the French, at least in lukewarm fashion.

The Hundred Years' War devastated France in the short run. During battles, armies destroyed cities and harried the countryside, breaking the morale of the population. Even when not officially "at war," bands of soldiers—"Free Companies" of mercenaries that hired themselves out to the highest bidder, whether in France, Spain, or Italy—roved the countryside, living off the gains of pillage. Nevertheless, soon after 1453, France began a long and steady recovery. Merchants invested in commerce, peasants tilled the soil, and the king exercised more power than ever before. A standing army was created, trained, billeted, and supplied with weapons, including the new "fiery" artillery, all under royal command.

Burgundy, so brilliantly created a century earlier, fell apart even more quickly: Charles the Bold's expansionist policies led to the formation of a coalition against him, and he died in battle in 1477. His daughter Mary, his only heir, tried to stave off French control by quickly marrying Maximilian of Habsburg. This was only partly successful: while she brought the County of Burgundy and most of the Low Countries to the Holy Roman Empire, the French kings were able to absorb the southern portions of the duchy of Burgundy as well as the Somme Towns in the north. Soon (in 1494) France was leading an expedition into Italy, claiming the crown of Naples.

In England, the Hundred Years' War brought about a similar political transformation. Initially France's victory affected mainly the topmost rank of the royal house itself. The progeny of Edward III formed two rival camps, York and Lancaster (named after some of their lands in northern England). (See Genealogy 8.2: York and Lancastrian [Tudor] Kings.) Already in 1399, unhappy with Richard II, who had dared to disinherit him, the Lancastrian Henry had engineered the king's deposition and taken the royal scepter himself as Henry IV. But when his grandson Henry VI lost the war to France, the Yorkists quickly took advantage of the fact. A series of dynastic wars—later dubbed the "Wars of the Roses" after the white rose badge of the Yorkists and the red of the Lancastrians—was fought from 1455 to 1487. In 1461, Edward of York deposed Henry, becoming Edward IV. Upon his death in 1483 there was further intrigue as his brother, Richard III, seized the eleven-year-old Edward V and his brother, packing them off to the Tower of London, where they were soon murdered. Two years later, Richard himself was dead on the fields of Bosworth, and Henry VII, the first Tudor king, was on the throne.

Map 8.4 (facing page): The Duchy of Burgundy, 1363–1477

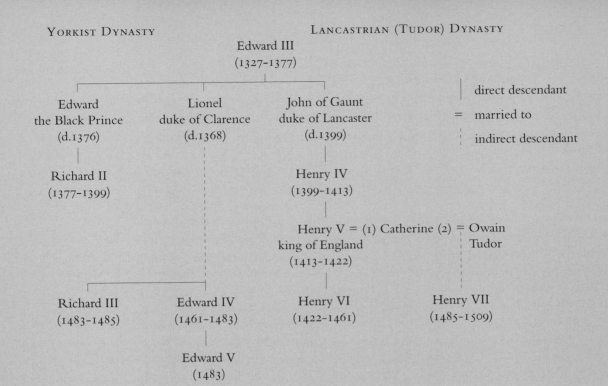

Edward III
(1327-1377)

| Edward the Black Prince (d.1376) | Lionel duke of Clarence (d.1368) | John of Gaunt duke of Lancaster (d.1399) | |

direct descendant
= married to
indirect descendant

Richard II
(1377-1399)

Henry IV
(1399-1413)

Henry V = (1) Catherine (2) = Owain
king of England Tudor
(1413-1422)

| Richard III (1483-1485) | Edward IV (1461-1483) | Henry VI (1422-1461) | Henry VII (1485-1509) |

Edward V
(1483)

Genealogy 8.2: York and Lancastrian (Tudor) Kings

All of this would later be grist for Shakespeare's historical dramas, but at the time it was more the stuff of tragedy, as whole noble lines were killed off, Yorkist lands were confiscated for the crown, and people caught in the middle longed for a strong king who would keep the peace. When the dust settled, the Tudors were far more powerful than previous English kings had ever been.

Princes, Knights, and Citizens

The Hundred Years' War, the Wars of the Roses, and other, more local wars of the fifteenth century brought to the fore a kind of super-prince: mighty kings (as in England, Scotland, and France), dukes (as in Burgundy), and *signori* (in Italy). All were supported by mercenary troops and up-to-date weaponry, putting knights and nobles in the shade. Yet the end of chivalry was paradoxically the height of the chivalric fantasy. We have already seen how delighted Froissart was by Walter de Manny's chivalric vow. Heraldry, a system of symbols that distinguished each knight by the sign on his shield, came into full flower around the same time. Originally meant to advertise the fighter and his heroic deeds on the battle-field, it soon came to symbolize his family, decorating both homes and tombs. Kings and other great lords founded and promoted chivalric orders with fantastic names—the Order of the Garter, the Order of the Golden Buckle, the Order of the Golden Fleece. All had mainly social and honorific functions, sponsoring knightly tournaments and convivial feasts precisely when knightly jousts and communal occasions were no longer useful for war.

While super-princes were the norm, there were some exceptions. In the mountainous terrain of the alpine passes, a coalition of members of urban and rural communes along with some lesser nobles promised to aid one another against the Habsburg emperors. Taking advantage of rivalries within the Holy Roman Empire, the Swiss Confederation created *c.*1500 a militant state of its own. Structured as a league, the Confederation put power into the hands of urban citizenry and members of peasant communes. The nobility gradually disappeared as new elites from town and countryside took over. Unlike the great European powers in its "republican" organization, Switzerland nevertheless conveniently served as a reservoir of mercenary troops for its princely neighbors.

Venice maintained its own republicanism via a different set of compromises. It was dominated by a Great Council from whose membership many of the officers of the state were elected, including the "doge," a life-long position. Between 1297 and 1324 the size of the Council grew dramatically: to its membership of 210 in 1296, more than a thousand new names were added by 1340. At the same time, however, the Council was gradually closed off to all but certain families, which were in this way turned into a hereditary aristocracy. Accepting this fact constituted the compromise of the lower classes. Its counterpart by the ruling families was to suppress (in large measure) their private interests in favor of the general welfare of the city. That welfare depended mainly on the sea for both necessities and wealth. Only at the end of the fourteenth century did the Venetians begin to expand within Italy itself, becoming a major land power in the region. But as it gobbled up Bergamo and Verona, Venice collided with the interests of Milan. Wars between the two city-states ended only with the Peace of Lodi in 1454. Soon the three other major Italian powers—Florence, the papacy, and Naples—joined Venice and Milan in the Italic League. (See Map 8.5.) The situation in Naples eventually brought this status quo to an end. Already in 1442 Alfonso V of Aragon had entered Naples as Alfonso I, ending Angevin rule there. A half century later, the Valois king of France's desire to reinstate French rule over Naples helped fuel his invasion of Italy in 1494.

Revolts in Town and Country

While power at the top consolidated, discontent seethed from below. Throughout the fourteenth century popular uprisings across Europe gave vent to discontent. The "popular" component of these revolts should not be exaggerated, as many were led by petty knights or wealthy burghers. But they also involved large masses of people, some of whom were very poor indeed. Although at times articulating universal principles, these revolts were nevertheless deeply rooted in local grievances.

Long accustomed to a measure of self-government in periodic assemblies that reaffirmed the customs of the region, the peasants of Flanders reacted boldly when the count's officials began to try to collect new taxes. Between 1323 and 1328, Flemish peasants drove out the officials and their noble allies, redistributing the lands that they confiscated. The peasants set up an army, established courts, collected taxes, and effectively governed themselves.

Scale

Boundary of the
Holy Roman Empire

Norway **Sweden**
Bergen
Oslo
Stockholm

North
Sea

Denmark
Copenhagen

Königsberg
(Kaliningrad)
Danzig
(Gdansk)

Baltic
Sea

Ireland
Dublin

Lancaster
York

England
London

Scotland

Lübeck
Hamburg
Bremen

Cologne

Vistula

Poland

Cracow

Ghent
Cassel
Flanders
(Burgundy)
Tournai
Arras

Brabant
(Burgundy)
Luxembourg
(Burgundy)
Mainz

Holy
Roman
Empire

Prague
Bohemia
Tabor

Atlantic

Ocean

Normandy

Seine
Paris

Brittany
Orléans

Loire

Constance

Vienna

Hungary

Danube

France

Poitiers
Bourges

Burgundy

Franche-
Comté
(Burgundy)

Swiss
Confeder-
ation

Bergamo

Duchy
of Milan
Milan
Lodi
Genoa

Rep. of
Venice

Venice
Verona
Mantua
Padua

Republic
of

Venice

Adriatic

Sava

Drava

Bordeaux

Rhône

Avignon

Provence
(French in
1486)
Marseilles

Languedoc

Gascony

Navarre

Rep.
of Genoa

Rep. of
Florence

Ravenna
Florence
Pisa
Siena

Urbino

Papal

States

Rome

Bosnia
(Ottoman in
1463)

Herzegovina
(Ottoman in
1465)

Serbia
(Ottoman in 1459)

Albania
(Ottoman in 1479)

Ebro

Catalonia

Aragon

Barcelona

Valencia

Kingdom

Portugal

Castile

Tagus

Duero

Guadiana

Lisbon

Córdoba

Guadalquiver

Granada
Granada

of

Aragon

Majorca

Sardinia

Cagliari

Corsica
(Genoa)

Mediterranean

Naples

Kingdom
of
Naples

Palermo
Sicily

Sea

(Portuguese
in 1471)

The cities of Flanders, initially small, independent pockets outside of the peasants' jurisdiction, soon followed suit, with the less wealthy citizens taking over city government. It took the combined forces of the rulers of France and Navarre plus a papal declaration of crusade to crush the peasants at the battle of Cassel in 1328.

Anti-French and anti-tax activities soon resumed in Flanders, however, this time at Ghent, where the weavers had been excluded from city government since 1320. When England prepared for the opening of the Hundred Years' War, it cut off wool exports to Flanders, putting the weavers (who depended on English wool) out of work. At Ghent the weavers took the hint and rallied to the English cause. Led by Jacob van Artevelde, himself a landowner but now spokesman for the rebels, the weavers overturned the city government. By 1339, Artevelde's supporters dominated not only Ghent but also much of northern Flanders. A year later, he was welcoming the English king Edward III to Flanders as king of France. Although Artevelde was assassinated in 1345 by weavers who thought he had betrayed their cause, the tensions that brought him to the fore continued. The local issues that pitted weavers against the other classes in the city were exacerbated by the ongoing hostility between England and France. Like a world war, the Hundred Years' War engulfed its bystanders.

In France, uprisings in the mid-fourteenth century signaled further strains of the war. At the disastrous battle of Poitiers (1356), King John II of France was captured and taken prisoner. The Estates General, which prior to the battle had agreed to heavy taxes to counter the English, met in the wake of Poitiers to allot blame and reform the government. When the new regent (the ruler in John's absence) stalled in instituting the reforms, Étienne Marcel, head of the merchants of Paris, led a plot to murder some royal councilors and take control of Paris. But the presence of some Free Company troops in Paris led to disorder there, and some of Marcel's erstwhile supporters blamed him for the riots, assassinating him in 1358.

Meanwhile, outside Paris, the Free Companies harried the countryside. In 1358 a peasant movement formed to resist them. Called the Jacquerie by dismissive chroniclers (probably after their derisive name for its leader, Jacques Bonhomme—Jack Goodfellow), it soon turned into an uprising against the nobility, failures as knights (in the eyes of the peasants) because of their loss at Poitiers and their inability to defend the rural peace. The revolt was depicted in sensationally gory detail: "Those evil men," wrote Froissart, "pillaged and burned everything and violated and killed all the ladies and girls without mercy, like mad dogs."[8] Perhaps. But the repression of the Jacquerie was at least equally brutal and, in most places, quicker.

More permanent in their consequences were peasant movements in England; Wat Tyler's Rebellion of 1381 is the most famous. During this revolt, groups of "commons" (in this case mainly country folk from southeast England) converged on London to demand an end to serfdom: "And they required that for the future no man should be in serfdom, nor make any manner of homage or suit to any lord, but should give a rent of 4 pennies an acre for his land."[9] Most immediately, the revolt was a response to a poll tax of one shilling per person, the third fiscal imposition in four years passed by Parliament to recoup the

Map 8.5 (facing page): Western Europe, *c*.1450

expenses of war. More profoundly, it was a clash between new expectations of freedom (in the wake of the Black Death, labor was worth much more) and old obligations of servitude. The egalitarian chant of the rebels signaled a growing sense of their own power:

> When Adam delved [dug] and Eve span [spun],
> Who then was the gentleman?

Although Tyler, the leader of the revolt, was soon killed and the rest of the commons dispersed, the death knell of serfdom in England had in fact been sounded, as the rebels went home to bargain with their landlords for new-style leases.

In the decades just before this in a number of Italian cities, cloth workers chafed under regimes that gave them no say in government. At Florence in 1378, matters came to a head as a coalition of wool workers (most of whom were barred from any guild), small businessmen, and some disaffected guild members challenged the ruling elites. The *ciompi* (wool-carders) rebellion, as the movement was called, succeeded briefly in taking over the Florentine government and permitting some new guilds to form there. But the movement soon splintered, and, strapped for money, it resorted to forced loans, an expedient that backfired. By 1382, the old elite was back in power, determined not to let the lower classes rise again; in the next century, the Florentine republic gave way to rule by a powerful family of bankers, the Medici.

Economic Contraction

While the Black Death was good for the silk trade, and the Hundred Years' War stimulated the manufacture of arms and armor, in other spheres economic contraction was the norm. After 1340, with the disintegration of the Mongol Empire, easy trade relations between Europe and the Far East were destroyed. Within Europe, rulers' war machines were fueled by new taxes and loans—some of them forced. At times, rulers paid back the loans; often they did not. The great import-export houses, which loaned money as part of their banking activities, found themselves advancing too much to rulers all too willing to default. In the 1340s the four largest firms went bankrupt, producing, in domino effect, the bankruptcies of hundreds more.

War did more than gobble up capital. Where armies raged, production stopped. Even in intervals of peace, Free Companies attacked not only the countryside but also merchants on the roads. To ensure its grain supply, Florence was obliged to provide guards all along the route from Bologna. Merchants began investing in insurance policies, not only against losses due to weather but also against robbers and pirates.

Meanwhile, the plague dislocated normal economic patterns. Urban rents fell as houses went begging for tenants, while wages rose as employers sought to attract scarce labor. In the countryside, whole swathes of land lay uncultivated. The monastery of Saint-Denis, so rich and powerful under Abbot Suger in the twelfth century, lost more than half its

income from land between 1340 and 1403. As the population fell and the demand for grain decreased, the Baltic region—chief supplier of rye to the rest of Europe—suffered badly; by the fifteenth century, some villages had disappeared.

Yet, as always, the bad luck of some meant the prosperity of others. While Tuscany lost its economic edge, cities in northern Italy and southern Germany gained new muscle, manufacturing armor and fustian (a popular textile made of cotton and flax) and distributing their products across Europe. The center of economic growth was in fact shifting northwards, from the Mediterranean to the European heartlands. There was one unfortunate exception: the fourteenth century saw the burgeoning of the slave trade in southern Europe. Girls, mainly from the Mongol world but also sometimes Greeks or Slavs (and therefore Christians), were herded onto ships; those who survived the harrowing trip across the Mediterranean were sold on the open market in cities such as Genoa, Florence, and Pisa. They were high-prestige purchases, domestic "servants" with the allure of the Orient.

THE CHURCH DIVIDED

The fourteenth and fifteenth centuries saw deep divisions within the church. Popes fought over who had the right to the papacy, and ordinary Catholics disputed about that as well as the very nature of the church itself.

The Great Schism

Between 1378 and 1409, rival popes—one line based in Avignon, the other in Rome—claimed to rule as vicar of Christ; from 1409 to 1417, a third line based in Bologna joined them. (See the list of Popes and Antipopes to 1500 on p. 341.) The popes at each venue excommunicated the others, surrounded themselves with their own college of cardinals, and commanded loyal followers. The Great Schism (1378–1417)—as this period of popes and antipopes is called—was both a spiritual and a political crisis.

Exacerbating political tensions, the schism fed the Hundred Years' War: France supported the pope at Avignon, England the pope at Rome. In some regions the schism polarized a single community: for example, around 1400 at Tournai, on the border of France and Flanders, two rival bishops, each representing a different pope, fought over the diocese. Portugal, more adaptable and farther from the fray, simply changed its allegiance four times.

The crisis began with the best of intentions. Stung by criticism of the Avignon papacy, Pope Gregory XI (1370–1378) left Avignon to return to Rome in 1377. When he died a year later, the cardinals elected an Italian as Urban VI (1378–1389). Finding Urban high-handed, however, the French cardinals quickly thought better of what they had done. At Anagni, declaring Urban's election invalid and calling on him to resign, they elected Clement VII, who installed himself at Avignon. The papal monarchy was

now split. The group that went to Avignon depended largely on French resources to support it; the group at Rome survived by establishing a *signoria*, complete with mercenary troops to collect its taxes and fight its wars. Thus Urban's successor, Boniface IX (1389–1404), reconquered the papal states and set up governors (many of them his family members) to rule them. Desperate for more revenues, the popes turned all their prerogatives into sources of income. Boniface, for example, put church benefices on the open market and commercialized "indulgences"—acts of piety (such as viewing a relic or attending a special church feast) for which people were promised release from Purgatory for a specific number of days. Now money payments were declared equivalent to performing the acts. Many people willingly made such purchases; others were outraged that Heaven was for sale.

Solutions to end the schism eventually coalesced around the idea of a council. The "conciliarists"—those who advocated the convening of a council that would have authority over even the pope—included both university men and princes anxious to flex their muscles over the church. At the Council of Pisa (1409), which neither of the popes attended, the delegates deposed them both and elected a new man. But the two deposed popes refused to budge: there were now *three* popes, one at Avignon, one at Rome, and a third at Bologna. The successor of the newest one, John XXIII, turned to the emperor to arrange for another council.

The Council of Constance (1414–1418) met to resolve the papal crisis as well as to institute church reforms. In the first task it succeeded, deposing the three rivals and electing Martin V as pope. In the second, it was less successful, for it did not end the fragmentation of the church. National, even nationalist, churches had begun to form, independent of and sometimes in opposition to papal leadership. Meanwhile the conciliar movement continued, developing an influential theory that held that church authority in the final instance resided in a corporate body (whether representing prelates or more broadly the community of the faithful) rather than the pope.

Popular Religious Movements in England and Bohemia

While the conciliarists worried about the structure of the church, many men and women thought more about their personal relationship with Christ. *The Book of Margery Kempe* is about an English woman (presumably Margery Kempe, though she calls herself "the creature" throughout the book) who had long conversations with the Lord. In "contemplation" she traveled back in time to serve Mary, the mother of Jesus:

> [Mary said to Margery], "follow me, your service pleases me well." Then [Margery] went forth with our Lady [i.e. Mary] and with Joseph [Mary's husband], bearing with her a vessel of sweetened and spiced wine. Then they went forth to Elizabeth, Saint John the Baptist's mother, and, when they met together, both of them worshipped each other, and so they dwelled together with great grace and gladness

twelve weeks.... And then [Margery] went forth with our Lady to Bethlehem and purchased her lodging every night with great reverence, and our Lady was received with a glad manner. Also she begged for our Lady fair white clothes and kerchiefs to swaddle her son when he was born, and, when Jesus was born, she prepared bedding for our Lady to lie in with her blessed son.[10]

This was the Gospel story (see, for example, Luke 1:39–40 and 2:4–7) with a new protagonist!

Others began to rethink the role of the church. In England, the radical Oxford-trained theologian John Wyclif (c.1330–1384), influenced in part by William of Ockham (see p. 266), argued for a very small sphere of action for the church. In his view, the state alone should concern itself with temporal things, the pope's decrees should be limited to what was already in the Gospels, the laity should be allowed to read and interpret the Bible for itself, and the church should stop promulgating the absurd notion of transubstantiation. At first the darling of the king and other powerful men in England (who were glad to hear arguments on behalf of an expanded place for secular rule), Wyclif appealed as well (and more enduringly) to the gentry and literate urban classes. Derisively called "lollards" (idlers) by the church and persecuted as heretics, the followers of Wyclif were largely, though not completely, suppressed in the course of the fifteenth century.

Considerably more successful were the Bohemian disciples of Wyclif. In Bohemia, part of the Holy Roman Empire but long used to its own monarchy (see above, p. 145), the disparities between rich and poor helped create conditions for a new vision of society in which religious and national feeling played equal parts. There were at least three inequities in Bohemia: the Germans held a disproportionate share of its wealth and power, even though Czechs constituted the majority of the population; the church owned almost a third of the land; and the nobility dominated the countryside and considered itself the upholder of the common good. In the hands of Jan Hus (1369/71–1415), the writings of Wyclif were transformed into a call for a reformed church and laity. All were to live in accordance with the laws of God, and the laity could disobey clerics who were more interested in pomp than the salvation of souls. Hus translated parts of the Bible into Czech while encouraging German translations as well. Furthering their vision of equality within the church, Hus's followers demanded that all the faithful be offered not just the bread but also the consecrated wine at Mass. (This was later called Utraquism, from the Latin *sub utraque specie*—communion "in both kinds.") In these ways, the Hussites gave shape to their vision of the church as the community of believers—women and the poor included. Hus's friend Jerome of Prague identified the whole reform movement with the good of the Bohemian nation itself, appropriating the traditional claim of the nobility.

Burned as a heretic at the Council of Constance, Hus nevertheless inspired a movement that transformed the Bohemian church. The Hussites soon disagreed about demands and methods (the most radical, the Taborites, set up a sort of government in exile in southern Bohemia, pooling their resources while awaiting the Second Coming), but most found

willing protectors among the Bohemian nobility. In the struggle between these groups and imperial troops—backed by a papal declaration of crusade in Bohemia—a peculiarly Bohemian church was created, with its own special liturgy for the Mass.

Churches under Royal Leadership: France and Spain

"National" churches did not need popular revolts to spark them. Indeed, in France and Spain they were forged in the crucible of growing royal power. In the Pragmatic Sanction of Bourges (1438), Charles VII surveyed the various failings of the church in France and declared himself the guarantor of its reform. Popes were no longer to appoint French prelates nor grant benefices to churchmen; these matters now came under the jurisdiction of the king.

The crown in Spain claimed similar rights about a half-century later, when the marriage of Ferdinand (r.1479–1516) and Isabella (r.1474–1504)—dubbed the "Catholic Monarchs" by the pope—united Aragon and Castile. In their hands, Catholicism became an instrument of militant royal sovereignty. King and queen launched an offensive against the Muslims in Granada (conquering the last bit in 1492). In 1502 the remaining Muslims were required to convert to Christianity or leave Spain. Many chose to convert (coming to be known as *moriscos*), but they were never integrated into the mainstream and were expelled from the kingdom in the early seventeenth century.

The Jews suffered a similar fate even earlier—in fact, right after the 1492 conquest of Granada. Their persecution had deep roots. The relatively peaceful co-existence of Christians and Jews in most of Spain during the twelfth and thirteenth centuries ended in the fourteenth. Virulent anti-Jewish pogroms in 1391 led many Spanish Jews to convert to Christianity (gaining the name *conversos*). But the subsequent successes of the *conversos*—some of whom obtained civil and church offices or married into the nobility—stirred resentment among the "Old Christians." Harnessing popular resentments, the Catholic Monarchs received a papal privilege to set up their own version of the Inquisition in 1478. Under the friar-inquisitor Tomás de Torquemada (1420–1498), wholesale torture and public executions became the norm for disposing of "crypto-Jews." After they conquered Grenada, the monarchs demanded that all remaining Jews convert or leave the country. Many chose exile over *conversos* status. Soon the newly "purified" church of Spain was extended to the New World as well, where papal concessions gave the kings control over church benefices and appointments.

DEFINING STYLES

Everywhere, in fact, kings and other rulers were intervening in church affairs, wresting military force from the nobility, and imposing lucrative taxes to be gathered by their

zealous and efficient salaried agents. All of this was largely masked, however, behind brilliant courts that employed every possible means to burnish the image of the prince.

Renaissance Italy

In 1416, taking a break from their jobs at the Council of Constance, three young Italians went off on a "rescue mission." One of them, Cincius Romanus (d. 1445) described the escapade to one of his Latin teachers back in Italy:

> In Germany there are many monasteries with libraries full of Latin books. This aroused the hope in me that some of the works of Cicero, Varro, Livy, and other great men of learning, which seem to have completely vanished, might come to light, if a careful search were instituted. A few days ago, [we] went by agreement to the town of St. Gall. As soon as we went into the library [of the monastery there], we found *Jason's Argonauticon*, written by C. Valerius Flaccus in verse that is both splendid and dignified and not far removed from poetic majesty. Then we found some discussions in prose of a number of Cicero's orations.... In fact we have copies of all these books. But when we carefully inspected the nearby tower of the church of St. Gall in which countless books were kept like captives and the library neglected and infested with dust, worms, soot, and all the things associated with the destruction of books, we all burst into tears.[11]

Cicero, Varro, Livy: these provided the models of Latin and the rules of expression that Cincius and his friends admired. To them the monks of St. Gall were "barbarians" for not wholeheartedly valuing ancient Latin rhetoric, prose, and poetry over all other writings. In the course of the fourteenth century Italian intellectuals turned away from the evolved Latin of their contemporaries to find models in the ancients. Already in 1333 the young Petrarch (1304–1374) had traveled through the Low Countries looking for manuscripts of the ancient authors; he discovered Cicero's *Pro Archia*, a paean to poetry, and carefully copied it out.

Petrarch's taste for ancient eloquence and his ability to write in a new, elegant, "classical" style (whether in Latin or in the vernacular) made him a star. But he was not alone, as Cincius' letter proves; he was simply one of the more famous exemplars of a new group calling themselves "humanists." There had been humanists before: we have seen Saint Anselm's emphasis on Christ's saving humanity, Saint Bernard's evocation of human religious emotion, and Thomas Aquinas's confidence in human reason to scale the heights of truth (see pp. 192 and 266). But the new humanists were more self-conscious about their calling, and they tied it to the cultivation of classical literature.

As Cincius' case also shows, if the humanists' passion was antiquity, their services were demanded with equal ardor by ecclesiastical and secular princes. Cincius worked for Pope John XXIII. Petrarch was similarly employed by princes: for several years, for example,

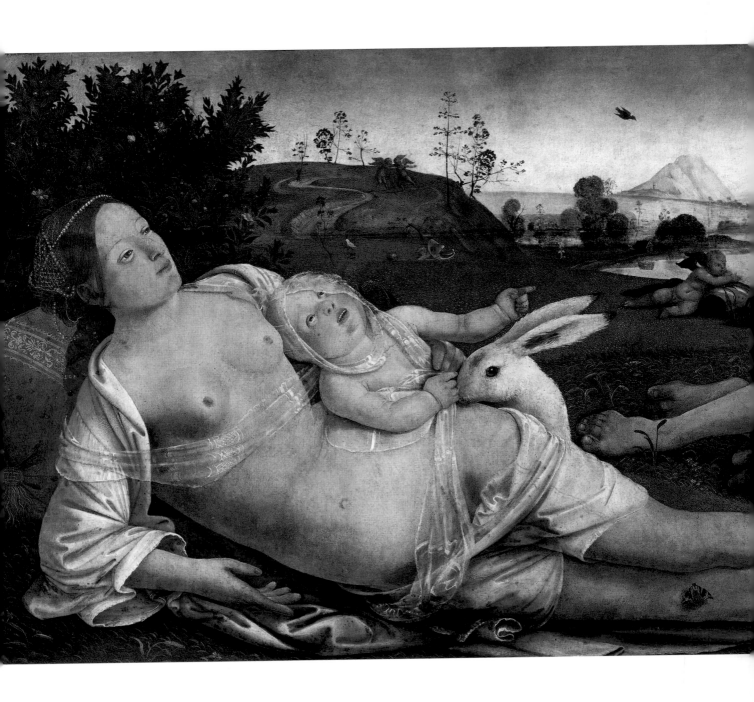

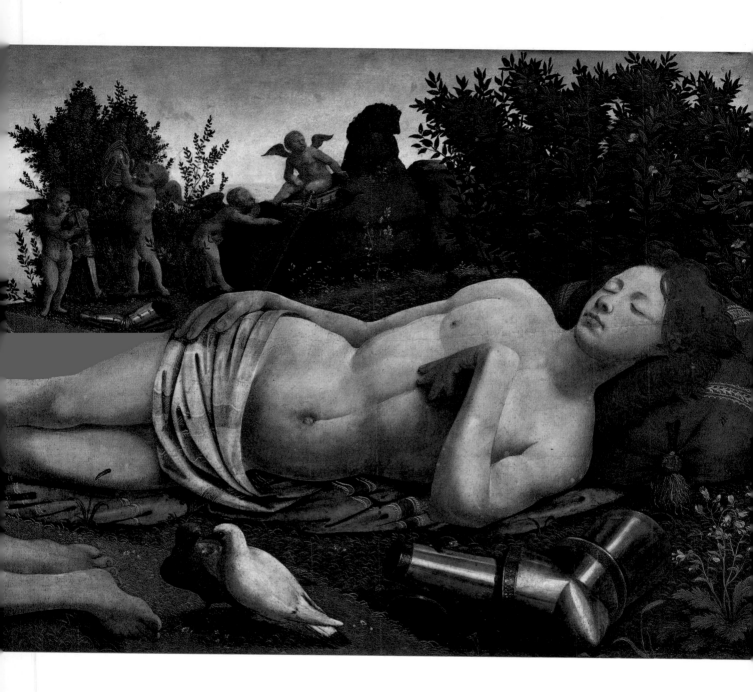

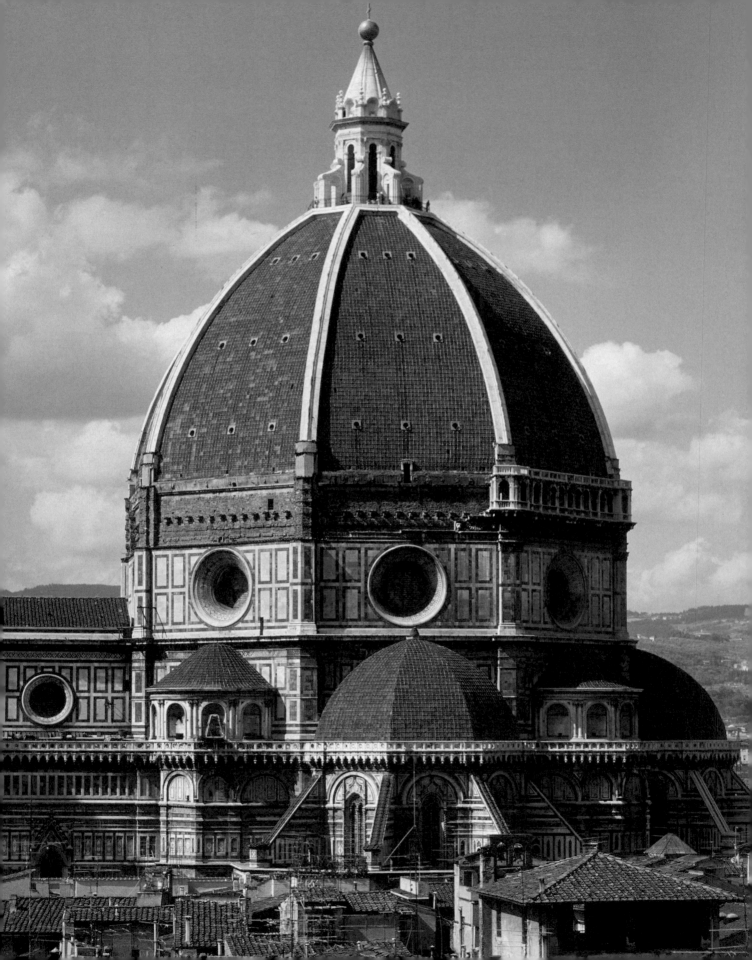

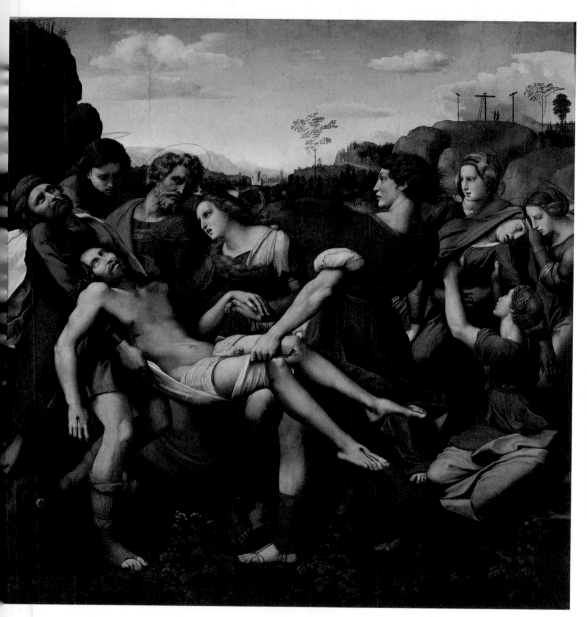

Plate 8.4 (facing page):
Filippo Brunelleschi, Florence Cathedral Dome (1418–1436). It was a major engineering feat to span the 42-meter (46-yard) octagonal space over the cathedral with a dome. Brunelleschi solved the problem by an ingenious use of ribs. He also designed the scaffolding that was necessary to build the dome and the hoisting equipment for the building materials. No wonder that Brunelleschi became a "star" —the first celebrity architect.

Plate 8.5: Raphael, *Entombment of Christ* (1507). Not so much about Christ's entombment as it is about carrying Christ, this central altarpiece panel should be read from right to left. First comes Christ's mother, the Virgin, her face white as a sheet, swooning into the arms of the three Maries (Holy Women mentioned in the Gospels). To their left are two men straining to bear Christ to his tomb, which is indicated by a cave-like opening. Mary Magdalene, one of the Maries, is there as well, lifting Christ's head and hand.

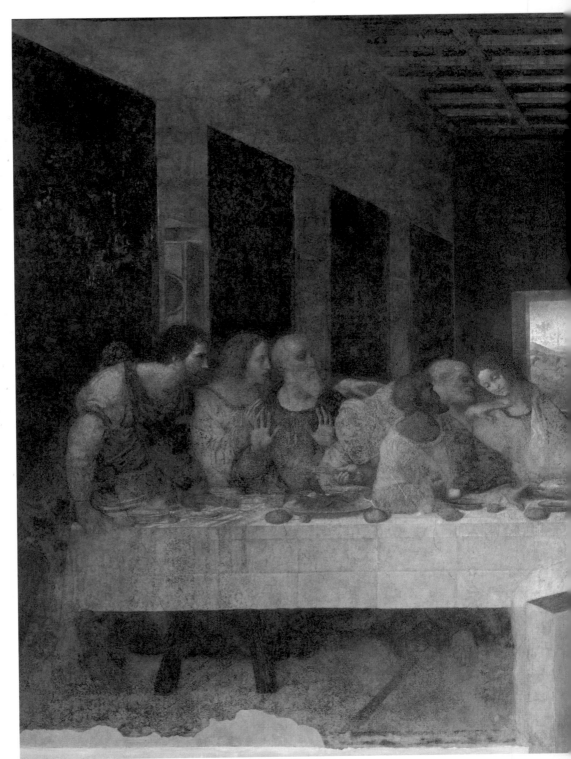

Plate 8.6: Leonardo da Vinci, *The Last Supper* (1494–1497). Leonardo first made his reputation with this painting, which evokes the precise moment when Christ said to his feasting apostles, "One of you is about to betray me." All the apostles react with horror and surprise, but the guilty Judas recoils, his face in shadows. Compare this depiction with the same moment in the Romanesque painting of Plate 5.4 on p. 183.

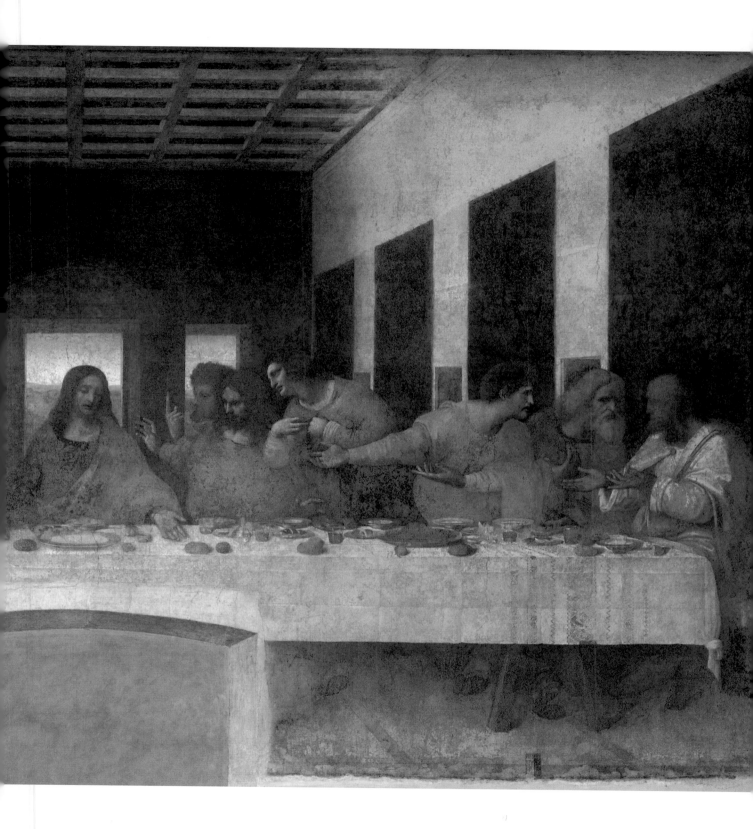

The Ottoman Court

Some of Ludovico's dinner presentations acted out a different preoccupation—the power of the new Ottoman state. When a whole roasted capon was brought in for each guest, it was accompanied by a little drama:

> A bull is presented by Indians and brought in by slaves of the Sultan in a most elaborately decorated procession of gold and silver with two little moors who sing very elaborately and an ambassador with an interpreter, who translates the words of the embassy.[15]

Here the Ottoman sultan was depicted as the lackey of Duke Ludovico, in a pageant that was meant to be very exotic and in need of "translation" (even though Ludovico himself was dubbed "il Moro," the Moor, because of his swarthy complexion). But imagine that the real sultan—the Ottoman ruler—held his own banquet at the same time: at *his* dinner, the lackey would be an *Italian*, and the sultan would have understood his language. For the Ottomans considered the Renaissance court to be their own as well. They had taken Byzantium, purified it of its infidel past (turning its churches into mosques), and reordered it along fittingly traditional lines. Although in popular speech Constantinople became Istanbul (meaning "the city"), its official name remained "Qustantiniyya"—the City of Constantine. The Ottoman sultans claimed the glory of Byzantium for themselves.

Thus Mehmed II continued to negotiate with Genoese traders, while he "borrowed" Gentile Bellini (*c.*1429–1507) from Venice to be his own court artist. In 1479, he posed for his portrait (see Plate 8.7), only a few decades after the genre of portrait painting itself had been "invented" in Europe. On the walls of his splendid Topkapi palace, he displayed tapestries from Burgundy portraying the deeds of Alexander the Great, each no doubt something like the tapestry illustrated in Plate 8.8, discussed below. Just as a statue of Judith gave glory to the Medici family, so Alexander burnished the image of the sultan. The tapestries were themselves trophies of war: a failed Burgundian crusade against the Ottomans in 1396 had ended in the capture of Duke John the Fearless; his ransom was the Alexander tapestries.

Learning as well as art was key to the sultans' notions of power. Mehmed and his successors staffed their cities with men well schooled in Islamic administration and culture and set up *madrasas* to teach the young. For himself, Mehmed commissioned a copy of Homer's *Iliad* in Greek, epic poetry in Italian, and other literary works by Turkish, Persian, and European writers. His zeal for scholarship was on a lesser scale but not very different in kind from that of the Florentine ruler Cosimo de' Medici (1389–1464), who in the mid-fifteenth century took over the nearly one thousand volumes of ancient Greek and Latin texts that had been collected with painstaking care by the humanist Niccolò Niccoli (1364–1437). Open to all, the Medici library became the model for princely bibliophiles throughout Italy and elsewhere. Calls for further crusades against the infidel Turks (in 1455 and 1459, for example) were in this sense "family disputes," attempts to contest the East's right to common notions of power and legitimacy.

Plate 8.7 (facing page): Gentile Bellini, *Portrait of Mehmed II* (1479). Mehmed, like other Renaissance princes, hired Renaissance artists to give him luster. In the 1460s he tried to obtain the services of the Rimini artist and architect Matteo de' Pasti, but his plans were foiled by Venice, which wanted no rivals at Constantinople. The Venetians sent their own Gentile Bellini instead, who celebrated the sultan's power with this portrait.

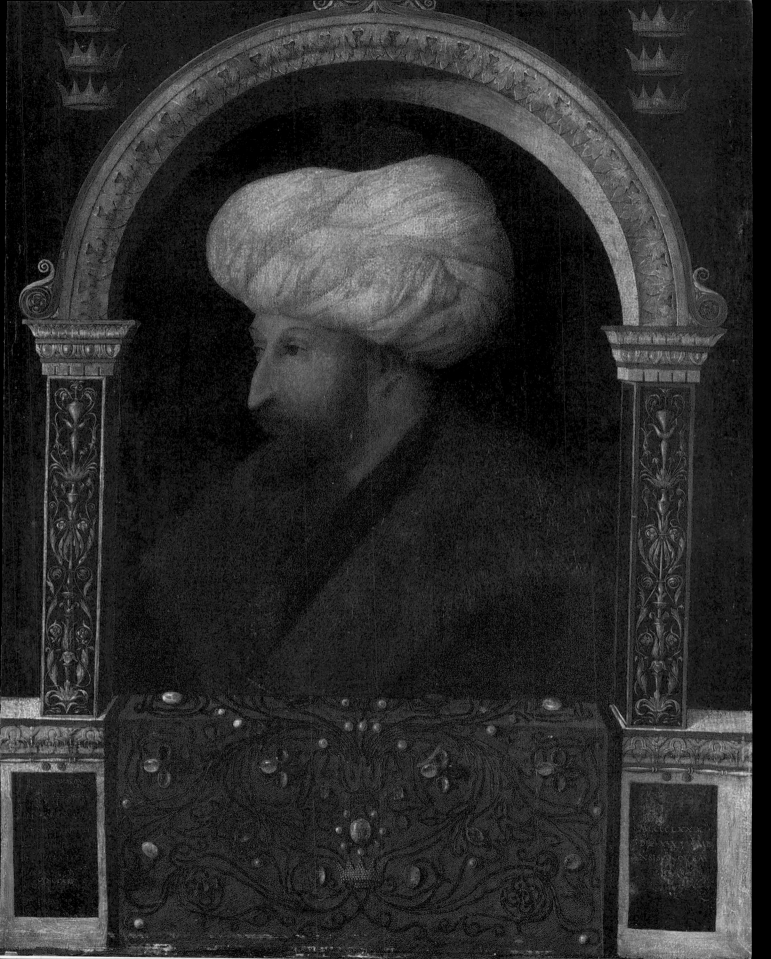

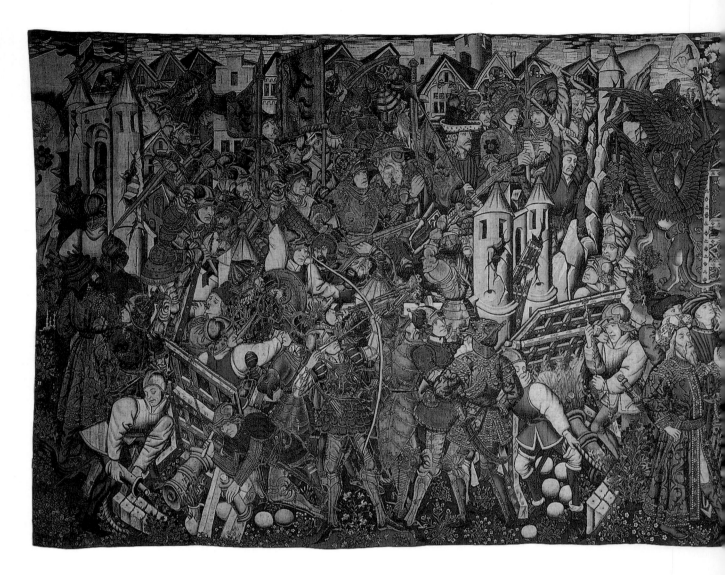

The Northern Renaissance

Northern Europe shared the same notions, but here the symbols of authority and piety were even more eclectic. Burgundy—an hourglass with its top in Flanders, its bottom just above the Alps—embraced nearly all the possibilities of Renaissance culture. Although Gothic style persisted in northern Europe, especially in architecture, the Greco-Roman world also beckoned. Ancient themes—especially the deeds of heroes, whether real or mythical—were depicted on tapestries that provided lustrous backdrops for rulers of every stripe. The dukes of Burgundy traveled from one end of their dominions to the other with such tapestries in tow. Weavings lined their tents during war and their boats during voyages. In 1459 Philip the Good bought a series of fine tapestries—woven in silk spiced with gold and silver threads—depicting the *History of Alexander the Great* (see Plate 8.8).

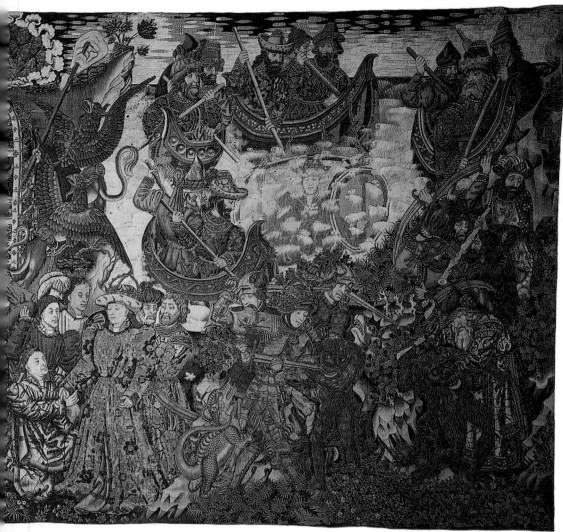

Plate 8.8: *History of Alexander the Great*, Tapestry (*c.*1459). To the right of the depiction of his ascent into the air, Alexander appears surrounded by his courtiers. Next he explores the underwater world: seated in a glass bell, he is encircled by sea creatures. Below, now returned to land, Alexander and his men fight dragons and monsters, one of whom is pierced by the hero's sword. The tapestry was commissioned by Philip the Good for 500 gold pieces and created by the master weaver of Tournai in silk, wool, and real gold thread. Alexander's adventures were recounted in vernacular romances; the text that probably directly inspired this tapestry was *The Book of the Conquests and Deeds of Alexander the Great* by Jean Wauquelin (d.1452), a copy of which was owned by the duke of Burgundy.

Following pages:

Plate 8.9: Rogier van der Weyden, *Columba Altarpiece* (1450s). Depicting three standard scenes from Christ's childhood— the Annunciation, the Adoration of the Magi, and the Presentation in the Temple— the *Columba Altarpiece* subtly introduces new themes alongside the old. For example, Christ's death is suggested by the crucifix above Mary in the central panel, while the present time (the fifteenth century) is suggested by the cityscape in the background, which probably represents Cologne, the native city of the man who commissioned the altar and the proud home of the relics of the Magi.

Reading this tapestry from left to right, we see a city besieged, the trumpeters, archers, and artillerymen and soldiers reflecting the realities of fifteenth-century warfare. At the center, Alexander rises to the sky in a decorated metal cage lifted by four winged griffons. The weaving was the perfect stage setting for the performance of ducal power. No wonder European rulers—from English kings to Italian *signori* (and on to Ottoman sultans)—all wanted tapestries from Burgundy for *their* palaces.

At the same time, dukes and other northern European patrons favored a new style of art that emphasized devotion, sentiment, and immediacy. (This style would later be one of the inspirations for Raphael's *Entombment* in Plate 8.5.) Painted in oil-based pigments, capable of showing the finest details and the subtlest shading, Netherlandish art was valued above all for its true-to-life expressivity. In the *Columba Altarpiece* (Plate 8.9) by Rogier van der Weyden—likely commissioned by Johann Dasse, a wealthy merchant from Cologne

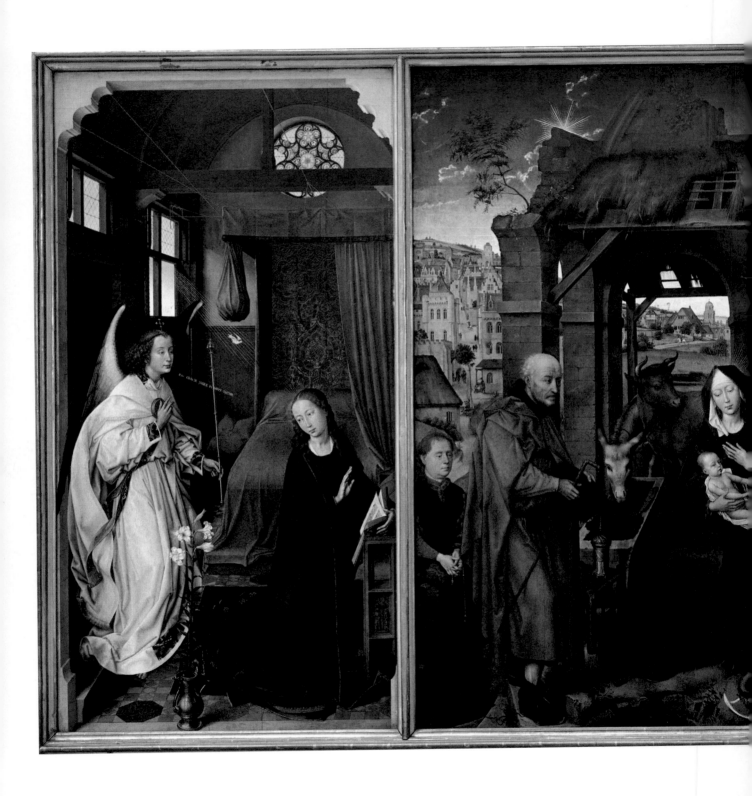

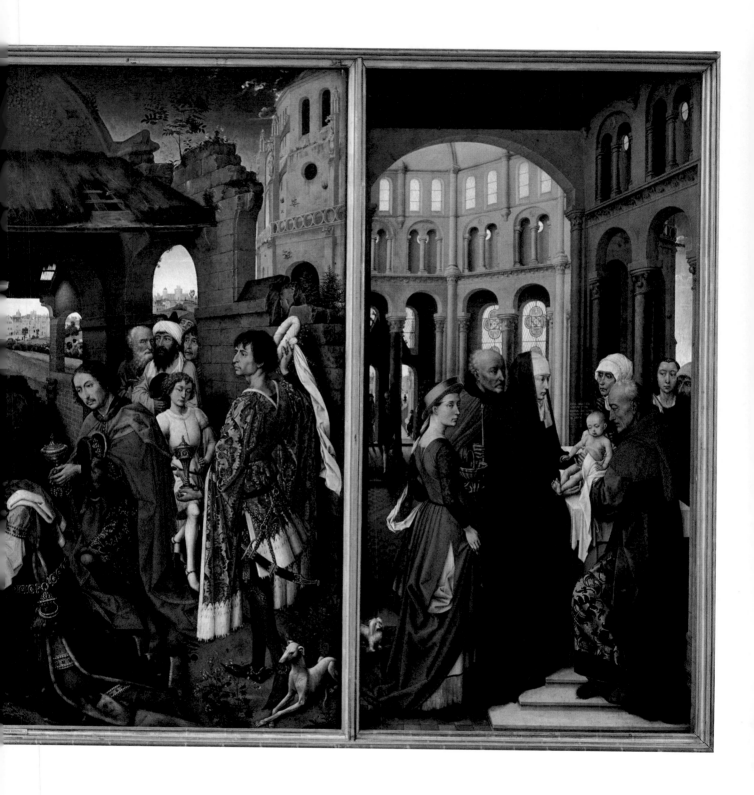

(Germany)—the donor himself is depicted, hat in hand (to the left in the central panel), humbly witnessing the visit of the Magi. Time itself is compressed in this picture, as the immediacy of the painting—its here-and-now presence—belies the historical reality: like Margery Kempe at the birth of Christ (see above, p. 302), so also here: no one from the fifteenth century could possibly have been at the scene.

The emphasis on the natural details of the moment was equally striking in secular paintings from the Netherlands. In *Man in a Red Turban* (see Plate 8.10) by Jan van Eyck (c.1390–1441), we even see the stubble of the man's beard. Yet this entirely secular theme—a man in stylish red headgear (evidence of the Turkish allure)—is infused with a quiet inner light that endows its subject with a kind of otherworldliness.

Both the Italian and Northern Renaissances cultivated music and musicians, above all for the aura that they gave rulers, princes, and great churchmen. In Italy, Isabella d'Este (1474–1539), marchesa of Mantua, employed her own musicians—singers, woodwind and string players, percussionists, and keyboard players—while her husband had his own band. In Burgundy the duke had a fine private chapel and musicians, singers, and composers to staff it. In England wealthy patrons founded colleges—Eton (founded by King Henry VI in 1440–1441) was one—where choirs offered up prayers in honor of the Virgin. Motets continued to be composed and sung, but now polyphonic music for larger groups became common as well. In the hands of a composer such as John Dunstable (d.1453), who probably worked for the duke of Bedford, regent for Henry VI in France during the Hundred Years' War, dissonance was smoothed out. In the compositions of Dunstable and his followers, harmonious chords that moved together even as they changed replaced the old juxtapositions of independent lines. Working within the old modal categories, composers made their mark with music newly sonorous and smooth.

NEW HORIZONS

Experiment and play within old traditions were thus the major trends of the period. They can be seen in explorations of interiority, in creative inventions, even in the conquest of the globe. Yet their consequences may fairly be said to have ushered in a new era.

Interiority

Donatello's Judith, intent on her single-minded task, and van Eyck's red-turbaned man, glowing from within, are similar in their self-involved interiority. Judith's self-centeredness is that of a hero; van Eyck's man's is that of any ordinary creature of God, the artist's statement about the holiness of nature.

These two styles of interiority were mirrored in religious life and expression. Saint Catherine of Siena (1347–1380) was a woman in Judith's heroic mold. A reformer with a

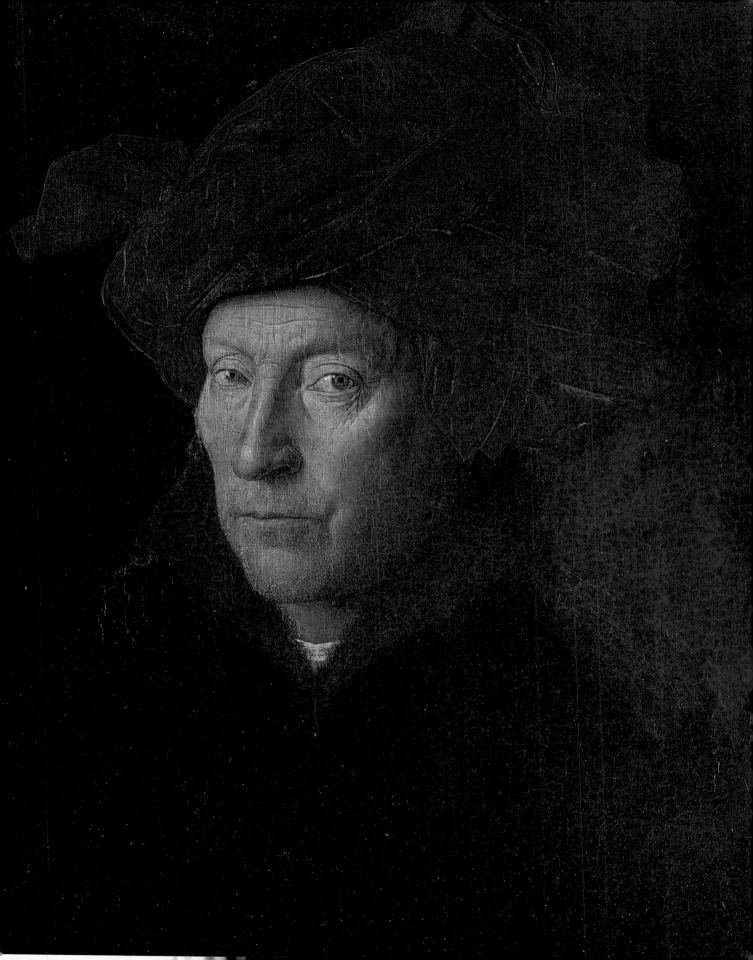

message, she was one of the first in a long line of women (Jeanne d'Arc is another example) to intervene on the public stage because of her private agonies. Writing (or rather dictating) nearly 400 letters to the great leaders of the day, she worked ceaselessly to bring the pope back to Rome and urged crusade as the best way to purge and revivify the church.

In the Low Countries, northern Germany, and the Rhineland, the *devotio moderna* (the "new devotion") movement found, to the contrary, purgation and renewal in individual reading and contemplation rather than in public action. Founded *c.*1380 by Gerhard Groote (1340–1384), the Brethren of the Common Life lived in male or female communities that focused on education, the copying of manuscripts, material simplicity, and individual faith. The Brethren were not quite humanists and not quite mystics, but they drew from both for a religious program that depended very little on the hierarchy or ceremonies of the church. Their style of piety would later be associated with Protestant groups.

Inventions

The enormous demand for books—whether by ordinary lay people, adherents of the *devotio moderna*, or humanists eager for the classics—made printed books a welcome addition to the repertory of available texts, though manuscripts were neither quickly nor easily displaced. The printing press, however obvious in thought, marked a great practical breakthrough: it depended on a new technique to mold metal type. This was first achieved by Johann Gutenberg at Mainz (in Germany) around 1450. The next step was getting the raw materials that were needed to ensure ongoing production. Paper required water mills and a steady supply of rag (pulp made of cloth); the metal for the type had to be mined and shaped; ink had to be found that would adhere to metal letters as well as spread evenly on paper.

By 1500 many European cities had publishing houses, with access to the materials that they needed and sufficient clientele to earn a profit. Highly competitive, the presses advertised their wares. They turned out not only religious and classical books but whatever the public demanded. Martin Luther (1483–1546) may not in fact have nailed his 95 Theses to the door of the church at Wittenberg in 1517, but he certainly allowed them to be printed and distributed in both Latin and German. Challenging prevailing church teachings and practice, the Theses ushered in the Protestant Reformation. The printing press was a powerful instrument of mass communication.

More specialized, yet no less decisive for the future, were new developments in navigation. Portolan maps charted the shape of the Mediterranean coastline through accurate measurements from point to point.[16] Compasses, long known in China but newly adopted in the West, provided readings that were noted down in nautical charts; sailors used them alongside maps and written information about such matters as harbors, political turmoil, and anchorage. But navigating the Atlantic depended on more; it required methods for exploiting the powerful ocean wind systems. New ship designs—the light caravel, the heavy galleon—featured the rigging and sails needed to harness the wind.

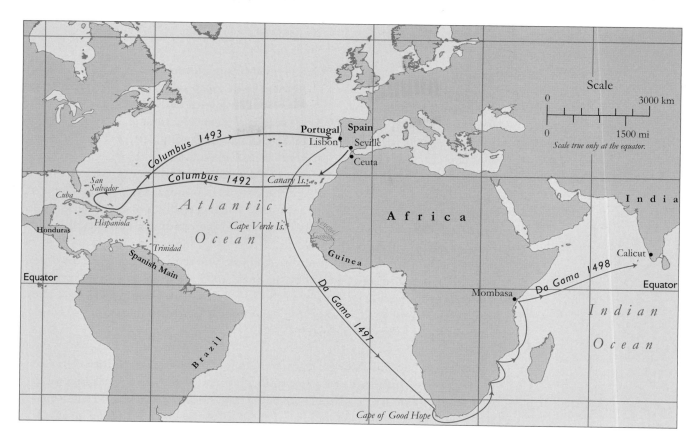

Voyages

Map 8.6: Long-distance
Sea Voyages of the Fifteenth
Century

As we have seen (p. 245), already in the thirteenth century merchants and missionaries from
Genoa and Majorca were making forays into the Atlantic. In the fifteenth century the initia-
tive that would eventually take Europeans around the Cape of Good Hope in one direction
and to the Americas in the other came from the Portuguese royal house. The enticements
were gold and slaves as well as honor and glory. Under King João I (r.1385–1433) and
his successors, Portugal extended its rule to the Muslim port of Ceuta and a few other
nearby cities. (See Map 8.6.) More importantly, João's son Prince Henry "the Navigator"
(1394–1460) sponsored expeditions—mainly by Genoese sailors—to explore the African
coast: in the mid-1450s they reached the Cape Verde Islands and penetrated inland via the
Senegal and Gambia rivers. A generation later, Portuguese explorers were working their
way far past the equator; in 1487 Bartholomeu Dias (d.1500) rounded the southern tip of
Africa (soon thereafter named the Cape of Good Hope), opening a new route that Vasco
da Gama sailed about ten years later all the way to Calicut (today Kozhikode) in India. In
his account of the voyage he made no secret of his methods: when he needed water, he
landed on an island and bombarded the inhabitants, taking "as much water as we wanted."[17]

Da Gama's cavalier treatment of the natives was symptomatic of a more profound
development: European colonialism. Already in the 1440s, Henry was portioning out the
uninhabited islands of Madeira and the Azores to those of his followers who promised to

find peasants to settle them. The Azores remained a grain producer, but, with financing by the Genoese, Madeira began to grow cane sugar. The product took Europe by storm. Demand was so high that a few decades later, when few European settlers could be found to work sugar plantations on the Cape Verde Islands, the Genoese Antonio da Noli, discoverer and governor of the islands, brought in African slaves instead. Cape Verde was a microcosm of later European colonialism, which depended on just such slave labor.

Portugal's successes and pretensions roused the hostility and rivalry of Castile. Ferdinand and Isabella's determination to conquer the Canary Islands was in part their "answer" to Portugal's Cape Verde. When, in 1492, they half-heartedly sponsored the Genoese Christopher Columbus (1451–1506) on a westward voyage across the Atlantic, they knew that they were playing Portugal's game.

Although the conquistadores confronted a New World, they did so with the expectations and categories of the Old. When the Spaniard Hernán Cortés (1485–1547) began his conquest of Mexico, he boasted in a letter home that he had reprimanded one of the native chiefs for thinking that Mutezuma, the Aztec emperor who ruled much of Mexico at the time, was worthy of allegiance:

> I replied by telling him of the great power of Your Majesty [Emperor Charles V, who was also king of Spain] and of the many other princes, greater than Mutezuma, who were Your Highness's vassals and considered it no small favor to be so; Mutezuma also would become one, as would all the natives of these lands. I therefore asked him to become one, for if he did it would be greatly to his honor and advantage, but if, on the other hand, he refused to obey, he would be punished.[18]

The old values lived on.

<p style="text-align:center">★ ★ ★ ★ ★</p>

Between the years 1350 and 1500, a series of catastrophes struck Europe. The Black Death felled at least a fifth of the population of Europe. The Hundred Years' War wreaked havoc when archers shot and cannons roared; it loosed armies of freebooters in both town and country during its interstices of peace. The Ottomans conquered Byzantium, took over the Balkans, and threatened Austria and Hungary. The church splintered as first the Great Schism and then national churches tore at the loyalties of churchmen and laity alike.

Yet these catastrophes were confronted, if not always overcome, with both energy and inventiveness. In England, peasants loosed the bonds of serfdom; in Portugal and Spain, adventurers discovered gold and land via the high seas; and everywhere bibliophiles and artists discovered wisdom and beauty in the classical past while princes flexed the muscles of sovereignty. History books normally divide this period into two parts, the crises going into a chapter on the Middle Ages, the creativity saved for a chapter on the Renaissance. But the two happened together, witness to Europe's aggressive resilience. Indeed, in the next century it would parcel out the globe.

1324/1326	Death of Othman, founder of Ottomans
1304–1374	Petrarch
c.1330–1384	John Wyclif
1337–1453	Hundred Years' War
c.1340–1400	Geoffrey Chaucer
1346–1353	Black Death
1351	Statute of Laborers in England
1358	Jacquerie in France
1369/1371–1415	Jan Hus
1378	Ciompi revolt in Florence
1378–1417	Great Schism of the papacy
1381	Wat Tyler's Rebellion
c.1390–1441	Jan van Eyck
1414–1418	Council of Constance
1429	Jeanne d'Arc leads French army to victory at Orléans
1438	Pragmatic Sanction of Bourges
1444–1446, 1451–1481	Rule of Mehmed II the Conqueror, Ottoman sultan
c.1450	Gutenberg invents the printing press
1452–1519	Leonardo da Vinci
1453	Ottoman conquest of Constantinople; end of Byzantine Empire
1454	Peace of Lodi in Northern Italy
1455–1487	Wars of the Roses
1477	Battle of Nancy; end of the Burgundian state
1492	Conquest of Granada; expulsion of Jews from Spain; first trans-Atlantic voyage of Columbus

NOTES

1 Nicephorus Gregoras, *Roman History*, in *Reading the Middle Ages: Sources from Europe, Byzantium, and the Islamic World*, ed. Barbara H. Rosenwein, 2nd ed. (Toronto: University of Toronto Press, 2014), p. 444.

2 Louis Guibert, ed. and trans., *Le livre de raison d'Etienne Benoist* (Limoges, 1882), p. 43.

3 Geoffrey Chaucer, *The Canterbury Tales*, trans. Nevill Coghill (Harmondsworth: Penguin, 1977), p. 88.

4 Ashikpashazade, *Othman Comes to Power*, in *Reading the Middle Ages*, p. 455.

5 Froissart, *Chronicles*, in *Reading the Middle Ages*, pp. 469–70.

6 Jeanne d'Arc, *Letter to the English*, in *Reading the Middle Ages*, p. 475.

7 Christine de Pisan, *The Tale of Joan of Arc*, quoted in Nadia Margolis, "The Mission of Joan of Arc," in *Medieval Hagiography: An Anthology*, ed. Thomas Head (New York: Routledge, 2000), p. 822.

8 Froissart, *Chronicles*, ed. and trans. Geoffrey Brereton (Harmondsworth: Penguin, 1968), p. 151.

9 *Wat Tyler's Rebellion*, in *Reading the Middle Ages*, p. 481.

10 *The Book of Margery Kempe*, in *Reading the Middle Ages*, p. 487.

11 Cincius Romanus, *Letter to His Most Learned Teacher Franciscus de Fiana*, in *Reading the Middle Ages*, p. 491.

12 Quoted in Evelyn Welch, *Art in Renaissance Italy, 1350–1500* (Oxford: Oxford University Press, 1997), p. 261.

13 Leon Battista Alberti, *On Painting*, in *Reading the Middle Ages*, pp. 493–94.

14 "A Sforza Banquet Menu (1491)," in *The Renaissance in Europe: An Anthology*, ed. Peter Elmer, Nick Webb, and Roberta Wood (New Haven, CT: Yale University Press, 2000), pp. 172–75.

15 Ibid., p. 173.

16 For an example, see *Reading the Middle Ages*, Plate 15, p. 252.

17 *A Journal of the First Voyage of Vasco da Gama, 1497–1499*, ed. and trans. E.G. Ravenstein (rpt. New York, 1964), p. 30.

18 Hernán Cortés, *The Second Letter*, in *Reading the Middle Ages*, p. 501.

FURTHER READING

Aberth, John. *From the Brink of the Apocalypse: Confronting Famine, War, Plague, and Death in the Later Middle Ages*. New York: Routledge, 2001.

Belozerskaya, Marina. *Rethinking the Renaissance: Burgundian Arts across Europe*. Cambridge: Cambridge University Press, 2002.

Blockmans, Wim, and Walter Prevenier. *The Promised Lands: The Low Countries under Burgundian Rule, 1369–1530*. Trans. Elizabeth Fackelman. Ed. Edward Peters. Philadelphia: University of Pennsylvnia Press, 1999.

Blumenfeld-Kosinski, Renate. *Poets, Saints, and Visionaries of the Great Schism, 1378–1417*. University Park: Penn State Press, 2006.

Cerman, Markus. *Villages and Lords in Eastern Europe, 1300–1800*. New York: Palgrave Macmillan, 2012.

Curry, Ann. *The Hundred Years' War, 1337–1453*. Oxford: Osprey, 2002.

Fernández-Armesto, Felipe. *Pathfinders: A Global History of Exploration*. New York: Norton, 2006.

Goffman, Daniel. *The Ottoman Empire and Early Modern Europe*. Cambridge: Cambridge University Press, 2002.

Hudson, Anne. *The Premature Reformation: Wycliffite Texts and Lollard History*. Oxford: Oxford University Press, 1988.

Imber, Colin. *The Ottoman Empire, 1300–1650: The Structure of Power*. 2nd ed. New York: Palgrave Macmillan, 2009.

Jardine, Lisa, and Jerry Brotton. *Global Interests: Renaissance Art between East and West*. Ithaca, NY: Cornell University Press, 2000.

Johnson, Geraldine A. *Renaissance Art: A Very Short Introduction*. Oxford: Oxford University Press, 2005.

Karras, Ruth Mazo. *Unmarriages: Women, Men, and Sexual Unions in the Middle Ages*. Philadelphia: University of Pennsylvania Press, 2012.

Klassen, John Martin. *The Nobility and the Making of the Hussite Revolution*. New York: Columbia University Press, 1978.

McKitterick, David. *Print, Manuscript and the Search for Order, 1450–1830*. Cambridge: Cambridge University Press, 2003.

Parker, Geoffrey. *The Cambridge History of Warfare*. Cambridge: Cambridge University Press, 2005.

Patton, Pamela A. *Art of Estrangement: Redefining Jews in Reconquest Spain*. University Park: Penn State Press, 2012.

Small, Graeme. *Late Medieval France*. New York: Palgrave Macmillan, 2009.

Watts, John. *The Making of Polities: Europe, 1300–1500*. Cambridge: Cambridge University Press, 2009.

Wheeler, Bonnie, and Charles Wood, eds. *Fresh Verdicts on Joan of Arc*. New York: Routledge, 1996.

To test your knowledge of this chapter, please go to
www.utphistorymatters.com
for Study Questions.

EPILOGUE

Cortéz may have used the old vocabulary of vassalage when speaking of his conquests in the Americas, but clearly the *reality* was so changed that we are right to see the years around 1500 as the turning point between the Middle Ages and a new phase of history. The Middle Ages began when the Roman provinces came into their own. They ended as those provinces—now vastly expanded, rich, and powerful, now "Europe," in fact—became in turn a new imperial power, its tentacles in the New World, Asia, and Africa. In the next centuries, as Europeans conquered most of the world, they (as the Romans had once done) exported themselves, their values, cultures, diseases, inventions, and institutions, while importing, usually without meaning to, many of the people, ideas, and institutions of the groups they conquered. In another phase, one not yet ended, former European colonies—at least some of them—have become, in turn, the center of a new-style empire involving economic, cultural, and (occasionally) military hegemony. It remains to be seen if this empire, too, will eventually be overtaken by its peripheries.

Does anything now remain of the Middle Ages? Without doubt. Bits and pieces of the past are clearly embedded in the present: universities, parliaments, ideas about God and human nature, the papacy, Gothic churches. We cling to some of these bits with ferocious passion, while repudiating others and allowing still more to float in and out of our unquestioned assumptions. Many things that originated in the Middle Ages are now so transformed that only their names are still medieval. And beyond that? Beyond that, "persistence" is the wrong question. The past need not be replayed because it is "us" but rather because it is "not us," and therefore endlessly fascinating.

GLOSSARY

aids
> In England, this refers to payments made by vassals to their lords on important occasions.

The Annunciation
> See Virgin Mary (below).

antiking
> A king elected illegally.

antipope
> A pope elected illegally.

Book of Hours
> A prayer book for lay devotion, meant to be read eight times a day either at home or in church. It normally contained the church calendar; a lesson from each of the gospels; prayers and other readings in honor of the Virgin Mary (see below) based on simplified versions of the Divine Office (see Office below); the penitential psalms; the Office of the Dead; and prayers to saints. Some were lavishly illustrated, and even humble ones were usually decorated.

bull
> An official document issued by the papacy. The word derives from *bulla*, the lead impression of the pope's seal that was affixed to the document to validate it.

canon law
> The laws of the church. These were at first hammered out as need arose at various regional church councils and in rules issued by great bishops, particularly the pope. Early collections of canon law were incomplete and sometimes contradictory. Beginning in the ninth century, commentators began to organize and systematize them. The most famous of these treatises was the mid-twelfth-century *Decretum* of Gratian, which, although not an official code, became the basis of canon law training in the schools.

cathedral
> The principal church of a bishop or archbishop.

church
> To the Roman Catholics of the Middle Ages, this had two related meanings. It signified in the first place the eternal institution created by Christ, composed of the whole body

of Christian believers, and served on earth by Christ's ministers—priests, bishops, the pope. Related to the eternal church were individual, local churches (parish churches, cathedrals, collegiate churches, chapels) where the daily liturgy was carried out and the faithful received the sacraments.

cleric
> A man in church orders.

collegiate church
> A church for priests living in common according to a rule.

The Crucifixion
> The execution of Jesus by hanging on a cross (*crux* in Latin). The scene, described in some detail in the Gospels, was often depicted in art; and free-standing crucifixes (crosses with the figure of Jesus on them) were often placed upon church altars.

diet
> A formal assembly of German princes.

dogma
> The authoritative truth of the church.

empire
> Refers in the first instance to the Roman Empire. Byzantium considered itself the continuation of that empire. In the West, there were several successor empires, all ruled by men who took the title "emperor": there was the empire of Charlemagne, which included more or less what later became France, Italy, and Germany; it was followed in the tenth century (from the time of Otto I on) by the empire held (after a crowning at Rome) by the German kings. This could be complicated: a ruler like Henry IV was king of Germany in 1056 at the age of six, but, as a minor, his kingdom was ruled by his mother and others in his name. In 1065, at the age of 15, he became an adult and was able to take the reins of power. But he was not crowned emperor until 1084. Nevertheless, he *acted* as an emperor long before that. That "German" empire, which lasted until the thirteenth century, included Germany and (at least in theory) northern Italy. Some historians call all of these successor empires of Rome the "Holy Roman Empire," but in fact, although Barbarossa called his empire *sacer*, "holy," the full phrase "Holy Roman Empire" was not used until 1254. This empire, which had nothing to do with Rome, ended in 1806. By extension, the term empire can refer to other large realms, often gained through conquest, such as the Mongol Empire or the Ottoman Empire.

episcopal

As used for the Middle Ages, this is the equivalent of "bishop's." An "episcopal church" is the bishop's church; an "episcopal appointment" is the appointment of a bishop; "episcopal power" is the power wielded by a bishop.

excommunication

An act or pronouncement that cuts someone off from participation in the sacraments of the church and thus from the means of salvation.

fresco

A form of painting using pigments on wet plaster, frequently employed on the walls of churches.

gentry

By the end of the Middle Ages, English landlords consisted of two groups, lords and gentry. The gentry were below the lords; knights, squires, and gentlemen were all considered gentry. Even though the term comes from the Late Middle Ages, it is often used by historians as a rough and ready category for the lesser English nobility from the twelfth century onward.

grisaille

Painting in monochrome grays highlighted with color tints.

Guelfs and Ghibellines

Guelf was the Italian for Welf (the dynasty that competed for the German throne against the Staufen), while Ghibelline referred to Waiblingen (the name of an important Staufen castle). In the various conflicts between the popes and the Staufen emperors, the "Guelfs" were the factions within the Italian city-states that supported the papacy, while the "Ghibellines" supported the emperor. More generally, however, the names became epithets for various inter- and intra-city political factions that had little or no connection to papal/imperial issues.

illumination

The term used for paintings in medieval manuscripts. These might range from simple decorations of capital letters to full-page compositions. An "illuminated" manuscript is one containing illuminations.

layman/laywoman/laity

Men and women not in church orders, not ordained. In the early Middle Ages it was possible to be a monk and a layperson at the same time. But by the Carolingian period, most monks were priests, and although nuns were not, they were not considered part of the laity because they had taken vows to the church.

Levant

The lands that border the eastern shore of the Mediterranean; the Holy Land.

liturgy

The formal worship of the church, which included prayers, readings, and significant gestures at fixed times appropriate to the season. While often referring to the Mass (see below), it may equally be used to describe the Offices (see below).

The Madonna

See Virgin Mary (below).

Maghreb

A region of northwest Africa embracing the Atlas Mountains and the coastline of Morocco, Algeria, and Tunisia.

Mass

The central ceremony of Christian worship; it includes prayers and readings from the Bible and culminates in the consecration of bread and wine as the body and blood of Christ, offered to believers in the sacrament of the "Eucharist," or "Holy Communion."

New Testament

This work, a compilation of the second century, contains the four Gospels (accounts of the life of Christ) by Matthew, Mark, Luke, and John; the Acts of the Apostles; various letters, mainly from Saints Paul, Peter, and John to fledgling Christian communities; and the Apocalypse. It is distinguished from the "Old Testament" (see below).

Office

In the context of monastic life, the day and night were punctuated by eight periods in which the monks gathered to recite a precise set of prayers. Each set was called an "Office," and the cycle as a whole was called the "Divine Office." Special rites and ceremonies might also be called offices, such as the "Office of the Dead."

Old Testament

The writings of the Hebrew Bible that were accepted as authentic by Christians, though reinterpreted by them as prefiguring the coming of Christ; they were thus seen as the precursor of the "New Testament" (see above), which fulfilled and perfected them.

Presentation in the Temple

An event in the life of Christ and his mother. See The Virgin below.

relief
>This has two separate meanings. In connection with medieval English government, the "relief" refers to money paid upon inheriting a fief. In the history of sculpture, however, "relief" refers to figures or other forms that project from a flat background. "Low relief" means that the forms project rather little, while "high relief" refers to forms that may be so three-dimensional as to threaten to break away from the flat surface.

sacraments
>The rites of the church that (in its view) Jesus instituted to confer sanctifying grace. With the sacraments, one achieved salvation. Cut off from the sacraments (by anathema, excommunication, or interdict), one was damned.

scriptorium
>(*pl.* scriptoria) The room of the monastery where parchment was prepared and texts were copied, illuminated, and bound.

summa
>(*pl.* summae) A compendium or summary. A term favored by scholastics to title their comprehensive syntheses.

The Virgin/The Virgin Mary/The Blessed Virgin/The Madonna
>The Gospels of Matthew (1:18–23) and Luke (1:27–35) assert that Christ was conceived by the Holy Spirit (rather than by a man) and born of Mary, a virgin. Already in the fourth century the Church Fathers stressed the virginity of Mary, which guaranteed the holiness of Christ. In the fifth century, at the Council of Chalcedon (451), Mary's perpetual (eternal) virginity was declared. Mary was understood as the exact opposite of (and antidote to) Eve. In the medieval church, Mary was celebrated with four feasts— her Nativity (birth), the Annunciation (when the Angel Gabriel announced to her that she would give birth to the Messiah), the Purification (when she presented the baby Jesus in the temple and was herself cleansed after giving birth), and her Assumption (when she rose to Heaven). (The Purification is also called the Presentation in the Temple.) These events were frequently depicted in paintings and sculpture, especially in the later Middle Ages, when devotion to Mary's cult increased and greater emphasis was placed on her role as intercessor with her son in Heaven.

APPENDIX: LISTS

LATE ROMAN EMPERORS
(Usurpers in Italics)

Maximinus Thrax (235–238)

Gordian I (238)

Gordian II (238)

Balbinus and Pupienus (238)

Gordian III (238–244)

Philip the Arab (244–249)

Decius (249–251)

Trebonianus Gallus (251–253)

Aemilian (253)

Valerian (253–260)

Gallienus (253–268)

Claudius II Gothicus (268–270)

Quintillus (270)

Aurelian (270–275)

Tacitus (275–276)

Florian (276)

Probus (276–282)

Carus (282–283)

In the West
Numerianus (283–284)

In the East
Carinus (283–285)

Diocletian (284–305)

Maximian (Augustus in the West) (286–305)

First Tetrarchy:*

Maximian (Augustus) (293–305) Diocletian (Augustus) (293–305)
Constantius I (Caesar) (293–305) Galerius (Caesar) (293–305)

Second Tetrarchy:

Constantius I (Augustus) (305–306) Galerius (Augustus) (305–306)
Severus II (Caesar) (305–306) Maximin (Caesar) (305–306)

Third Tetrarchy:

Severus II (Augustus) (306–307) Galerius (Augustus) (306–307)
Constantine I (Caesar) (306–307) Maximin (Caesar) (306–307)

Fourth Tetrarchy:

Licinius (Augustus) (308–311) Galerius (Augustus) (308–311)
Constantine I (Caesar) (308–311) Maximin (Caesar) (308–311)

Maxentius (in Italy) (306–312)

Constantine I (Augustus) (311–337), Licinius (Augustus) (311–324), Maximin (Augustus) (311–313)

Constantine I and Licinius (313–324)

Constantine I (324–337)

Constantine II (Augustus) (337–340), Constans (Augustus) (337–350), Constantius II (Augustus) (337–361)

Constans (340–350) Constantius II (340–361)

Constantius II (350–361)

Magnentius (350–353)

Julian (361–363)

Jovian (363–364)

Valentinian I (364–375) Valens (364–378)

Gratian (367–383) Theodosius I (379–395)

Valentinian II (375–392)

Magnus Maximus (383–388) and Flavius Victor (384–388)

Eugenius (392–394)

* Dates refer to the duration of the tetrarchy.

Theodosius I (394–395)

Honorius I (395–423)
(Stilicho regent) (395–408)

Arcadius (395–408)

Theodosius II (408–450)

Constantius III (421)

John (423–425)

Valentian III (425–455)

Marcian (450–457)

Petronius Maximus (455)

Leo I (457–474)

Avitus (455–456)

Majorian (457–461)

Libius Severus (461–465)

Anthemius (467–472)

Olybrius (472)

Glycerius (473–474)

Julius Nepos (474–475)

Zeno (474–491)

Romulus Augustulus (475–476)

Anastasius I (491–518)

Justin I (518–527)

Justinian I (527–565)

BYZANTINE EMPERORS

Justinian I (527–565)
Justin II (565–578)
Tiberius I (578–582)
Maurice (582–602)
Phocas (602–610)
Heraclius (610–641)
Constantine III and Heraclius II
 (Heraclonas) (641)
Constans II (641–668)
Constantine IV (668–685)
Justinian II (685–695)
Leontius (695–698)
Tiberius II (698–705)

Justinian II (again) (705–711)
Philippicus (711–713)
Anastasius II (713–715)
Theodosius III (715–717)
Leo III (717–741)
Constantine V (741–775)
Leo IV (775–780)
Constantine VI (780–797)
Irene (797–802)
Nicephorus I (802–811)
Stauracius (811)
Michael I (811–813)
Leo V (813–820)

Michael II (820–829)
Theophilus (829–842)
Michael III (842–867)

Macedonian Dynasty (867–1056)
Basil I (867–886)
Leo VI (886–912)
Alexander (912–913)
Constantine VII (913–959)
Romanus I (920–944)
Romanus II (959–963)
Nicephorus II (963–969)
John I (969–976)
Basil II (976–1025)
Constantine VIII (1025–1028)
Romanus III (1028–1034)
Michael IV (1034–1041)
Michael V (1041–1042)
Zoe and Theodora (1042)
Constantine IX (1042–1055)
Theodora (again) (1055–1056)

Michael VI (1056–1057)
Isaac I (1057–1059)
Constantine X (1059–1067)
Romanus IV (1068–1071)
Michael VII (1071–1078)
Nicephorus III (1078–1081)

Comnenian Dynasty (1081–1185)
Alexius I (1081–1118)
John II (1118–1143)
Manuel I (1143–1180)
Alexius II (1180–1183)
Andronicus I (1183–1185)

Isaac II (1185–1195)
Alexius III (1195–1203)
Isaac II (again) and Alexius IV (1203–1204)
Alexius V (1204)
Theodore I (1205–1221)
John III (1221–1254)
Theodore II (1254–1258)
John IV (1259–1261)

Palaiologan Dynasty (1259–1453)
Michael VIII (1259–1282)
Andronicus II (1282–1328)
Michael IX (1294/5–1320)
Andronicus III (1328–1341)
John V (1341–1391)
John VI (1347–1354)
Andronicus IV (1376–1379)
John VII (1390)
Manuel II (1391–1425)
John VIII (1425–1448)
Constantine XI (1449–1453)

POPES AND ANTIPOPES TO 1500* (Antipopes in Italics)

Peter (?–c.64)
Linus (c.67–76/79)
Anacletus (76–88 or 79–91)
Clement I (88–97 or 92–101)
Evaristus (c.97–c.107)
Alexander I (105–115 or 109–119)
Sixtus I (c.115–c.125)

Telesphorus (c.125–c.136)
Hyginus (c.136–c.140)
Pius I (c.140–155)
Anicetus (c.155–c.166)
Soter (c.166–c.175)
Eleutherius (c.175–189)
Victor I (c.189–199)

* Only since the ninth century has the title of "pope" come to be associated exclusively with the bishop of Rome.

Zephyrinus (*c*.199–217)
Calixtus I (Callistus) (217?–222)
Hippolytus (217, 218–235)
Urban I (222–230)
Pontian (230–235)
Anterus (235–236)
Fabian (236–250)
Cornelius (251–253)
Novatian (251)
Lucius I (253–254)
Stephen I (254–257)
Sixtus II (257–258)
Dionysius (259–268)
Felix I (269–274)
Eutychian (275–283)
Galus (283–296)
Marcellinus (291/296–304)
Marcellus I (308–309)
Eusebius (309/310)
Miltiades (Melchiades) (311–314)
Sylvester I (314–335)
Mark (336)
Julius I (337–352)
Liberius (352–366)
Felix II (355–358)
Damasus I (366–384)
Ursinus (366–367)
Siricius (384–399)
Anastasius I (399–401)
Innocent I (401–417)
Zosimus (417–418)
Boniface I (418–422)
Eulalius (418–419)
Celestine I (422–432)
Sixtus III (432–440)
Leo I (440–461)
Hilary (461–468)
Simplicius (468–483)
Felix III (or II) (483–492)
Gelasius I (492–496)
Anastasius II (496–498)
Symmachus (498–514)

Laurentius (498, 501–c.505/507)
Hormisdas (514–523)
John I (523–526)
Felix IV (or III) (526–530)
Dioscorus (530)
Boniface II (530–532)
John II (533–535)
Agapetus I (535–536)
Silverius (536–537)
Vigilius (537–555)
Pelagius I (556–561)
John III (561–574)
Benedict I (575–579)
Pelagius II (579–590)
Gregory I (590–604)
Sabinian (604–606)
Boniface III (607)
Boniface IV (608–615)
Deusdedit (also called Adeodatus I)
 (615–618)
Boniface V (619–625)
Honorius I (625–638)
Severinus (640)
John IV (640–642)
Theodore I (642–649)
Martin I (649–655)
Eugenius I (654–657)
Vitalian (657–672)
Adeodatus II (672–676)
Donus (676–678)
Agatho (678–681)
Leo II (682–683)
Benedict II (684–685)
John V (685–686)
Conon (686–687)
Sergius I (687–701)
Theodore (687)
Paschal (687)
John VI (701–705)
John VII (705–707)
Sisinnius (708)
Constantine (708–715)

Gregory II (715–731)

Gregory III (731–741)

Zacharias (Zachary) (741–752)

Stephen II (752–757)

Paul I (757–767)

Constantine (II) (767–768)

Philip (768)

Stephen III (768–772)

Adrian I (772–795)

Leo III (795–816)

Stephen IV (816–817)

Paschal I (817–824)

Eugenius II (824–827)

Valentine (827)

Gregory IV (827–844)

John (844)

Sergius II (844–847)

Leo IV (847–855)

Benedict III (855–858)

Anastasius (Anastasius the Librarian) (855)

Nicholas I (858–867)

Adrian II (867–872)

John VIII (872–882)

Marinus I (882–884)

Adrian III (884–885)

Stephen V (885–891)

Formosus (891–896)

Boniface VI (896)

Stephen VI (896–897)

Romanus (897)

Theodore II (897)

John IX (898–900)

Benedict IV (900–903)

Leo V (903)

Christopher (903–904)

Sergius III (904–911)

Anastasius III (911–913)

Lando (913–914)

John X (914–928)

Leo VI (928)

Stephen VII (929–931)

John XI (931–935)

Leo VII (936–939)

Stephen VIII (939–942)

Marinus II (942–946)

Agapetus II (946–955)

John XII (955–964)

Leo VIII (963–965)

Benedict V (964–966?)

John XIII (965–972)

Benedict VI (973–974)

Boniface VII (1st time) (974)

Benedict VII (974–983)

John XIV (983–984)

Boniface VII (2nd time) (984–985)

John XV (or XVI) (985–996)

Gregory V (996–999)

John XVI (or XVII) (997–998)

Sylvester II (999–1003)

John XVII (or XVIII) (1003)

John XVIII (or XIX) (1004–1009)

Sergius IV (1009–1012)

Gregory (VI) (1012)

Benedict VIII (1012–1024)

John XIX (or XX) (1024–1032)

Benedict IX (1st time) (1032–1044)

Sylvester III (1045)

Benedict IX (2nd time) (1045)

Gregory VI (1045–1046)

Clement II (1046–1047)

Benedict IX (3rd time) (1047–1048)

Damasus II (1048)

Leo IX (1049–1054)

Victor II (1055–1057)

Stephen IX (1057–1058)

Benedict (X) (1058–1059)

Nicholas II (1059–1061)

Alexander II (1061–1073)

Honorius (II) (1061–1072)

Gregory VII (1073–1085)

Clement (III) (1080–1100)
Victor III (1086–1087)
Urban II (1088–1099)
Paschal II (1099–1118)
Theodoric (1100–1102)
Albert (also called Aleric) (1102)
Sylvester (IV) (1105–1111)
Gelasius II (1118–1119)
Gregory (VIII) (1118–1121)
Calixtus II (Callistus) (1119–1124)
Honorius II (1124–1130)
Celestine (II) (1124)
Innocent II (1130–1143)
Anacletus (II) (1130–1138)
Victor (IV) (1138)
Celestine II (1143–1144)
Lucius II (1144–1145)
Eugenius III (1145–1153)
Anastasius IV (1153–1154)
Adrian IV (1154–1159)
Alexander III (1159–1181)
Victor (IV) (1159–1164)
Paschal (III) (1164–1168)
Calixtus (III) (1168–1178)
Innocent (III) (1179–1180)
Lucius III (1181–1185)
Urban III (1185–1187)
Gregory VIII (1187)
Clement III (1187–1191)
Celestine III (1191–1198)
Innocent III (1198–1216)
Honorius III (1216–1227)
Gregory IX (1227–1241)
Celestine IV (1241)
Innocent IV (1243–1254)
Alexander IV (1254–1261)
Urban IV (1261–1264)
Clement IV (1265–1268)
Gregory X (1271–1276)
Innocent V (1276)

Adrian V (1276)
John XXI (1276–1277)
Nicholas III (1277–1280)
Martin IV (1281–1285)
Honorius IV (1285–1287)
Nicholas IV (1288–1292)
Celestine V (1294)
Boniface VIII (1294–1303)
Benedict IX (1303–1304)
Clement V (at Avignon, from 1309) (1305–1314)
John XXII (at Avignon) (1316–1334)
Nicholas (V) (at Rome) (1328–1330)
Benedict XII (at Avignon) (1334–1342)
Clement VI (at Avignon) (1342–1352)
Innocent VI (at Avignon) (1352–1362)
Urban V (at Avignon) (1362–1370)
Gregory XI (at Avignon, then Rome from 1377) (1370–1378)
Urban VI (1378–1389)
Clement (VII) (at Avignon) (1378–1394)
Boniface IX (1389–1404)
Benedict (XIII) (at Avignon) (1394–1417)
Innocent VII (1404–1406)
Gregory XII (1406–1415)
Alexander (V) (at Bologna) (1409–1410)
John (XXIII) (at Bologna) (1410–1415)
Martin V (1417–1431)
Clement (VIII) (1423–1429)
Eugenius IV (1431–1447)
Felix (V) (also called Amadeus VIII of Savoy) (1439–1449)
Nicholas V (1447–1455)
Calixtus III (Callistus) (1455–1458)
Pius II (1458–1464)
Paul II (1464–1471)
Sixtus IV (1471–1484)
Innocent VIII (1484–1492)
Alexander VI (1492–1503)

CALIPHS

Early Caliphs
Abu-Bakr (632–634)
Umar I (634–644)
Uthman (644–656)
Ali (656–661)

Umayyads
Mu'awiyah I (661–680)
Yazid I (680–683)
Mu'awiyah II (683–684)
Marwan I (684–685)
'Abd al-Malik (685–705)
al-Walid I (705–715)
Sulayman (715–717)
Umar II (717–720)
Yazid II (720–724)
Hisham (724–743)
al-Walid II (743–744)
Yazid III (744)
Ibrahim (744)
Marwan II (744–750)

Abbasids*
al-Saffah (750–754)
al-Mansur (754–775)
al-Mahdi (775–785)
al-Hadi (785–786)
Harun al-Rashid (786–809)
al-Amin (809–813)
al-Ma'mun (813–833)

al-Mu'tasim (833–842)
al-Wathiq (842–847)
al-Mutawakkil (847–861)
al-Muntasir (861–862)
al-Musta'in (862–866)
al-Mu'tazz (866–869)
al-Muhtadi (869–870)
al-Mu'tamid (870–892)
al-Mu'tadid (892–902)
al-Muqtafi (902–908)
al-Muqtadir (908–932)
al-Qahir (932–934)
al-Radi (934–940)

Fatimids
'Ubayd Allah (al-Mahdi) (909–934)
al-Qa'im (934–946)
al-Mansur (946–953)
al-Mu'izz (953–975)
al-'Aziz (975–996)
al-Hakim (996–1021)
al-Zahir (1021–1036)
al-Mustansir (1036–1094)
al-Musta'li (1094–1101)
al-Amir (1101–1130)
al-Hafiz (1130–1149)
al-Zafir (1149–1154)
al-Fa'iz (1154–1160)
al-'Adid (1160–1171)

* Abbasid caliphs continued at Baghdad—with, however, only nominal power—until 1258. Thereafter, a branch of the family in Cairo held the caliphate until the sixteenth century.

OTTOMAN EMIRS AND SULTANS

Othman (Uthman) (d.1324/1326)
Orkhan (1324/1326–1359/1360)
Murad I (1359/1360–1389)
Bayazid I (1389–1402)
Ottoman Civil War (1402–1413)

Mehmed I (1413–1421)
Murad II (1421–1444, 1446–1451)
Mehmed II the Conqueror (1444–1446,
 1451–1481)
Bayazid II (1481–1512)

Seeing the Middle Ages: Guido da Vigevano, "The Seven Cells of the Uterus" (1345). Uterus. Liber notabilium Philippi septimi francorum regis, a libris Galieni extractus. 1345. 32 x 22 cm. MS 334, fol. 267v. Photo: René-Gabriel Ojéda. Musée Condé, Chantilly, France. Copyright © RMN-Grand Palais / Art Resource, NY.

7.4 *Hours of Jeanne d'Evreux* (c.1325–1328). Jean Pucelle, fol. 15v, 16r. I. Walther, N. Wolf: Codices illustres; Köln 2005, S. 208.

7.5 Tomb and Effigy of Robert d'Artois (1317). Effigy (stone), Pepin, Jean (Jean Pepin de Huy) (14th century) / Basilique Saint-Denis, France / Giraudon / The Bridgeman Art Library. Reproduced by permission.

7.6 The Motet *S'Amours* (c.1300). *Chansons anciennes (en latin et en français) avec la musique.* MS H196, fol. 270r. Reproduced by permission of the Bibliothèque universitaire de médecine, Université Montpellier.

7.7 Saint John, "Dominican" Bible (mid-13th cent.). MS Lat. 16722m, fol. 205v. Reproduced by permission of the Bibliothèque nationale de France.

7.8 Saint John, "Aurifaber" Bible (mid-13th cent.) Reproduced by permission of Württembergische Landesbibliothek Stuttgart, Cod. bibl. qt. 8, fol. 402v.

7.9 Nicola Pisano, Pulpit (1266–1268). Siena, Baptistry, Pulpit, Adoration of the Magi, detail / De Agostini Picture Library / G. Nimatallah / The Bridgeman Art Library. Reproduced by permission.

7.10 Giotto, Scrovegni Chapel, Padua (1304–1306). Reprinted by permission of Comune di Padova—Assessorato alla Cultura.

7.11 Giotto, *Raising of Lazarus*, Scrovegni Chapel (1304–1306). Fresco (post restoration), Giotto di Bondone (c.1266–1337) / Scrovegni (Arena) Chapel, Padua, Italy / Alinari / The Bridgeman Art Library. Reproduced by permission.

8.1 Corpses Confront the Living (c.1441). Sign. XVIII B 18, fol. 542r: Alexander de Villa Dei, Hieronymus Stridonensis, Pseudo-Augustinus. Reproduced by permission of the National Museum, Prague, Czech Republic.

8.2 Donatello, *Judith and Holofernes* (c.1420–1430). Donatello (c.1386–1466). Bronze. Palazzo Vecchio, Florence, Italy. Reproduced by permission of Scala / Art Resource, NY.

8.3 Piero di Cosimo, *Venus, Cupid, and Mars* (c.1495–1505). Piero di Cosimo (1462–1521). Oil on poplar wood. 72 x 182 cm. Inv. 107. Reproduced by permission of bpk, Berlin / Gemaeldegalerie, Staatliche Museen, Berlin / Jörg P. Anders / Art Resource, NY.

8.4 Filippo Brunelleschi, Florence Cathedral Dome (1418–1436). Brunelleschi, Filippo (1377–1446). Exterior view of the dome. Duomo (S. Maria del Fiore), Florence, Italy. Reproduced by permission of Scala / Art Resource, NY.

8.5 Raphael, *Entombment of Christ* (1507). Galleria Borghese, Rome, Italy. Reproduced by permission of Erich Lessing / Art Resource, NY.

8.6 Leonardo da Vinci, *The Last Supper* (1494–1497). Leonardo da Vinci (1452–1519). Post-restoration. Photo: Mauro Magliani. S. Maria delle Grazie, Milan, Italy. Reproduced by permission of Alinari / Art Resource, NY.

8.7 Gentile Bellini, *Portrait of Mehmed II* (1479). The Sultan Mehmet II (1432–81) 1480 (oil on canvas), Bellini, Gentile (*c*.1429–1507) (attr. to) / National Gallery, London, UK / The Bridgeman Art Library. Reproduced by permission.

8.8 *History of Alexander the Great*, Tapestry (*c*.1459). Affairs of Alexander the Great in the East. Second in a series of tapestries showing the life of Alexander the Great, Hall of the Giants. Tournai, ca. 1460. Reproduced by permission of Alinari / Art Resource, NY.

8.9 Rogier van der Weyden, *Columba Altarpiece* (1450s). Oil on panel. Reproduced by permission of SuperStock.

8.10 Jan van Eyck, *Man in a Red Turban* (1433). Portrait of a Man, 1433 (oil on oak), Eyck, Jan van (*c*.1390–1441) / National Gallery, London, UK / The Bridgeman Art Library. Reproduced by permission.

FIGURES

5.1 Saint-Germain of Auxerre (12th cent.). Christian Sapin (dir.), *Archéologie et architecture d'un site monastique: 10 ans de recherche à l'abbaye Saint-Germain d'Auxerre* (Auxerre: Centre d'etudes medievales; Paris: CTHS, 2000), Figs. 3 and 371.

5.2 A Model Romanesque Church: Saint-Lazare of Autun. Adapted from Fig. 70 in Linda Seidel, *Legends in Limestone: Lazarus, Gislebertus, and the Cathedral of Autun* (Chicago: University of Chicago Press, 1999), p. 120, original drawing attributed to Anthony Titus.

5.3 Plan of Fountains Abbey (founded 1132). Adapted from Plate 70 in Wolfgang Braunfels, *Monasteries of Western Europe: The Architecture of the Orders* (Princeton: Princeton University Press, 1972), p. 84. Copyright © Dumont Buchverlag GmbH.

7.1 Single Notes and Values of Franconian Notation. From *Anthology of Medieval Music*, ed. Richard Hoppin (W.W. Norton, 1978).

INDEX

Page numbers for illustrations are in italics.

Lyon, 233
 Carthusian Diurnal from (12th cent.), 184, *188*, 189

school of medicine, 179, 220, 229
Samarkand, 287
Samarra, 123
S'Amours (*c.*1300) (motet), 268, *269*
San Damiano (Assisi), 231
San Francesco (Assisi)
 Upper Church (completed by 1253), 221, *226*,
 227–28
San Francesco (Bologna) (1263), *153*
San Miniato
 bacino (bowl) (late 12th cent.), 163, *163*
 Cathedral (late 12th cent.), *162*, 163
Sant Tomàs de Fluvià
 Last Supper, painted vault (early 12th cent.), 183,
 183, 189
Santiago de Compostela, 175
Saxony, 127, 132, 141, 235
Scandinavia, 121, 138–39, 148–49, 173
scholastics/scholasticism, 179, 265–67, 279
schools/schooling. *See* education
science, 126, 178, 220. *See also* liberal arts; medicine
Scotland, 127, 129, 203, 231, 254, 259, 296
Scotti, Alberto, *signore* of Piacenza, 250
scriptorium/scriptoria, 270
 definition of, 334
Seljuks, 155–58, 170, 241
 genealogy, 156
seneschals, 208, 255
Sententiae (Peter Lombard), 179
Serbia, 212, 287
serfs/serfdom, 130–32, 148, 165, 233, 253, 278,
 299–300, 324
sheriff/sheriffs, 137–38, 164, 203, 207, 254
Shi'ites, 123–24, 127
Shirkuh (d.1169), 198
Shrine Madonnas, 261–63
 Shrine Madonna (*c.*1300), *262*
Sic et non (Yes and No) (Abelard), 179, 266
Sicilian Vespers (1282), 212
Sicily, 119, 130, 158, 167, 179, 211–13, 237, 247, 278
 rulers of, genealogy, 209
signore/signori/signoria, 250, 296, 302, 317
Silesia, 257
Simon de Montfort (*c.*1208–1265), 254
slaves, 117, 121, 123, 125–26, 135, 157, 175, 234, 243,
 314, 323–24
Slavs, 119, 212, 301
Spain, 120, 161, 167, 170, 175, 179, 186, 197, 207, 212,
 231, 233–34, 237, 247, 251–52, 279, 286, 295,
 304, 324

St. Gall, 305
Statute of Laborers (1351) (Edward III), 284
Statute of the Jewry (1275) (Edward I), 250
statutes, 218–19, 220, 237
Staufen, 208, 212, 254
 genealogy, 209
Stephen of Blois, 175
Stephen I, prince and king of Hungary (r.997–
 1038), 148
Strasbourg, 286
students. *See* education
Suger, abbot of Saint-Denis (1081–1151), 176, 221,
 276, 300
Summa against the Gentiles (Thomas Aquinas), 266
summa/summae, 266, 279. *See also* scholastics/
 scholasticism; Thomas Aquinas
 definition of, 334
Sunni orthodoxy, 155, 158
Sunnis, 125, 127, 197–98
Sutri, Synod of (1046), 165–66
Sweden, 139
Swiss Confederation (*c.*1500), 297
Switzerland, 286, 297
Syria, 125, 157, 197–98, 200, 242

taifas, 125, 167, 175
Tamerlane. *See* Timur the Lame
taxes/taxation, 123, 133, 155, 164, 174, 176, 178,
 200–201, 208, 210, 212, 213–14, 221, 248, 250,
 253, 288–89, 297, 299–300, 302, 304–5
 of the clergy, 258
 Danegeld, 129
 taille, 278
teachers. *See* education
Templar Knights/Templars, 173, 207, 235, 255
Tertiary Order/Tertiaries, 231
Teutonic Knights, 235–36, 258
themes, 119, 159
theology, 179, 192, 220, 228–29, 266
Thomas Aquinas (*c.*1225–1274), 265–67, 305
 Summa against the Gentiles, 266
Timur the Lame (Tamerlane) (1336–1405), 287
Toledo, 175, 179
Tomb and Effigy of Robert d'Artois (1317), 264–65,
 265
Torquemada, Tomás de (1420–1498), 304
Tours, 160–61
 estates assembly at (1308), 255
Toury, 132, 276
transubstantiation, 261, 267, 303. *See also* Eucharist